The Complete Guide to the
Statues and Sculptures of Dublin City

ABOUT THE AUTHOR

Neal Doherty was born in Dublin, educated in Terenure College and achieved an MBA from the Open University. His first career was with Nestlé, where he managed its chilled food business in Ireland. After 37 years his position was made redundant and a second career beckoned as a tourist guide. He completed the tourist guide course with Fáilte Ireland and now works as a freelance guide in French and English for various tour operators. As a guide, Neal has extensively researched many aspects of the history, heritage and inhabitants of Ireland. This book is the end result of that research.

Making maximum use of Gandhi's philosophy, 'Live like you are going to die tomorrow and learn like you are going to live forever', Neal is very active. He is a keen sailor, hill-walker and member of Engineers Toastmasters club for public speaking. He travels to France each year for up to two months to work as a volunteer in the Banque Alimentaire, a food bank for the poor, and to keep his French up to date. When not working he likes to spend as much time as possible in Belmullet in the west of Ireland, where he has a holiday home.

Neal lives in Sandymount with his wife, Barbara. They are 'empty nesters' as their eldest son, James, lives in Berlin while their younger son, John, lives locally.

The Complete Guide to the Statues and Sculptures of Dublin City

Neal Doherty

ORPEN PRESS

Published by
Orpen Press
Lonsdale House
Avoca Avenue
Blackrock
Co. Dublin
Ireland

email: info@orpenpress.com
www.orpenpress.com

Please see p. vi for copyright information on photographs.

Every effort has been made to include information about the sculptors and dates of erection of all pieces profiled in this book. If you can clarify any errors or omissions please notify the publishers who will rectify the information at the earliest opportunity.

Paperback ISBN 978-1-909895-72-0
ePub ISBN 978-1-909895-73-7
Kindle ISBN 978-1-909895-74-4
PDF ISBN 978-1-909895-75-1

Printed in Belfast by GPS Colour Graphics Ltd

For Barbara, my wife and best friend

PHOTO CREDITS

All photographs © Neal Doherty except:
A15 William Dargan: Photograph courtesy of the National Gallery of Ireland.
B47 Thomas Moore: Photograph courtesy of Dublin City Council.
B49 Styne Stone: Photograph courtesy of Dublin City Library and Archive.
B53 The People's Island: Photograph courtesy of Rachel Joynt.
C20 Absolute Jellies Make Singing Sounds: Photograph courtesy of Maud Cotter.
D30 Death of Cú Chulainn: Photograph courtesy of An Post.

OTHER ACKNOWLEDGEMENTS

B15 Standing Figure Knife Edge: Reproduced by permission of the Henry Moore Foundation.
B35 Cactus Provisoire: Alexander Calder, *Cactus Provisoire*, 1967, welded steel, Trinity College Dublin Art Collections.
B36 Sfera con Sfera: Arnaldo Pomodoro, *Sfera con Sfera*, 1982, bronze, Trinity College Dublin Art Collections.
B37 Untitled: Geoffrey Thornton, *Untitled*, marble, Trinity College Dublin Art Collections
B38 Countermovement: Michael Warren, *Countermovement*, 1985, Spanish chestnut, Trinity College Dublin Art Collections.
B39 Double Helix: Brian King, *Double Helix*, bronze, Trinity College Dublin Art Collections.
B40 Apples and Atoms: Eilís O'Connell, *Apples and Atoms*, 2013, mirror polished stainless steel, Trinity College Dublin Art Collections.

B41 Reclining Connected Forms: Henry Moore, *Reclining Connected Forms*, 1969, bronze, Trinity College Dublin Art Collections. Reproduced by permission of the Henry Moore Foundation.

B42 Campanile: Charles Lanyon, *Campanile*, 1883, granite and Portland stone, The University of Dublin, Trinity College Dublin. Reproduced by kind permission from the Board of The University of Dublin, Trinity College Dublin, Ireland. Joseph Robinson Kirk, *Campanile Sculptures*, The University of Dublin, Trinity College Dublin. Reproduced by kind permission from the Board of The University of Dublin, Trinity College Dublin, Ireland.

B43 William Lecky: Sir William Goscombe John, *William Edward Hartpole Lecky*, 1906, marble, Trinity College Dublin Art Collections. Reproduced by kind permission from the Board of The University of Dublin, Trinity College Dublin, Ireland.

B44 George Salmon: John Hughes, *George Salmon*, 1911, marble, Trinity College Dublin Art Collections. Reproduced by kind permission from the Board of The University of Dublin, Trinity College Dublin, Ireland

B45 Edmund Burke: John Henry Foley, *Edmund Burke*, 1868, copper electrotype, Trinity College Dublin Art Collections. Reproduced by kind permission from the Board of The University of Dublin, Trinity College Dublin, Ireland.

B46 Oliver Goldsmith: John Henry Foley, *Oliver Goldsmith*, 1861, copper electrotype, Trinity College Dublin Art Collections. Reproduced by kind permission from the Board of The University of Dublin, Trinity College Dublin, Ireland.

ACKNOWLEDGEMENTS

Producing a book like this requires many hundreds of hours of research, site visits and lots of persistence. This takes time and in this regard the person to whom I should give greatest credit is my wife, Barbara, who patiently looked after me as I gave most of my attention to my 'mistresses', the statues and sculptures of Dublin. I should also mention my mum, Maureen, who nurtured my interest in history and French while I was young.

I would also like to thank the many people who took calls, answered emails and helped when I met a blank wall. I would particularly like to thank Leo Higgins, who has a wealth of information and kindly brought Barbara and I on a tour of his foundry. Charles Duggan, Michael Noonan and Ronan O'Donnell of Dublin City Council helped fill some of the gaps.

Thanks to Sandra Bell, Maud Cotter, Cliodna Cussen, Felim Egan, Rachel Joynt and Michael Warren, who kindly provided or sourced photographs of their work, some of which are reproduced in the book.

Other sculptors such as John Coll, Don Cronin, Jason Ellis, Rowan Gillespie, Michael Keane, Brian King, Adam May, Eileen McDonagh, Austin McQuinn, Carolyn Mulholland, Eilís O'Connell, Patrick O'Reilly, Killian Schurmann, Louise Walsh and Grace Weir all helped to keep me on the right track with their works. Thank you to Roger Kirken of the National Maritime Museum, who provided information on the Seamen's Memorial; Miriam O'Brien, Gerry Donoghue, Margaret Gormley, Angela Rolf, Paul Sherwin (retired) of the Office of Public Works, who helped with work in St Stephen's Green and the Iveagh Gardens; Conor Molloy, Cosgrave Developments, who helped with the Peadar Kearney Memorial; and finally Colette Jordan, who helped with the Iveagh Markets.

If I have left anybody out I apologise, but thanks to you too!

CONTENTS

INTRODUCTION

Having lived in Dublin for more than 50 years I felt I knew the city well; that was until I retired from my first career and started to work as a Dublin tourist guide. It was then that I discovered how little I actually knew – the origin of street names, the history of buildings and the stories behind the sculptures and statues of the city. It was while researching for information that I might need to know as a guide that I discovered there was no one publication that told the story of all of the sculptures and statues in Dublin city. Indeed, often the work is not signed or credited to the sculptor, which is a shame as their input is very important.

We pass by these works every day without knowing what is really behind them or giving them a second thought – their sculptors, their erection dates, their symbolism, but most importantly why they were erected. So here it is, the result of two years' research, covering all of the statues and sculptures within the canals and as far west as Kingsbridge. Each entry has a number to identify it on the map, the name of the work, the location, the sculptor and the year erected, where known. All are within reasonable walking distance of the city centre and it will take you more than two days to cover all of them on foot. Good luck!

I have divided the city up into five manageable chunks, each of which can be covered in a half-day's walk. In each case I've tried to put them in order to make it easier to find all the statues in each section. If a half-day is too much to tackle why not just spend an hour or two in the parks or historic locations where you can explore our art and history.

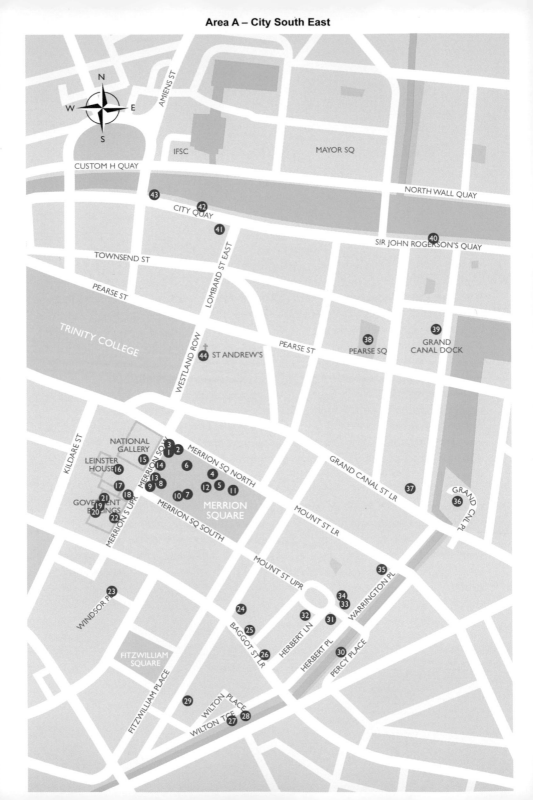

1

CITY SOUTH EAST

This area covers south of the River Liffey and includes the statues located along the Grand Canal, Georgian Dublin, Merrion Square and Government Buildings. It includes one of the most popular groups of statues in the city: Oscar Wilde; his pregnant and long-suffering wife, Constance; and Dionysus, the Greek god of wine.

MERRION SQUARE

Merrion Square is a twelve-acre garden created in the eighteenth century as a place for the residents of the surrounding town houses to take the air. This part of the city is known as Georgian Dublin as it was created during the reigns of the Kings George I to George IV of Great Britain. The houses were built in this area from the 1760s following the building of Leinster House in 1745 by the Duke of Leinster. When he built the house his friends told him that this was not the fashionable side of the city. He replied, 'where I go others will follow.' He was right; many houses were subsequently built and Merrion Square quickly became one of the most fashionable addresses in Dublin. Today many of the grand houses formerly used by the Dublin elite have been converted into offices used by professional people and associations.

The garden was bought by the Catholic Church in the 1930s with a plan to build a cathedral in this location. The plans, however, never came to fruition and the park was leased to the city council in 1974 for the use of the people of Dublin. Today it is a quiet garden in the 'jardin anglaise' style on the borders but with well-maintained flowerbeds in the centre. Most importantly, it contains fourteen works for your consideration.

A1 OSCAR WILDE (1854–1900), Merrion Square *(Danny Osborne, 1997)*

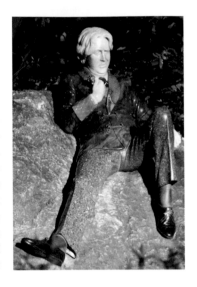

Oscar Fingal O'Flahertie Wills Wilde was born at 21 Westland Row and brought up at 1 Merrion Square, a far smarter address. He would have spent many hours playing in the park as a young boy. His father, Sir William Wilde, was an eminent eye and ear surgeon who also had a great interest in Irish antiquities. His mother, Jane, was a fanatical nationalist who wrote many inflammatory pieces under the pen name 'Speranza'. Wilde was educated at Portora Royal School in Enniskillen and won a scholarship to Trinity College Dublin where he studied classics. He subsequently attended Magdalen College, Oxford, from where he qualified with first class honours in 1876.

Following his graduation, Wilde moved to London. He didn't have much success with his early plays but, starting with *The Picture of Dorian Gray* in 1890 and *Lady Windermere's Fan* in 1892, he gained fame for his work. *A Woman of No Importance*, *An Ideal Husband* and *The Importance of Being Earnest* followed to great acclaim. However, there were clouds on the horizon.

Wilde had married Constance Lloyd in 1884 and they had two children, despite the fact that he was homosexual. He had many relationships with men, starting with his good friend Robbie Ross, but the love of his life was Lord Alfred Douglas, whom he met in 1891. Lord Alfred's father, the Marquess of Queensbury, felt that Wilde had an undue influence on his son and he tried to break them up. He left his card at Wilde's club with a note accusing Wilde of being a 'posing somdomite [sic]'. Wilde was horrified and felt that he had no choice but to sue him for libel. Wilde lost the case and was subsequently tried for gross indecency, found

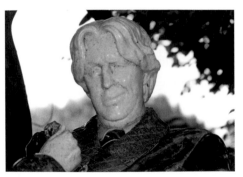

guilty and sentenced to two years' hard labour. The time was very hard on Wilde and when he was released from prison in 1897 he was a broken and bankrupt man. He moved to Paris where he died in 1900. On his deathbed his parting remarks are said to have included 'either this wallpaper goes or I do.' He is buried in Père Lachaise Cemetery in Paris.

Of course Wilde is famous for many great one-liners from his book and plays: 'There is only one thing worse than being talked about, and that's not being talked about'; 'I can resist everything except temptation'; 'I am not young enough to know everything'; 'Always forgive your enemies, nothing annoys them so much'; and 'she is a peacock in everything … except her beauty.'

This lovely statue captures Oscar Wilde perfectly. Resting on a 30-ton white quartz boulder from Co. Wicklow, there are many elements to the statue: the jacket is made of green nephrite jade from Canada; the collars and cuffs of thulite from central Norway; the shoes and socks of black granite from India; the trousers of blue pearl granite from Norway; the shoe laces and buttons of bronze; and the head and hands of white jade from Mexico. Note that his tie is that of an alumnus of Trinity College Dublin. View the statue from the right and you can see Oscar as he dreams of a witticism for his next play, but view him from the left and you will observe that he appears sad, maybe after his time in prison. Deliberate or coincidence, who knows? The statues were commissioned by Guinness.

A2 PREGNANT CONSTANCE WILDE (1859–1898), Merrion Square *(Danny Osborne, 1997)*

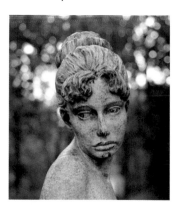

Constance was Oscar Wilde's wife. On the pillar opposite his statue we see her represented in bronze when she was six months pregnant with their first child, Cyril, who was born on 5 June 1885. It was not long after this that Oscar had his first sexual encounter with his friend Robbie Ross. Constance looks sad and forlorn and she is turning her head away from Oscar, perhaps a sign of her disappointment in him.

A3 DIONYSUS, Merrion Square
(Danny Osborne, 1997)

The two pillars represent life and art. Each of them is decorated with quotes from Wilde's work selected by people from the Irish art world in their own handwriting. The sculpture on top is the torso of Dionysus, the Greek god of wine. This is particularly appropriate as Oscar was very fond of having a good time.

A4 BERNARDO O'HIGGINS (1778–1842), Merrion Square *(Francisco Orellana Pavez, 1995)*

Bernardo O'Higgins was the illegitimate son of Ambrosio O'Higgins, a Spanish army officer who was born in

Co. Sligo, and Isabel Riquelme, who was from a prominent Chilean family. Bernardo was supported by his father but spent his early years with his mother and used her surname until his father died in 1801. He studied in London and became interested in the idea of independence for Chile. He was involved in the revolt against Spain in 1810 and was elected to the first independent Chilean parliament.

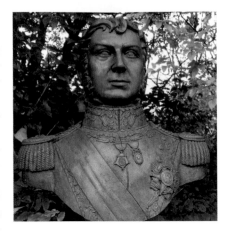

His life was subsequently eventful and he fought many battles against the Spanish and local opposition, eventually becoming leader of Chile in 1820. As leader he implemented many reforms in education, business and the armed forces. Reform cost money and he ran up large debts for the country and was deposed in 1823. He left Chile and fought with Simón Bolívar in the liberation of Peru, where he died at the age of 64. This statue was presented by the people of Chile to Ireland in 1995.

A5 A TRIBUTE HEAD, Merrion Square *(Dame Elisabeth Frink, 1982)*

This sculpture was donated by Artists for Amnesty to mark the twentieth anniversary of the arrest and jailing of Nelson Mandela in 1962. At this time the campaign

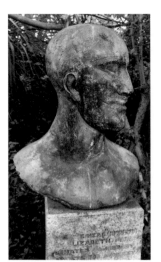

for the abolishment of apartheid in South Africa was gaining momentum and Mandela's continued imprisonment symbolised this struggle. It took another seven years before Mandela was released, and the rest, as they say, is history.

Mandela was awarded the Freedom of the City of Dublin in 1988, two years before he was released, and this was acknowledged through his solicitor in his first external communication from prison in 24 years. After his release in 1990 he visited Dublin to accept the Freedom personally and subsequently visited Ireland on numerous occasions.

This long-faced bald bust, with a gaze that is stoic and resolute, symbolises the strength and endurance of those fighting injustice. It is part of a series of statues known as Tribute Heads that Frink created, dedicated to those who died for their beliefs.

A6 MOTHER AND CHILD, Merrion Square
(Patrick Roe, 1985)

This semi-abstract sculpture captures the protection and closeness of a mother and her child. The granite has been formed to show the baby as it nestles under the curved protection of the mother. At the time of writing, this statue was being restored and is due to be relocated close to the children's playground at the north-west side of the park. The park is an appropriate place for the sculpture as the National Maternity Hospital is located at the north-east corner of the park at Holles Street.

A7 HENRY GRATTAN (1746–1820), Merrion Square
(Peter Grant, 1982)

Grattan was born into a Protestant household in Fishamble Street behind Christ Church Cathedral. He studied classical literature and oratory in Trinity College and law at King's Inns, from where he was called to the Bar in 1772. He entered the Irish Parliament in 1775, being sponsored by Lord Charlemont. Grattan was reported as being not of significant appearance; he had a thin and sharp voice but his oratorical skills were formidable. Indeed, he was once referred to as the 'Irish Demosthenes'. He played a large part in the relaxing of restrictions on Irish exports in 1780 and went on to ensure the passing of the Constitution of 1782, giving the Irish Parliament the power to govern herself without interference from Britain.

In subsequent years the Parliament become known as 'Grattan's Parliament'. He was rewarded with a payment of £50,000 for his efforts. In fact, Parliament

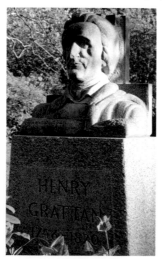

wanted to award him £100,000 but he would only accept the lesser amount. His main efforts towards the end of the eighteen century were to achieve Catholic Emancipation but he did not manage to make any progress with the Conservatives in Parliament.

He retired from Parliament in 1797 but returned to speak against the Act of Union in 1800. Despite his opposition to the Union he took a seat at Westminster in 1805, where he once again fought for Catholic Emancipation. He died in 1820 and is buried in Westminster Cathedral, an indication of the esteem in which he was held. After his death his son Henry Jr published numerous volumes of his speeches, which continue to keep his name in the limelight.

Today he is remembered with a bust in the House of Commons in London, a statue in College Green (**C3**) and a bust in Merrion Square; there is also a street and a bridge in Dublin named after him.

A8 GEORGE RUSSELL (1867–1935), Merrion Square *(Jerome Connor, 1985)*

George Russell was born in Lurgan in Co. Armagh and moved to Dublin with his family at the age of eleven. He was educated at the Metropolitan School of Art, where he met and became good friends with William Butler Yeats. In 1897 he began working for the Irish Agricultural Organisation Society (IAOS), an agricultural cooperative society, which was founded to encourage farmers to work together in a business-like manner. The IAOS office was located at No. 84 Merrion Square at the south of the square. He travelled extensively throughout Ireland setting up credit societies and cooperative banks. In 1903 he became editor of the *Irish Homestead* and subsequently the *Irish Statesman*, with which it merged.

Russell was very much at the forefront of the Irish literary revival and he wrote and published many books of poetry. His pen name was Æ, which he adapted when a printer inadvertently misspelt 'aeon' in one of his pieces. In his role as editor he supported many young Irish writers, among them Patrick Kavanagh (**A27**), Frank O'Connor and James Joyce (**B8**). Joyce acknowledged his support and the fact that he lent him money with a number of references in *Ulysses*, including 'beard and bicycle' and 'A.E.I.O.U.'

In his lifetime Russell was a painter, poet, editor, writer, mystic and, in the words of Kavanagh, 'a great and holy man'. He died in Bournemouth, England but is buried in Mount Jerome Cemetery in Dublin.

This sculpture shows Russell, with his beard, looking at the ground, perhaps representing the story of when he and William Butler Yeats (**B15**), who lived two doors from Russell's office, simultaneously decided to visit each other. However they missed each other in passing as Yeats was observing something overhead while Russell was looking at the ground.

A9 THE VICTIMS, Merrion Square *(Andrew O'Connor, 1976)*

Dedicated to the victims of war, this sculpture was originally proposed in 1918 as a war memorial for Washington DC. It was planned to locate the sculpture in front of a mausoleum with a highly decorated niche and a woman figure representing

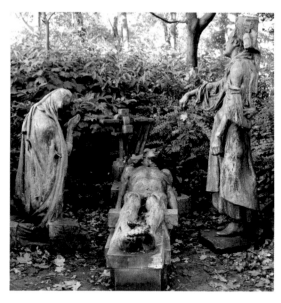

the mother country. The proposal was, however, not accepted. O'Connor liked the statue and continued to work on it in his spare time. The theme of the group is the return of a dead war hero to his native land, placed on a bier and being mourned by his wife, kneeling, and his mother, standing. The quote on the base of the kneeling statue is a quote from Dante's *Inferno*, Canto V – the vision of Paolo and Francesca: 'As cranes, chanting their dolorous notes, traverse the sky'. Note also the quote on the right side of the bier: 'Naked you came into the world', which is adapted from the Book of Job 1:21, 'Naked I came from my mother's womb.'

A10 MICHAEL COLLINS (1890–1922), Merrion Square *(Dick Joynt, 1988)*

Michael Collins was born in West Cork to a farming family. At the age of fifteen he moved to London and worked with the Royal Mail. It was while there that he became involved with the Irish Republican Brotherhood (IRB), an organisation whose objective was Irish independence. He moved back to Ireland in 1916 and was aide-de-camp to Joseph Plunkett, one of the leaders of the 1916 Easter Rebellion. Indeed Collins fought in the General Post Office (GPO) during the Rebellion. After the Rebellion he was interned in Frongoch in Wales but was freed in December of the same year under an amnesty. He became a leading figure in the vacuum that followed the Rebellion and was elected a Member of Parliament for Cork South in 1918. Along with other members of the independence movement he refused to take his seat in Westminster and instead took part in the first Dáil (Irish for Parliament) in January 1919. As a member of the Provisional Government he was Minister for Finance and Director of Intelligence.

He developed a network of spies and organised a guerrilla war against the British in Ireland, targeting British informers and members of the secret service. He used 'flying squads' in an early form of guerrilla warfare to attack the British army and the Royal Irish Constabulary, making Ireland ungovernable and attracting a bounty of £10,000 on his head. He avoided capture through bravado and the use of safe houses throughout the city. The British government reacted by

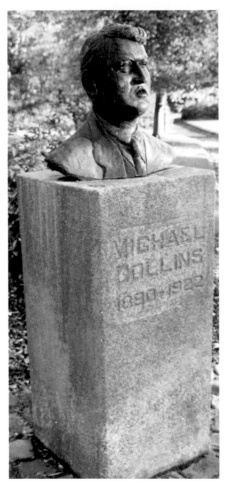

sending in auxiliaries known as the Black and Tans, due to their uniform, to wage a campaign of terror. This period became known as the Irish War of Independence, which lasted from January 1919 until a ceasefire was agreed in July 1921.

Against his wishes, Collins was part of the Irish delegation that negotiated the Anglo-Irish Treaty, signed in December 1921. This gave dominion status to Ireland, effectively confirmed the six counties of Northern Ireland as part of the United Kingdom and maintained three ports in Ireland for the Royal Navy. This was not what the delegation wanted but, as Collins said, it gave 'the freedom to achieve freedom'. The Treaty split the Provisional Government, leading to the Civil War in which Collins was killed in August 1922. Ireland had lost one of its great leaders.

This bust shows Collins in a defiant mood, as was often his demeanour. This is the only statue of Collins in Dublin but one of Ireland's main military barracks, Collins Barracks, was named after him. The barracks was subsequently closed and today houses the National Museum of Ireland, Decorative Arts and History.

A11 ÉIRE, Merrion Square *(Jerome Connor, 1976)*
This sculpture represents Éire, the Gaelic name for Ireland. The name derives from old Irish, Ériu, which was the name of the Celtic goddess of land. She is seen here holding a harp, a symbol of Ireland, richly decorated with Celtic and Viking motifs and also animals, including a rhinoceros. The sculpture was originally dedicated as a memorial to Kerry poets but due to its lack of religious symbolism money for the project was blocked by opponents in the 1930s and the sculptor went bankrupt. The plaster casts lay rotting in Connor's studio after his death in 1943. However Domhnall O'Murchadha, a lecturer in the National College of Art

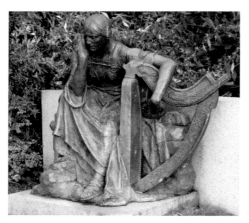

and Design, rescued and restored them with the help of then student Fred Conlon (see 'Beds', **E9**). This was one of the first sculptures erected after the park was leased to the City of Dublin by the Catholic Church in 1974.

A12 THRONE, Merrion Square
(Catherine Greene, 2002)
This 'Joker's Chair' was commissioned by Radio Telefís Éireann (RTÉ) and Dublin City Council and is dedicated to Dermot Morgan (1952–1998), teacher, actor and comedian. He was a teacher in St Michael's College who started to work in comedy as a sideline. One of his popular early characters was Fr Trendy, a cool priest giving short radio and TV sermons using modern-day metaphors to present Catholic philosophy, who was modelled on popular priest Fr Brian D'Arcy. An early success in the 1980s was his political satire show on radio called *Scrap Saturday*, in which he lampooned the political leaders of the day.

Morgan went on to star in the ever-popular TV sitcom *Father Ted*, written by Graham Linehan and Arthur Matthews. He played Fr Ted Crilly, a parish priest banished to Craggy Island off the west coast of Ireland for embezzling parish funds. He tries to cope with everyday life in the parochial house with his two fellow priests – Fr Jack Hackett, an alcoholic sex maniac, and Fr Dougal McGuire, an innocent half-wit – and the housekeeper, Mrs Doyle, with her ever-present cups of tea. The result is hilarious comedy as the priests' various schemes and plots are developed and inevitably come to ruins. The series was first shown in 1995 but it remains fresh today as evidenced by its continuous re-runs. The show received numerous BAFTA awards. Morgan died suddenly of a heart attack at the height of his fame in 1998.

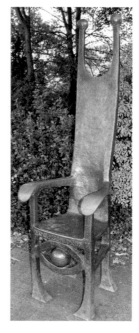

The bronze throne with its joker symbolism reminds us that he was a king of comedy who was taken at the height of his career. The messages on the back of the chair are from his wife and children.

A13 AN DÚN CUIMHNEACHÁIN (Monument to the Defence Forces),
Merrion Square *(Brian King, 2008)*

An Dún Cuimhneacháin means 'the Commemorative Fort' in Irish. It commemo-
rates all members of our Defence Forces who lost their lives in the course of
duty. As Ireland is a neutral country our forces do not take part in any active
campaigns but do participate in United Nations peacekeeping missions. It was
on one of these missions that the most significant loss of life took place when, in

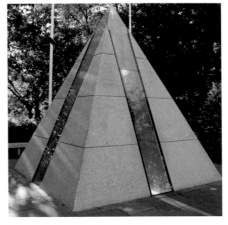

1960, during a patrol in the Congo, a
platoon of Irish soldiers was attacked
by 100 Baluba warriors. Nine members
of the eleven-man patrol were killed.
For a neutral country this was a shock
and significant measures were subse-
quently taken to ensure better safety
for our troops while on UN duty.

 The monument consists of granite
slabs and glass on a steel construction
to resemble an army tent. Inside there
are four uniformed people represent-
ing the Army, Navy, Air Corps and Army
Reserve. In the centre an eternal flame
appears through the cap badge of the Irish armed forces. The cap badge consists
of a sunburst with an eight-pointed star, on which rests an ancient sword belt
with the words 'Óglaigh na h'Éireann' (Irish volunteers) while in the centre the
letters 'FF' stand for Fianna Fáil (soldiers of destiny).

A14 RUTLAND FOUNTAIN, Merrion Square *(Francis Sandys, 1792)*

This fountain was installed at the behest of Charles Manners (1754–
1787), the Duke of Rutland and Viceroy for Ireland, to provide clean
drinking water for the people of Dublin. It is a blind arch with screen walls and
piers in granite with Portland stone dressing adorned with various Coade stone
items. Coade stone is a top-quality manufactured stone that resists weathering.

 The central panel shows the Marquis of Granby, a brother of Charles Manners

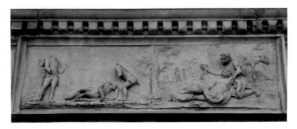

and officer in the British
army, helping a distressed
soldier. The two roundels
with heads are Charles
Manners himself and
his wife, Lady Mary. The
allegorical reliefs show
Hibernia with the harp and

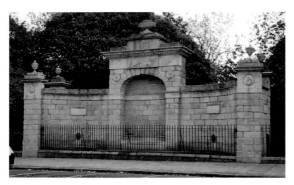

Britannia with arms in the background. The whole affair is topped off with five magnificent Coade stone urns. Originally there was water spouting from a centre fountain into a conch shell and also water flowing from the two lions' heads but the plumbing is not operational today. Unfortunately the main panel has been vandalised over the years but the monument was cleaned and restored by Dublin Corporation in 1975.

A15 WILLIAM DARGAN (1799–1867), Merrion Square *(Thomas Farrell, 1864)*
This statue of William Dargan is located on the front lawn of the National Art Gallery. He was an engineer, entrepreneur, philanthropist, farmer and distiller during his eventful life. He was born in Co. Carlow to tenant farmers of Huguenot decent. He showed an early proficiency in maths and accounting and as a young man became involved in road and rail construction in North Wales under Thomas Telford. Back in Ireland he won the contract to build the first railway in Ireland from Dublin to Kingstown (Dun Laoghaire), an engineering triumph which was completed in 1834. Over the next 30 years he went on to build 1,000 miles of railways throughout the country. He also built the Ulster Canal, linking Lough Erne with Lough Neagh, and developed Queen's Island in Belfast, which is the location of the Harland & Wolff shipyards today. He built many bridges, stations and tunnels that are still in use. During one period of his work he employed 50,000 men, paying them a total of £4 million in wages.

Dargan became extremely wealthy and involved himself in other enterprises such as a flax mill in Chapelizoid, a distillery in Belturbet and various farms throughout the country. During the Famine he paid workers before they started work so that they could buy food. His generosity led him to become known as 'the man with his hand in his pocket'. He organised and funded the Great Dublin Exhibition of 1853 in the grounds of Leinster House to showcase Irish art and industry. The Exhibition ran for six months and was attended by more than 1 million people, including Queen Victoria and Prince Albert. The exhibition led directly to the founding of the National Gallery, which was first opened in 1864 with just 130 paintings. Despite its success, Dargan lost £20,000 on the venture. The Queen called on him at Dargan Villa in Mount Anville and offered him a knighthood for his enterprise but he turned it down.

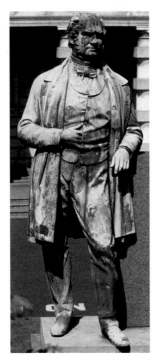

Dargan suffered a fall from his horse in 1865 and his health began to fail. To make matters worse, a financial crisis resulted in a collapse of share values and Dargan's creditors got nervous, leading to financial difficulties. He died of malignant liver disease at his townhouse at 2 Fitzwilliam Street in February 1867. His funeral was the largest seen in the city since that of Daniel O'Connell. He is buried in Glasnevin Cemetery in the O'Connell Circle.

His statue in the grounds of the National Gallery honours his contribution to the foundation of what is today a collection of 1,500 works dating from the thirteenth century. The Luas bridge in Dundrum near his home in Mount Anville is also named in his honour.

A16 OBELISK, Merrion Square *(Raymond McGrath, 1950)*

The 60-foot granite obelisk with a gilt bronze flame at the centre of the lawn on the Merrion Street entrance to Leinster House is dedicated to the first Executive Council or Government of the Irish Free State, founded in 1922. On the plinth of the obelisk there are three plaques commemorating the lives of men who were members of the council: Michael Collins (**A10**), Kevin O'Higgins (1882–1927) and Arthur Griffith (1872–1922).

Kevin O'Higgins was born in Stradbally, Co. Laois as one of sixteen children. He was educated at Clongowes Wood College, St Mary's Christian Brothers College in Carlow and University College Dublin. He joined the Irish Volunteers in 1915 but did not take part in the 1916 Rising. He was imprisoned in 1918 and while there he was elected as MP for Laois. He was appointed Assistant Minister for Local Government in the first Executive Council. He was appointed Minister for Justice after his election in 1922 and took a very hard line on those who opposed the Anglo-Irish Treaty. While Minister he approved the execution of 77 members of the anti-Treaty forces, including Erskine Childers and Rory O'Connor, who had been best man at his wedding in 1921. Despite his efforts to bring the country to democratic politics he was a figure of hate for those who opposed the Treaty. His father was shot and the family home burned by the IRA as a result of his tough stance. O'Higgins himself was assassinated on his way to Mass in Booterstown on 10 July 1927.

Arthur Griffith was born in Dublin, the son of a printer. He took up the trade himself and used this skill to have a significant influence on Irish nationalist thinking in the early part of the twentieth century. He was involved in a number of

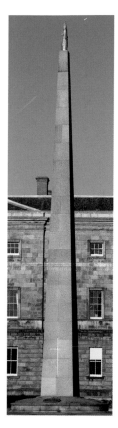

anti-British publications, including the *United Irishman* and *Sinn Féin* ('ourselves alone'). He was a member of the Irish Republican Brotherhood, the Gaelic League, Cumann na nGaedheal, Sinn Féin and the Irish Volunteers, all of which were organisations dedicated to the promotion of Irishness and independence from Great Britain. He did not take part in the 1916 Rebellion but was arrested and imprisoned for his writings. He was elected as MP for East Cavan in a by-election in 1918 and retained his seat in the general election of the same year. He refused to take his seat in Westminster, sitting instead in the first Dáil (Irish for Parliament) in Dublin in January 1919 where he was elected Vice-President. He was arrested and imprisoned again in November 1920 and remained there until the Anglo-Irish Truce in July 1921.

He led the Irish delegation in the Anglo-Irish Treaty negotiations, which were finally concluded on 6 December 1921. The Treaty led to a split in the Dáil; Éamon de Valera resigned as President of the Dáil and Griffith was elected in his place. The workload and conflict post-independence were too much for Griffith and he died of a suspected brain haemorrhage on 12 August 1922. He is buried in Glasnevin Cemetery.

For information on **Michael Collins** see **A10**.

A17 PRINCE ALBERT (1819–1861), Merrion Square *(John Henry Foley, 1871)*

Prince Albert was the prince consort to Queen Victoria of Great Britain. He was born in the Duchy of Saxony, which is today part of Germany. He married Victoria, his first cousin, in 1840 and they went on to have nine children in what was a happy marriage. He had a very strong influence on her and became interested in many public causes, such as education reform, modernisation of the army and the abolition of slavery, which was still legal in the United States at the time. It was he who first leased Balmoral, the estate in Scotland that is still used as the summer retreat by the royal family today. He died of typhoid fever on 14 December 1861 and the Queen mourned him for the rest of her life.

This monument is located in the grounds of Leinster House. It is partly hidden by a hedge and is difficult to see from the road. It shows Albert above four representations of him as a youth showing his interests: as a shepherd, an artist, a tradesman and an explorer/photographer. The statue was sculpted by John Henry Foley, who also sculpted the statue for the Albert Memorial in Kensington

Gardens, London. This statue was moved to its present location in 1923 to make space for a cenotaph to Michael Collins and Arthur Griffith, which has since been replaced by an obelisk (see **A16**). There also used to be a statue of Queen Victoria by John Hughes on the plaza, erected in 1908, but this was removed to storage in 1948 when Ireland became a republic. It was relocated in 1988 to the Bicentennial Plaza in Sydney, Australia where it stands today.

A18 THOMAS HEAZLE PARKE (1857–1893), Merrion St Upper
(Percy Wood, 1896)

Thomas Heazle Parke was born in Kilmore, Co. Roscommon. He obtained his medical degree from the Royal College of Surgeons in Dublin and served as a doctor in the British army in Africa, where he became the first Irishman to cross the African continent. In 1885 he was a member of the relief mission which was sent to relieve General Charles Gordon, who led the defence of Khartoum against a siege by Muhammad Ahmad's forces, but they arrived too late. In 1887, Parke accompanied Sir Henry Stanley on his three-year, 3,000-mile expedition up the Congo River to rescue Emin Pasha, General Gordon's besieged governor of Equatoria. During this expedition 500 men died of disease, starvation and attacks from natives. Parke saved the life of William Grant Stairs, a Canadian engineer, when he sucked the venom from his body after Stairs was hit by a poisoned arrow. Parke recounted his adventures in *My Personal Experiences in Equatorial Africa*, which was

published in 1891. He died from a heart attack at the age of 36 and is buried in Drumsna, Co. Leitrim.

This statue was paid for by public subscription, which was contributed to by Stanley. It shows Parke in his equatorial outfit with his rifle in hand. The bas-relief on the pedestal shows him sucking the poison from Stairs' wound.

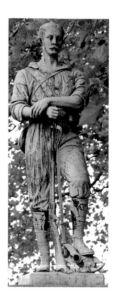

GOVERNMENT BUILDINGS

The Government Buildings were originally built in 1922 to house the Department of Local Government, the Department of Agriculture and Technical Instruction, and the Royal College of Science. Today the building houses the Department of the Taoiseach (Prime Minister).

The building was restored in the 1980s with money from the sale of houses opposite which today contain the five-star Merrion Hotel.

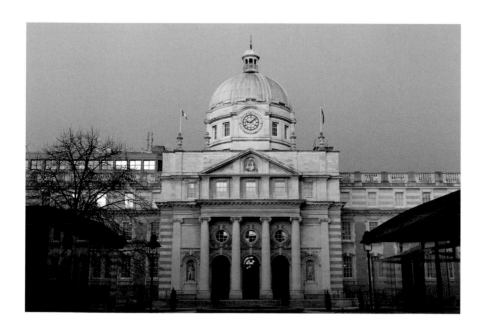

A19 SCIENCE, Govt Buildings, Merrion St Upper
(Oliver Sheppard & Albert Power, 1911)

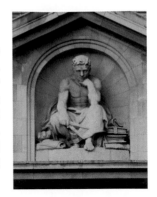

The figure of Portland stone located high up in the pediment above the entrance is that of Science. The figure is modelled on Rodin's *Thinker* from *The Gates of Hell*. The figure is holding a dividers and on either side of him are some books, a cog wheel and a scroll representing science, technology and theory. It symbolises the power of science in British official thought. The statue was modelled by Sheppard and carved by Power.

A20 WILLIAM ROWAN HAMILTON (1805–1865), Govt Buildings,
Merrion St Upper *(Oliver Sheppard & Albert Power, 1912)*

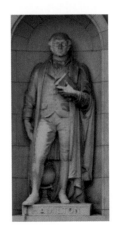

Situated in a niche to the left of the entrance is a statue in Portland stone of Sir William Rowan Hamilton, the great Irish physicist, astronomer and mathematician of the nineteenth century. He was born at 38 Dominick Street and his initial education was provided by his uncle at Talbot's Castle in Trim. It was here that he excelled at languages, mastering many by the time be became a teenager. He went on to attend Trinity College, where he excelled at all of his subjects. Before graduation he was appointed Professor of Astronomy and he took up residence at Dunsink Observatory. He was knighted in 1835 and elected president of the Royal Irish Academy (RIA) in 1837.

On 16 October 1843, while on his way to a meeting of the RIA, he managed to define the theory of quaternions, which is a theory of complex numbers. As he was walking along the Royal Canal to the north of Dublin he had a Eureka moment and used his pen knife to carve the formula $i^2 = j^2 = k^2 = ijk = -1$ onto a nearby bridge (today called Broombridge). The formula is still used today in computer graphics. Hamilton died on 2 September 1865 of a severe attack of gout. He is buried in Mount Jerome Cemetery, Dublin.

A21 ROBERT BOYLE (1627–1691), Govt Buildings,
Merrion St Upper *(Oliver Sheppard & Albert Power, 1912)*

This statute of Boyle is located in a niche to the right of the entrance to Government Buildings. Acknowledged as one of the most influential scientists to come out of Ireland and often referred to as the Father of Chemistry, Robert Boyle was born in Lismore, Co. Waterford to the First Earl of Cork, a wealthy landowner. Boyle was initially educated at Eton but at the age of eleven he was taken on a

grand tour of Europe with a tutor; a tour which lasted six years. He went on to make a number of significant contributions to science, such as refining the Boyle air pump for creating a vacuum, which he used to demonstrate the need for air for combustion, breathing and the transmission of sound. His most well-known theory is Boyle's Law, which states that the volume of a gas is inversely proportional to the amount of pressure applied to it – a theory that is still being taught in schools today.

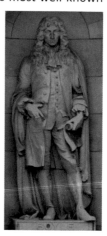

After a very busy life of experimentation and writing he died on 31 December 1691. He is buried at St-Martin-in-the-Fields Church in London. In his will he bequeathed a sum for the delivery of the Boyle Lecture for the Proving of the Christian Religion against Notorious Infidels, and this lecture is still being delivered today at St-Mary-le-Bow Church in London. Boyle's papers and books can be seen at Marsh's Library and the Worth Library, both in Dublin. Finally, the Boyle Monument, located in St Patrick's Cathedral, Dublin, has a small child kneeling in the centre who is thought to be Robert Boyle.

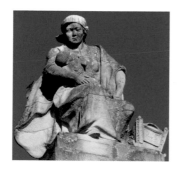

A22 URNS AND FOUR FIGURE GROUPS, Govt Buildings, Merrion St Upper
(C.W. Harrison & Albert Power, 1922)
The central screen linking the two street-front pavilions of Government Buildings contain a number of sculptures: Over the screen itself there are two large urns and bas-reliefs with children holding the names of the departments that the building was originally built to house, Agriculture and Local Government. Over the pavilions there are four allegorical sculptures, three of which signify the rearing and education of children. On the left a child is being taught to read, next is a figure capturing a large fish with a rope. Over the right pavilion is a woman nurturing a child with a cradle alongside and finally a figure guarding an adolescent.

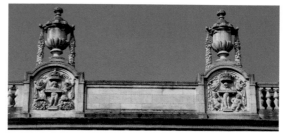

A23 AN SPÉIRBHEAN, Windsor Place *(Robin Buick,1990)*

An Spéirbhean means 'sky woman' or 'heavenly woman' in Irish. An Spéirbhean was said to be an inspiration for poets and artists; she would appear to them bemoaning the state of Ireland and the Irish people. Typically she was the allegorical representation of Ireland, subdued after the defeat of the Catholic House of Stuart at the Battle of the Boyne (1690). The Catholic religion was suppressed following the battle, with the introduction of the Penal Laws. This led to the creation of political poetry with the promise that one day Ireland and her people would rise and be free from suppression. The sculpture captures the concept perfectly with the figure almost bird-like rising on her tiptoes with her arms and the hem of her dress echoing the wings and tail of a bird as it takes flight.

A24 RED CARDINAL, Baggot St Lower
(John Burke, 1978)
The influence of constructivism and cubism on Burke's work can be seen in this giant bolted steel construction. From some angles it resembles a cardinal's hat.

A25 REFLECTIONS, Baggot St Lower
(Michael Bulfin, 1975)

Bulfin's giant yellow steel sculpture seems to reflect both on itself and in the windows of the former Bank of Ireland headquarters, which surrounds it on three sides. However when viewed from behind it could reflect the share price of the bank, which has declined significantly since the heady days of the Celtic Tiger.

A26 CIRCLE OF MERCY, Baggot St Lower *(Michael Burke, 1994)*
Catherine McAuley was born into a comfortable Catholic family in Drumcondra in 1778. However after her father died in 1783, her mother squandered the family fortune and when she died in 1798 the children were farmed out to relatives. Catherine went to live with distant relatives, Catherine and William Callaghan, Quakers who had just returned from India. She acted as a companion and house manager for the couple for 25 years and when they died they left her their house and the sum of £25,000 (worth about €1 million today).

Catherine went on to give help to the sick, the poor and the hungry, particularly unemployed servant girls who may have become pregnant. In 1824 she purchased a house in Baggot Street to use to care for and educate vulnerable women and children. She was joined by like-minded women and the house

became a place of refuge. She became the legal guardian of some of her nieces and nephews when her sister and her husband died. She was criticised by some members of the Catholic hierarchy for giving charity without official sanction and so she joined the formation programme of the Presentation Sisters and professed her vows in 1831. She went on to form the Religious Sisters of Mercy, which would become a worldwide organisation for helping the poor and vulnerable. Following this, she established twelve convents in Ireland and two in England.

On her death in 1841 there were 150 sisters in her order; more convents were opened in Canada, the US, Australia and New Zealand in the following years. By 1936 the order comprised 1,500 convents with 2,000 nuns worldwide. Catherine McAuley was declared Venerable in 1990 by Pope John Paul II, and she featured on the £5 note of the old Irish currency. She left a worldwide legacy that still continues to implement the ethos of the order she founded: 'There are three things the poor prize more highly than gold, tho' they cost the donor nothing; among these are the kind word, the gentle, compassionate look and the patient hearing of their sorrows.'

This bronze statue represents Sister McCauley helping a mother and child, an image which epitomises her life's work. The statue is located outside the headquarters of the Mercy order, the original House of Mercy purchased by Catherine McAuley in 1824.

A27 PATRICK KAVANAGH (1904–1967), Wilton Terrace *(John Coll, 1991)*

Patrick Kavanagh was born in Inniskeen, Co. Monaghan, one of ten children. His father was a small farmer and also a part-time shoemaker. Kavanagh left school at the age of thirteen to help his father with his work. He was influenced by reading copies of the *Irish Homestead* edited by George Russell (**A8**) and some of his work was subsequently published by Russell in the *Irish Statesman*. Russell was such an influence that Kavanagh walked 80 km from Inniskeen to Dublin to meet with him. He received great encouragement from Russell, who lent him many books to read.

Kavanagh's first major poetry collection, *Ploughman and Other Poems*, was published in 1936. He subsequently moved to London but, finding that he could not make a living there, he returned to Dublin. He published the semi-autographical novel *The Green Fool* in 1936 but it brought trouble as Oliver St John Gogarty (**C15**) sued him for libel as a result. 'The Great Hunger', possibly one of his greatest poems – recounting the lack of sexual fulfilment of bachelor farmers – was published in 1942 and was censored for a time. Another autobiographical novel, *Tarry Flynn*, was published in 1948. In 1952 he was depicted as an alcoholic sponger by *The Leader* and he sued for libel, a case he lost in 1954. Shortly afterwards he was diagnosed with lung cancer and had a lung removed. This was the low point in Kavanagh's life and he found it difficult to write until, sitting by the Grand Canal, the surroundings once again brought him inspiration.

Kavanagh wrote many great poems but possibly his best-known ones are 'A Christmas Childhood in Ireland', which all Irish children learned at school, and 'Raglan Road', which was put to the air of 'The Dawning of the Day' and sung so well by the late Luke Kelly. Kavanagh influenced many writers, including Seamus Heaney. Kavanagh died of pneumonia on 30 November 1997 and is buried in Inniskeen.

This bench celebrates his re-invigoration and creativity after sitting by the canal. The location of the statue was inspired by his poem 'Lines Written on a Seat on the Grand Canal, Dublin'. There is a copy of this bench outside the Raglan Road Bar in Disney World, Florida. This is not the original bench dedicated to Kavanagh – that was erected by his friends in 1968 on the south side of the canal. He lived nearby at 63 Pembroke Road, which is now an office block.

A28 PERCY FRENCH (1854–1920), Wilton Terrace *(Unknown, 1990)*

William Percy French, engineer, entertainer and artist, was born in Cloonyquin,

Co. Roscommon in 1854. His father was a landlord and justice of the peace while his mother was the daughter of a clergyman. He was educated initially by tutors and subsequently at Foyle College in Derry. He entered Trinity College in Dublin in 1873 to study engineering, but spent much of his time playing tennis, composing and performing his songs. Indeed it was at Trinity that he composed the first of his well-known songs, 'Abdul Abulbul Amir'.

He finally graduated from Trinity in 1881 with his degree, but he said that the only reason they gave him the degree was because if he remained there any longer he would be

looking for a pension. He worked as an inspector of drains in Co. Cavan but spent much of his time mixing with the locals, writing comic songs and painting water-colours. In 1888 he founded *The Jarvey*, a weekly comic publication, most of which he wrote himself. Following the decline of the magazine two years later he took to entertaining with his shows in collaboration with Houston Collinson.

On 10 August 1897, French was travelling on the West Clare Railway from Ennis to Kilkee, where he was due to perform. Unfortunately, the locomotive broke down in Milltown Malbay due to weeds blocking the injectors, resulting in a five-hour wait for a replacement engine. The show in Kilkee was due to start at 8 p.m. but French did not arrive until 9 p.m., by which time most of the audience had gone home. He subsequently sued the West Clare Railway for £10 loss of earnings, which the company settled out of court. He went on to write the comic song 'Are Ye Right There Michael?', which poked fun at the punctuality of the railway. The story goes that the railway sued French for libel but he arrived late for the court case. When asked why, he said he had travelled by the West Clare Railway, and so the case was thrown out.

French travelled extensively with Collinson and toured Canada, the United States and the West Indies in 1910. After the First World War things had changed dramatically and the music-hall style of entertaining was out of fashion. He strug-gled to maintain his living and gave his last concert in Glasgow on 16 January 1920. He contracted pneumonia shortly afterwards and died in a friend's house in Formby near Liverpool.

French wrote many songs, including 'The Mountains of Mourne', 'The Emigrant's Letter', 'Slattery's Mounted Fut', 'Come Back Paddy Reilly to Bally-jamesduff' and 'Phil the Fluter's Ball'. It is estimated that he painted more than 1,000 watercolours, which are of some value today.

This bench is located on the bank of the Grand Canal not far from No. 35 Mespil Road, where he lived with his second wife, Helen, in the late 1890s. The inscription on the bench reads, 'Remember me is all I ask, and yet, if the remembrance prove a task, forget.' This is a quote from Percy French's comment in a visitor's book in Glenveagh Castle, Co. Donegal.

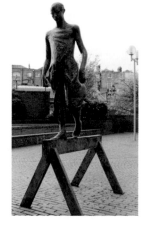

A29 MAN ON A TRESTLE, Wilton Place *(Carolyn Mulholland, 1987)*
This sculpture is located in the courtyard of Wilton House. New Ireland Assurance held a competition to find a sculpture for this location and this particular piece was chosen. The work was more powerful on

its own before the installation of the fountain behind it. The man represents an Ireland free from oppression after winning our independence. The man is described as 'sans souci', without worry.

A30 THE BARGE HORSE, Percy Place *(Maurice Harron, 1999)*

The Grand Canal linking Dublin with the River Shannon was opened in 1804 at a cost of £877,000. It is 82 miles (132km) long and there are 43 locks between the River Liffey and the River Shannon. Passage boats measuring 16 metres long would have been used to transport passengers from town to town up to the arrival of the railways in the 1840s. The barges were crewed by up to four people, often a family living on board.

During the Second World War the government built 39 barges for the transport of turf from the Bog of Allen and horses were re-introduced to haul them due to the shortage of oil. The canal was used up until the 1960s, after which it fell into disrepair. However it was restored for navigation during the 1980s and today it is looked after by Waterways Ireland.

This sculpture represents the type of horse that was used to pull the barges

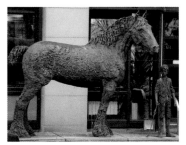

on the canals up until the introduction of engines in 1913. A horse can pull fifty times as much cargo on water as on road and this represented a very efficient method of transport. The horses were hired out to the boats by the canal company and hauled the barges from point A to point B. The horses were often looked after by the lock-keepers.

A31 MEMORIES OF MOUNT STREET, Mount St Upper
(Derek A. Fitzsimons, 1988)

The Mount Street area has a number of beautiful town houses that were built in the late eighteenth century for the landed gentry of this country. After the Act of Union, which merged the Irish Parliament with the Westminster Parliament in London, the elite moved there. As a consequence, property values tumbled and many of the fine town houses of the aristocracy became tenements housing full families in each room. The situation worsened after the Famine when many families moved from the country to the city, resulting in cramped conditions in many of these houses. As the city grew, so did the poverty and crowded conditions, leading to the spread of diseases such as TB.

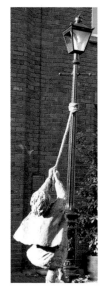

For the children of the city, the street was their playground and they utilised street lamps to make a type of swing that allowed them to swing in one direction as the rope coiled around the post and then in the other as it uncoiled. During the 1950s and 1960s new estates were built in the suburbs and the people of the tenements moved to them, bringing their traditions with them, including the street lamp swing, which was often to be seen in the new suburbs in the 1960s and 1970s. These days the swings are more likely to be seen as part of a computer game.

A32 BIRDY, Mount St Upper *(Rowan Gillespie, 1997)*

Located on a ledge above the entrance to Crescent Hall, Birdy was commissioned by Treasury Holdings, who gave the artist three weeks to complete the sculpture.

This is number two of a series of three concepts on reaching one's potential. The subject, who is climbing a wall in concept one, 'Aspiration' (**A37**), has reached an objective and is getting ready to take flight in the second concept, 'Birdy'. Due to its location the sculpture is often missed by passers-by, but those who do spot it must wonder what is going through the mind of the girl who is about to overcome the next challenge of a leap of faith as she throws herself from the edge and flies.

A33 JOHN B. KEANE (1928–2002), Warrington House, Mount St Upper *(Neil C. Breen, 1994)*

Raconteur, playwright and novelist, John B. Keane was born in Listowel in North Kerry. He grew up with the lore and legend of the locals in the countryside. He emigrated to England for a few years in the 1950s, returning to Listowel to buy a pub in 1955. He felt that the stories and problems of the locals were never represented in the media and that with his work he became the 'spokesman' for the people of the area. He wrote about everyday life of the people of rural Ireland, focusing on loneliness, repression, lack of sex and the greed of the locals.

His work was initially rejected by the national theatres but came eventually to be accepted and performed regularly. He once said that playwrights put down what we say and charge us to hear it. His best known plays include *Sive* (1959), *Big Maggie* (1969) and *The Field* (1965), which was made into a film by Jim Sheridan in

1990, starring Richard Harris as The Bull McCabe. He also wrote a series of books in the form of letters between various characters, including *Letters of a Successful T.D.* (Member of Parliament), *Letters of a Love-Hungry Farmer* and *Letters of a Parish Priest*. He died in 2002 but his pub is still a mecca for visitors to the town, particularly during Writers' Week and Listowel Race Week.

A34 BRIAN FRIEL (1929–), Warrington House, Mount St Upper
(Neil C. Breen, 1994)

Brian Friel is considered to be one of the greatest living dramatists in the English language. He was born in Omagh, Co. Tyrone and educated at St Colm's College, Derry and Maynooth College, Co. Kildare, where he gained his BA. He entered the seminary in Maynooth but left after three years. He worked as a teacher for ten years before deciding to concentrate on writing full time. Initially writing for various publications, he published two books of short stories, *The Saucer of Larks* in 1962 and *The Gold in the Sea* in 1966. His first major success as a playwright

came with *Philadelphia, Here I Come!*, first performed in 1964 and made into a film in 1975. He went on to write many other plays, including *Faith Healer* (1979), *Translations* (1980) and *Dancing at Lughnasa* (1990), for which he won three Tony Awards. This last play was made into a film in 1998, directed by Pat O'Connor and starring Meryl Streep.

Friel has written more than thirty plays, many of them taking place in the fictional town of Ballybeg in Co. Donegal. He was also written adaptions of work by Chekhov and Turgenev. He co-founded the Field Day Theatre with Stephen Rea in 1980 and often collaborated with Seamus Heaney on work for the theatre. He was appointed to the Irish Senate in 1989 and remained a Senator for two years. He is a member of Aosdána (an honorary association for Irish artists) and was awarded the honour of Saoi (wise man) by its members in 2005. He quipped that this was like 'extreme unction, like the last rights of Aosdána'.

A35 WAVE FORM, Warrington Place
(Michael Warren, 2008)

This 4.4m (14ft) sculpture, shaped like a character from an Oriental script, is designed to both compliment and contrast with the architectural structure of the building behind. It is located on an equal footing with pedestrians and provides a bridge between human and architectural scale. The

work appears to be momentarily poised like a great wave ready to break. As with a great wave, nobody can say what will happen next.

A36 MORE EQUAL, Grand Canal St Upper
(Eilís O'Connell, 1999)
This large sculpture is located on Grand Canal Plaza in front of the office buildings built by Rowan Holdings, who commissioned the work. It consists of two giant geometric cones in bronze rising from the ground, which appear to have grown together with a branch-like structure joining them at the top. Each would fall down if they were on their own but together they remain erect. O'Connell makes good use of the space and we have a good view of the work from a distance.

A37 ASPIRATION, Grand Canal St *(Rowan Gillespie, 1995)*
This sculpture was commissioned by Treasury Holdings, who own the building on which it is located. This site was the location of the last Irish rebel garrison to surrender after the 1916 Easter Rebellion. The garrison was commanded by Éamon de Valera who, following capture and trial, had his death sentence commuted to life imprisonment because he was a US citizen. He went on to become Taoiseach (Prime Minister) and finally President of Ireland.

The sculpture celebrates the right of individuals to strive for that in which they believe. The idea was inspired by W.B. Yeats (**B15**), whose play *Cathleen Ní Houlihan* personified Ireland as a woman. It looks to the future rather than the past. The sculpture is composed of a foam-filled fibreglass shell impregnated with bronze, as pure bronze would be too heavy for the granite tiles. The installation was delayed by two years due to an anonymous objection to a nude on such public display. This is the first of a series of three concepts on reaching one's potential sculpted by Gillespie. The second, 'Birdy' (**A32**), is located on Upper Mount Street and the third, a suspended flying woman called 'Free', is located at the artist's studio.

A38 HARMONY, Pearse Park *(Sandra Bell, 1998)*
This sculpture takes the place of the old bandstand and was erected to celebrate the refurbishment of the park by Dublin City Council. The artist discussed some options with the local residents and discovered that the old Queen's Theatre was located not far from here and the performers often stayed as boarders in local houses. The residents wanted something tall that was associated with the past.

Bell captures the concepts perfectly with the musical theme of the statue blowing a trumpet towards the heavens while the strings of the harp keep the figure attached to the earth. This reflects humanity's aspirations while reminding us of reality. The sculpture is 14 feet tall and cast in bronze.

A39 TORO, Grand Canal Dock
(Patrick O'Reilly, 2010)
This caricature of a powerful bull is located in front of the Grand Canal Theatre. It is created in highly polished bronze.

A40 ADMIRAL BROWN (1777–1857),
Sir John Rogerson's Quay *(Fundicion de Bronce Artistica, 2006)*
Admiral William Brown holds the status of a superhero in Argentina and is regarded as the father of the Argentinian navy. He was born in Foxford, Co. Mayo in 1777 but emigrated with his father to Philadelphia in the United States in 1789. Shortly after his arrival his father died of yellow fever, leaving the young William effectively an orphan. Luckily, he was employed shortly after as a cabin boy on a merchant ship and he managed to work his way up to captain over the next ten years. As captain he was press-ganged by the Royal Navy and subsequently captured by the French during the Napoleonic wars. He spent a number of tough years in a French prison before managing to make a daring escape and returning

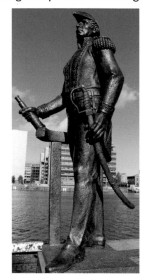

to Britain, where he was treated as a hero. He married and subsequently emigrated to South America where he became involved in maritime affairs, once more taking command of a merchant ship and subsequently becoming commander-in-chief of the Argentinian fleet. He defeated the Spanish at the Battle of the River Plate in 1814 by attacking them first at sea and then on land. When his force was under severe pressure he asked his pipers to play 'St Patrick's Day in the Morning', which rallied his troops, many of whom were Irish.

Brown involved himself in farming for the next ten years but took to the water again for the war against Brazil. His most famous victory was with his fleet of eleven ships against thirty-one Brazilian ships fought in full view of the population of Buenos Aires. He used guile and his knowledge of the shallows to defeat the

Brazilian threat without the loss of a single ship. On his return ashore he was carried shoulder-high through the city.

Brown returned home to Foxford with his daughter in 1847, where he met his brother for the first time. This was during the Famine and he donated money to help those affected during this terrible time. He died in 1857 at the age of 80 and is buried in Buenos Aires.

Today Brown is much remembered both here and in Argentina. There are three towns, six football teams, 320 schools, 430 monuments and 1,100 streets named in his honour in Argentina. The Admiral William Brown Cup is awarded to the winning team in rugby matches between Argentina and Ireland.

This statue was collected from Argentina by the Irish naval ship LÉ *Eithne* and brought here to mark the 150th anniversary of Brown's death. Brown is also remembered in his home town of Foxford, where there are two memorials and a museum dedicated to his memory.

A41 SEAMEN'S MEMORIAL, City Quay
(Niall Montgomery, 1990)
This 20ft (6.5m) granite memorial contains the names of all Irish seamen who were lost at sea during the Second World War. Although Ireland was neutral during the war, sixteen ships and two trawlers were attacked and sunk, resulting in the deaths of 150 men. The anchor is 200 years old and was recovered off the south Irish coast. It was donated by Harry Crosbie, a local property developer, in memory of his father.

A42 THE LINESMAN, City Quay *(Dony MacManus, 2000)*
This bronze representation of one of the dockworkers shows a linesman toiling to get a ship into the quayside. There was a great tradition of dockers in this area before the port moved to the east as containerisation required larger ships and deeper ports. However, we can see the effort being made by the linesman in order to get the

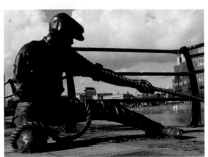

ship safely secured so that the cargo could be unloaded, another onerous task then done by hand. The sculpture was the winner of a public art competition commissioned by the Dublin Docklands Development Authority, which is responsible for the development of the quays on both sides of the river.

A43 MATT TALBOT (1856–1925), City Quay *(James Power, 1988)*

Matt Talbot was one of twelve children born to a docks labourer in 1856. He left school at the age of twelve and took up work with E. & J. Burke, a firm involved in the drinks business. The easy access to alcohol allowed Talbot to develop a taste for and ultimately a dependence on drink, which was to rule his life for the next sixteen years. He moved to various jobs, spending most of his wages on alcohol and indeed pawning his possessions or borrowing and stealing to fund his drinking when funds ran out.

Talbot finally took the pledge of temperance and give up alcohol at the age of 28 when none of his friends would lend him money for drink. He went on to pay back all of his debts and devoted himself to a life of hard work, prayer and attendance at daily Mass. After his mother died he lived a monastic life alone, practicing self-denial by sleeping on bare boards with a wooden pillow. Matt Talbot collapsed and died on Granby Row just off Parnell Square in 1925. Nobody knew who he was but when he was brought to the hospital it was discovered that he had mortification chains wound around various parts of his body. His funeral was a small affair but as the story of his devotion spread his memory gathered followers and he became known as the patron saint of alcoholics.

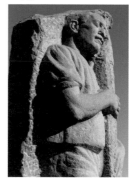

His remains were taken from Glasnevin and placed in Our Lady of Lourdes Church in Seán McDermott Street in Dublin in 1972 and he was declared Venerable, a step on the path to sainthood, by Pope Paul VI in 1975.

The bridge beside which the statue is located was named after Matt Talbot in 1978 and this granite statue was erected in 1988. It was commissioned by the Matt Talbot Committee and shows Talbot in his labours. His name can be found in societies around the world and his feast day is 19 June.

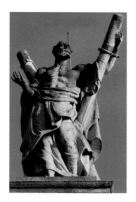

A44 ST ANDREW, St Andrew's Church, Westland Row
(John Smyth, 1834)

Carved from Portland stone, this statue is located above the pediment of St Andrew's Church, which in 1834 was the first Catholic church to be opened for worship after the passing of the Catholic Relief Act of 1829. It was Daniel O'Connell's parish church when he lived at Merrion Square.

St Andrew was a brother of St Peter, a fisherman and originally a disciple of St John the Baptist. He ultimately gave up fishing and became an apostle of Christ. After the Ascension of Christ he travelled east and spread the

Christian message around the Black Sea as far as Kiev. According to legend, he was crucified on an X-shaped cross or saltire. He is the patron saint of a number of countries, including Ukraine, Romania, Russia and Scotland (whose national flag is the St Andrew's Cross). His feast day is 30 November.

A42 The Linesman

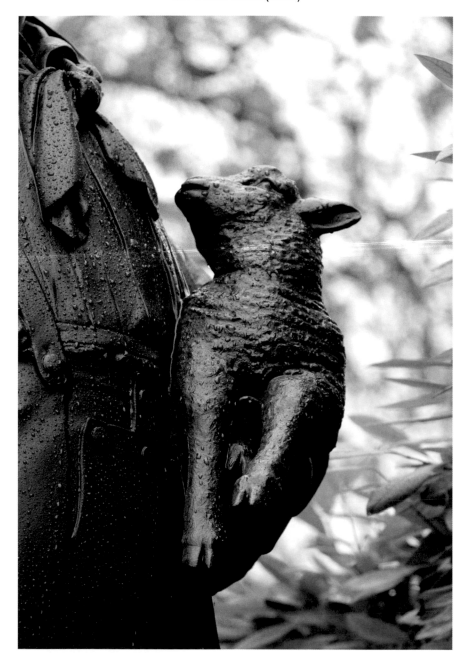

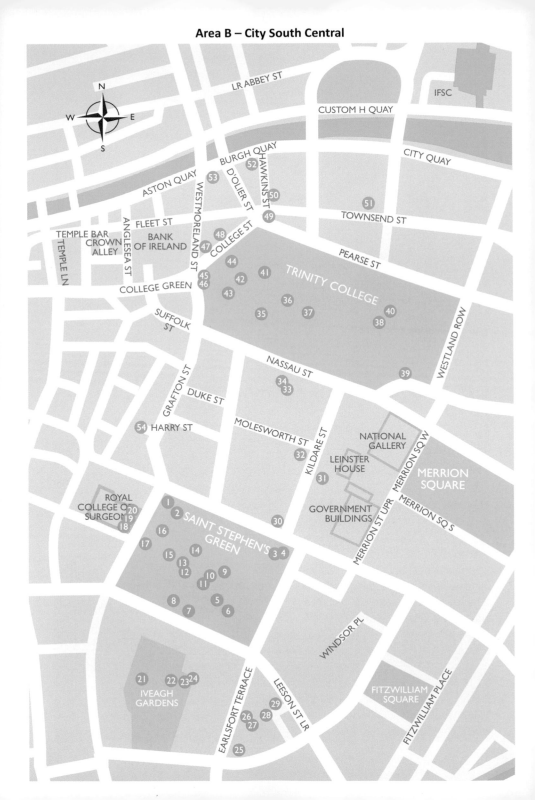

Area B – City South Central

N
W E
S

LR ABBEY ST

IFSC

CUSTOM H QUAY

CITY QUAY

BURGH QUAY

52

HAWKINS ST

ASTON QUAY

53

D'OLIER ST

50

51

TOWNSEND ST

WESTMORELAND ST

49

TEMPLE BAR
CROWN
ALLEY

TEMPLE LN

ANGLESEA ST

FLEET ST

BANK
OF IRELAND

48

47

COLLEGE ST

PEARSE ST

44

45
46

42

41

TRINITY COLLEGE

COLLEGE GREEN

43

36

40

SUFFOLK
ST

35

37

38

WESTLAND ROW

NASSAU ST

39

GRAFTON ST

DUKE ST

34
33

54 HARRY ST

MOLESWORTH ST

KILDARE ST

NATIONAL
GALLERY

32

LEINSTER
HOUSE

MERRION SQ W

MERRION
SQUARE

31

ROYAL
COLLEGE O
SURGEON

20
19
18

1

2 SAINT STEPHEN'S
GREEN

16

30

GOVERNMENT
BUILDINGS

MERRION ST UPR

MERRION SQ S

17

15

14

13
12

10 9

11

3 4

8

5

7

6

WINDSOR PL

21

22 23 24

IVEAGH
GARDENS

EARLSFORT TERRACE

LEESON ST LR

FITZWILLIAM
SQUARE

FITZWILLIAM PLACE

29

26
27

28

25

2

CITY SOUTH CENTRAL

This part of Dublin has the greatest concentration of statues in the city. It includes Trinity College, St Stephen's Green and the Iveagh Gardens. Icons such as the Campanile in Trinity College, the Fusiliers' Arch and the statue of Wolfe Tone in St Stephen's Green can be seen in this part of the city. The good thing about this section is that much of it can be discovered away from vehicular traffic by using pedestrianised streets to link the main concentration of statues.

St Stephen's Green

St Stephen's Green is the largest of Dublin's Georgian squares, at thirty acres. It was originally a marshland which was drained in the 1660s to allow the fine people of the city to take the air. The railings were erected in the early nineteenth century so that only people who had houses around the square had access to it, and they had to pay one guinea per year for the privilege. The square was re-opened to the public in the 1880s thanks to Arthur Guinness, 1st Baron Ardilaun (great-grandson of the Arthur Guinness, founder of the eponymous brewery) who provided funding for the landscaping and to allow access to the public. Today it is enjoyed by the people of Dublin who regularly visit, particularly in fine weather. If you are ever lucky enough to become a free man or a free woman of Dublin one of the privileges is that you will be allowed to graze your sheep in St Stephen's Green. There are seventeen statues and sculptures to view here.

B1 ROYAL FUSILIERS' MEMORIAL ARCH, St Stephen's Green
(John Howard Pentland & Sir Thomas Drew, 1907)
The Royal Dublin Fusiliers was a regiment of the British army, four battalions of which fought in the Second Boer War between 1899 and 1902. This triumphal

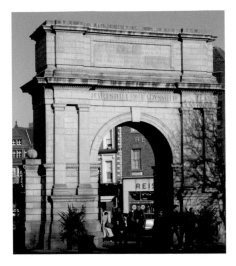

granite arch lists the major battles in which the regiment took part. Such was the courage shown by the regiment that Queen Victoria decreed that on Saint Patrick's Day a sprig of shamrock should be displayed on all caps of the Irish units to commemorate their actions, a tradition that continues to this day.

Over the arch can be seen the dedication in Latin, which translates as 'This monument is dedicated to the valiant soldiers of Dublin 1907.' The bronze badge is the regimental badge with the Latin motto *Spectemur Agendo*, which translates as 'Let us be judged by our actions.' The underside of the arch shows the names of those who died during the campaign. Due to the revival of Irish nationalism during the period in which it was erected, the arch was sometimes referred to as 'Traitors' Gate' as these men had fought for a 'foreign power'. Note the damage to the east side of the structure, caused by fighting during the 1916 Easter Rising between the British army, based in the Shelbourne Hotel to the east, and the Irish rebels, who were based in the Royal College of Surgeons (p. 50) on the west side of the park.

B2 JEREMIAH O'DONOVAN ROSSA (1831–1915), St Stephen's Green
(Seamus Murphy, 1954)
O'Donovan Rossa was a tenacious fighter for Irish freedom for most of his life. He was born in Roscarberry in Co. Cork to a family of tenant farmers who had lost their land during the seventeenth century. He moved to Skibbereen, Co. Cork in 1856 and founded the Phoenix National and Literary Society, which had the aim of gaining Irish independence by force of arms. This organisation later merged with the Irish Republican Brotherhood (IRB), a similar organisation. In 1858 he was jailed without trial for his illegal activities, including membership of a secret society. In 1865 he was charged with plotting a rebellion and jailed for life with penal servitude. He was a defiant prisoner and spent many weeks

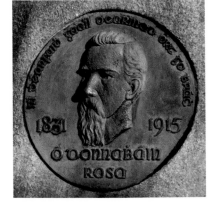

manacled and in solitary confinement for violating prison rules. While in prison he was elected to Westminster Parliament as MP for Tipperary but the election was declared invalid as he was a convicted felon.

In 1870, as part of a general amnesty, he was released on condition that he leave Ireland. He moved to New York where he joined Clan na Gael (The Irish Family), a sister organisation of the IRB, and the Fenian Brotherhood, a revolutionary organisation whose main aim was Irish freedom. During the 1880s O'Donovan Rossa organised a terror campaign in the United Kingdom using dynamite and bombs and the British tried in vain to have him extradited back from the United States.

O'Donovan Rossa was married three times and had eighteen children. He died in New York in June 1915 and his body was returned to Ireland for burial. His funeral was attended by tens of thousands of people, with special trains laid on to bring people to Dublin for the occasion. It generated much publicity for the Irish Volunteers and the IRB, and served as a rallying point for Irish nationalism. At the graveside in Glasnevin Cemetery Pádraig Pearse (future leader of the 1916 Rebellion) gave a powerful oration which included the famous lines: 'the fools, the fools, the fools! They have left us our Fenian dead, and while Ireland holds these graves, Ireland unfree will never be at peace.'

The 12-ton boulder of Dublin granite has a bronze relief panel with the phrase in Irish: 'Ní deanfaid gaeil dearmad ort go brác' ('The Irish will never forget you'). The work was unveiled by then President Seán T. O'Kelly.

B3 FAMINE COMMEMORATION, St Stephen's Green *(Edward Delaney, 1967)*

This sculpture group is a conceptual vision of life for millions of Irish people affected by the Great Famine in the 1840s. In 1845 there was about eight million people living in Ireland. About three million of these were tenant farmer families who were dependent on the potato for food and to raise money to pay their rent. The potato was highly efficient and could feed a large population on relatively little land. Blight arrived from eastern Europe in 1845 and began to destroy the crop. Over the next five years at least one million people died of starvation and disease and more than one million emigrated to the United Kingdom, the United States and Canada. To make matters worse, when the crop failed these families had no money to pay their rent and up to 500,000 people were evicted

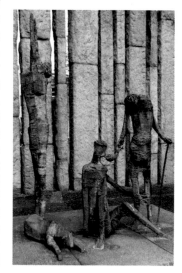

from their homes. The situation was made worse by inaction from the British government at the time as they had a policy of laissez-faire and some members of the government believed that the famine was sent by God to force the Irish into self-sufficiency.

This monument is one of a number of works in memory of those who suffered during this terrible period of our history. Their sufferings are remembered in a ceremony in May each year.

B4 WOLFE TONE (1763–1798), St Stephen's Green *(Edward Delaney, 1966)*

Theobald Wolfe Tone was born in Naas, Co. Kildare to Protestant (Church of Ireland) parents. He graduated from Trinity College before studying law in London and was called to the Irish Bar in 1789. He became involved in a secret society which went on to become the Society of the United Irishmen. This society had the objective of 'making a united society of the Irish nation'. The society utilised the Franco-British war, started in 1793, to request assistance from France against their common enemy, Britain. Tone wrote a paper on the possibility of a French invasion of Ireland which fell into government hands and, being compromised, Tone agreed to self-exile in the United States.

After some time in the US, where he even considered settling as a farmer, he

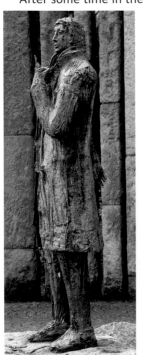

subsequently went to France in 1796 to try to influence the French to support a United Irishmen rising with an invasion. During the summer he met with General Hoche, who was to become the leader of an invasion force of 15,000 troops. While preparing for the invasion Tone enlisted and became a colonel in the French army.

A fleet of 43 ships set sail for Ireland in December 1796 but the expedition was doomed from the start. One ship struck a rock and sank on the first night, another ran ashore with the loss of 1,000 men, and the fleet was split up due to stormy weather. By the time they reached Bantry Bay, Co. Cork on 21 December, they had no leader and only half of the original contingent of troops. Conditions had still not improved by 25 December and the decision was made to return to France without attempting to land.

A rebellion by the United Irishmen did take place during the summer of 1798 but it was doomed to failure due to lack of support and government spies. The French did eventually make a landing in Co. Mayo under General Humbert on 22 August 1798 with a

relatively small force of 3,000 men but after some initial victories was defeated by the British army under its commander-in-chief, Marquess Cornwallis, at Ballinamuck, Co. Longford. Tone accompanied another attempted landing of 3,000 men that October but the force was intercepted by the British at Lough Swilly in Co. Donegal. He was offered a fast schooner by the French in order to make his escape but he refused. He did not try to hide his identity when captured and was brought to Dublin in chains.

Tone was tried by court martial and found guilty of acting hostile towards the king. He requested that as an officer of the French military that he be shot rather than hanged. His request was denied and he tried to take his own life by cutting his throat. However, he only cut his windpipe which did not end his life, at least not immediately. He died about eight days later in quite a lot of pain. Tone is still remembered as the father of Irish republicanism and is commemorated by various political parties at his graveside in Bodenstown, Co. Kildare each year.

A statue to Tone was originally due to be erected on the centenary of the rebellion in 1898. A base for the statue was installed at the north-west corner of St Stephen's Green by John O'Leary using an ornate trowel sent by Tone's American granddaughter. However the statue was never completed due to lack of funds and the Fusiliers' Arch (**B1**) was erected instead. The current statue, unveiled in 1966, was blown up by loyalist paramilitary groups in 1971. The statue was subsequently restored, allowing the artist to rectify some mistakes that had been made on the original.

B5 FIANNA ÉIREANN MEMORIAL, St Stephen's Green *(A.J. Breen, 1966)*

Na Fianna Éireann (the soldiers of Ireland) was a type of nationalist boy scout movement that was founded in 1909 by Blumer Hobson and Constance Markievicz (**B11**). They trained boys in military discipline, the use of weapons and first aid, and provided young recruits for the struggle for independence during the 1912–1922 period. Some of the members were involved in the Howth gun-running incident in July 1914, when arms were smuggled into Ireland in response to a similar gun-running by the loyalist Ulster Volunteers at Larne in Northern Ireland earlier that year. The arms were hidden and subsequently used for the Rebellion of 1916. Markievicz was second in command of the garrison which took control of the Royal College of Surgeons (p. 50), located to the west of St Stephen's Green during the rebellion.

The limestone cross has a relief of a sunburst, a symbol of Fianna Éireann, and inscriptions in English and Irish,

which don't quite match. The English version reads 'To honour all those who served with Fianna Éireann 1909–1916 and through the War of Independence', while the Irish version translates to 'In honour of all of those who served loyally and bravely with Fianna Éireann between 1909 and 1916 and who stood in the "Gap of Danger" in the War of Independence.'

B6 THREE FATES, St Stephen's Green *(Josef Wackerle, 1956)*

Within Nordic mythology, the Three Fates, known as Norns, lived beside the Well of Urðr, where they used the water to keep the roots of Yggdrasil, the tree of the world, from drying out. In this sculpture we see the fates with the thread of life: one is weaving and feeding the thread to the second, who is measuring the thread, and finally the third is cutting the thread according to our destiny. The group was presented to the Irish people by the German government in thanks for Operation Shamrock, an initiative which brought about 1,000 German children to Ireland after the Second World War. They had lost their parents and/or their homes during the war and they were fostered by Irish families. Most of the children returned home but about 50 remained and were adopted by their host families.

B7 RABINDRANATH TAGORE (1861–1941), St Stephen's Green
(Gautam Pal, 2011)

Tagore was a renowned Indian poet who wrote groundbreaking poetry and prose using the colloquial Bengali language. He was born in Calcutta into a wealthy family and was initially tutored by his father and brother. He attended public school in Brighton in England and read Law for a time in University College London. He had a great understanding of the sciences and he used this in his work. He espoused Indian nationalism and independence from Great Britain.

Tagore won the Nobel Prize in Literature in 1913, the first non-European writer to do so. He travelled extensively throughout Asia, North and South America, and Europe. He met W.B. Yeats (**B15**) in 1912 and they influenced each other, seeing similarities in their philosophies. Yeats went on to write the introduction for the English version of Tagore's 'Gitanjali' (Song Offerings) and added Tagore's play *The Post Office* to the repertoire of the Abbey Theatre, of which he was co-founder. Tagore wrote a significant volume of work, including poetry, novels, essays, short stories, dramas, travelogues and 2,300 songs. His complete works extend to 80 volumes.

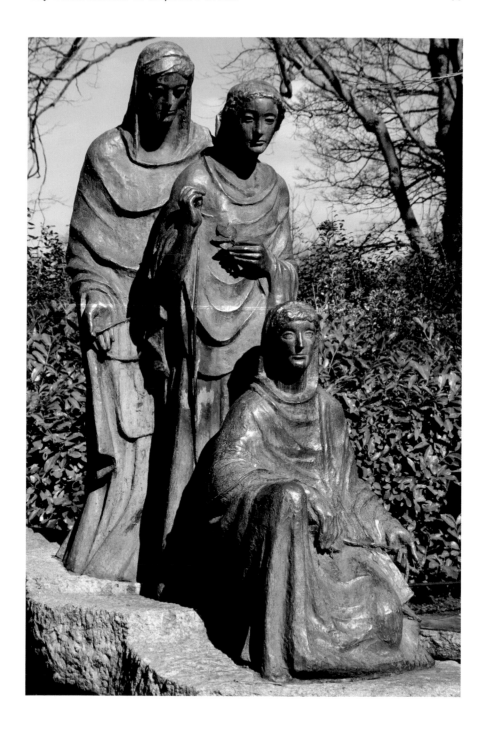

This bronze bust was erected in St Stephen's Green to celebrate the 150th anniversary of Tagore's birth and is one of a number that were erected in various countries around the world at that time.

B8 JAMES JOYCE (1882–1941), St Stephen's Green *(Marjorie Fitzgibbon, 1982)*
James Joyce is thought to be one of the greatest writers in English of the twentieth century. He was born in Rathgar in Dublin, one of ten surviving children of a reasonably wealthy father who was 'fond of the drink' and who squandered his money. The family moved many times to poorer and poorer accommodation as fortunes declined, leading Joyce to develop a very thorough knowledge of the city. He attended the Jesuit-run Clongowes Wood College until his father was unable to pay the fees and he was withdrawn. Luckily, he had a chance meeting with a Fr Conmee, a Jesuit, who recognised his genius and brought him and his brother Stanislaus on a scholarship to Belvedere College, also run by the Jesuits.

Joyce attended University College Dublin (UCD), studying English, French, Italian and logic, graduating in 1902. He moved to Paris to study medicine but returned when his mother died in April 1903. He met Nora Barnacle and took her out on their fateful first date on 16 June 1904, the date on which the events of his masterpiece, *Ulysses*, take place. They eloped to Italy and spent the next few years moving between Pola, Rome and Trieste.

He published *Chamber Music*, a book of 36 poems, in 1907 and in 1914, after a great struggle, published *Dubliners*, a book of eighteen magnificent short stories. *A Portrait of the Artist as a Young Man*, an autobiography, was published in 1916. He continued to struggle with money and moved consistently between Italy, Switzerland and France while fine-tuning his masterpiece, *Ulysses*, which was finally published by Shakespeare and Co. on 2 February 1922, his birthday.

Ulysses garnered acclaim and notoriety in equal measure and was banned in the United States as obscene. One critic wrote that '*Ulysses* isn't fit to read', to which Joyce replied, 'If *Ulysses* isn't fit to read, then life isn't fit to live.' He published his final and most challenging novel, *Finnegans Wake*, in 1939.

Joyce moved to Zurich in 1940, fleeing from the Nazis. Complaining of severe stomach cramps, he entered hospital and was operated on for a perforated ulcer but died on 13 January 1941. He is buried in Flutern Cemetery in Zurich. He was survived by his wife, Nora, and children, Giorgio and Lucia. This statue is located here as, in 1902, UCD was located

just across the street from St Stephen's Green. Today it is located to the south of Dublin in Belfield.

B9 THOMAS KETTLE (1880–1916), St Stephen's Green *(Albert Power, 1919)*

Thomas Kettle was a nationalist, poet, lawyer, politician, soldier, wit, professor and journalist. He was born into a farming family in Artane, Co. Dublin. His father was a supporter of Parnell (**D36**) and a founder member of the Irish Land League, founded to campaign for tenant rights. While Kettle was attending University College Dublin he was a leading student politician and was auditor of the Literary and Historical Society, a well-known debating society. He qualified as a barrister in 1905 and was elected as Member of Parliament for East Tyrone in 1906 as a member of the Irish Parliamentary Party. He was appointed as Professor of National Economics in UCD in 1908, leading to him resigning as an MP in 1910.

Kettle held strong nationalist views and supported Home Rule. He also supported the strikers in the 1913 Lockout. He joined the Irish Volunteers in 1913 and went to Europe to procure arms for the Volunteers. He was in Belgium when the First World War started and while there he wrote a regular column for the *Daily News*. He was horrified by the atrocities perpetrated by the Germans and decided that he would join the British army to fight against them. Due to ill health he was not allowed to join an active unit but used his skills of oratory at recruitment meetings to get Irish men to join for the 'defence of the small nations'.

He was dismayed by the 1916 Rebellion, arguing that it would kill the hopes of achieving Home Rule for Ireland, but he was even more horrified by the shooting of the rebel leaders after a series of swift courts martial. In frustration, Kettle insisted that he be sent to France on active service. That request was in the end accepted and he joined the 9th Battalion of the Royal Dublin Fusiliers. He was sent to the Somme and was killed while leading his troops at the Battle of Ginchy in September 1916. He has no known grave.

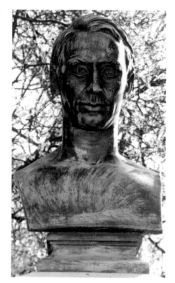

The words at the bottom of the plinth are the last three lines from one of Kettle's sonnets, 'To My Daughter Betty, the Gift of God': 'Died not for flag, nor King, nor Emperor,— But for a dream born in a herdsman's shed, And for the secret Scripture of the poor.' The poem was dated September 1916 and was written just a few days before his death.

B10 THE HASLAMS' SEAT, St Stephen's Green *(Unknown, 1923)*

This seat is dedicated to Anna (1829–1922) and Thomas (1825–1917) Haslam, who dedicated their lives to gaining equal rights for women. Both were Quakers from Cork who married in 1853 and moved to Dublin. They campaigned for equal rights for women in education and founded the Irish Society for Training and Employment for Educated Women.

In 1866 Thomas's health declined and he became unable to work, so Anna set up a stationery business in Rathmines to support them both. The Haslams' campaigns helped to gain access for women to study for degrees in the 1870s. They then became active in the Married Women's Property Campaign, looking for an end to the law which declared that a woman's property and possessions legally belonged to her husband. They also campaigned for repeal of the Contagious Diseases Act for the monitoring of prostitutes used by the British armed forces, which effectively treated women as commodities who, if they contracted venereal disease, were cleaned up and passed 'fit for use' again.

The campaign that the Haslams are most famous for is the women's suffrage campaign seeking votes for women. They founded the Dublin Women's Suffrage Association (DWSA) in 1876. This became the Irish Women's Suffrage and Local Government Association in 1901 and included supporters of nationalist and

unionist persuasion. They had some success with changing laws to allow women become eligible to stand for and vote in elections for local government, but it was not until 1918 that women over the age of thirty were allowed to vote in general elections. By then Thomas had died but Anna voted in her first general election at the age of 89 years.

The seat is made from Kilkenny limestone and was erected in honour of the Haslams' work in 1923.

B11 CONSTANCE MARKIEVICZ (1868–1927), St Stephen's Green
(Seamus Murphy, 1932)

Campaigner, artist, actress, revolutionary, benefactor, prisoner, hunger striker – Markievicz filled many roles in her life. She was born Constance Gore-Booth in London in 1868 to Lady Georgina and Sir Henry Gore-Booth, an arctic explorer. The family home was Lissadell House in Co. Sligo and she spent a happy childhood there. The Yeats family frequently socialised at Lissadell and W.B. Yeats **(B15)** went on to write a poem dedicated to the two Gore-Booth sisters, 'In Memory of Eva Gore-Booth and Con Markievicz'.

Constance attended the Slade School of Art in London and then Académie Julian in Paris. It was in Paris that she met the Polish Count Casimir Dunin-Markievicz. They married in 1900 and the following year Constance gave birth to her only child, Maeve Alyss, who was reared by her grandparents. She became involved with Sarah Purser, Nathaniel Hone and Jack B. Yeats in the United Arts Club. She was also influenced by Maud Gonne, a revolutionary of the time.

Having found her calling in the suffrage and revolutionary movements, Markievicz became involved in Inghinidhe na hÉireann (Daughters of Ireland – a revolutionary women's movement) and in 1909 she founded Na Fianna Éireann (**B5**), a type of boy scout movement that trained members in the use of arms. This became a training ground for many who fought in the 1916 Rebellion. She helped the Irish Trade and General Workers' Union during the 1913 Strike and Lockout, using her own money to provide food and fuel for hungry families.

Markievicz was second in command under Michael Mallin in the Royal College of Surgeons (p. 50) rebel garrison, which held out for six days during the 1916 Rebellion. When she surrendered it was to Captain Wheeler of the British army, her first cousin. She was tried by court martial, found guilty and sentenced to death. However due to her sex, her sentence was commuted to life imprisonment. She was released under a general amnesty in 1917 and went on to become the first woman to be elected to the British Parliament in 1918. However as a member of Sinn Féin she refused to take her seat in Westminster, becoming the Minister for Labour in the first Dáil instead.

After Irish independence was achieved she fought on the anti-Treaty side during the Civil War. She was again imprisoned and went on hunger strike. She went on to join Fianna Fáil upon its foundation in 1926. She continued to work for the poor, using all of her money to help them. Constance Markievicz died of appendicitis in a public ward in Sir Patrick Dunn's Hospital on 15 July 1928.

This bust was unveiled in 1932 by Taoiseach Éamon de Valera in the presence of Vithalbhai Patel, ex-speaker of the Indian Parliament, who was visiting Ireland seeking support for Indian independence from Great Britain at the time. It was severely damaged in 1945 when someone took a hammer to it but was subsequently repaired. There is also a statue of Markievicz with her pet dog, Poppet, in Townsend Street (**B51**).

B12 JAMES CLARENCE MANGAN (1803–1849), St Stephen's Green
(Oliver Sheppard, 1909)

James Mangan, the son of a hedge schoolmaster and grocery store owner, was born in Fishamble Street in 1803. He was educated by the Jesuits but the family lost their money when his father speculated on property with disastrous consequences. This resulted in Mangan having to support both his parents and a brother until they died.

From a young age Mangan was producing poetry and went on to write over 1,000 poems along with many pieces of prose, fiction and a short autobiography. He came to the notice of Dublin's literary elite when some of his works were published in the pro-unionist *Dublin University Magazine*. His later works were published in nationalist magazines such as the *Irish Catholic* and *The Nation*. His finest and most famous works were produced during this period, including 'My Dark Rosaleen' and 'Vision of Connaught in the Thirteenth Century'.

Mangan was an alcoholic and was always struggling to make ends meet. He produced work based on financial need or to repay debts. He was found by some friends in a destitute state in June 1849 and brought to the Meath Hospital where he died shortly after. His funeral at Glasnevin was attended by no more than five people but his influence lasted to impact on such artists as William Butler Yeats, James Joyce and Pádraig Pearse.

This statue was commissioned by the National Literary Society to celebrate the centenary of his birth. The poet is idealised in noble style with his face framed by his full head of hair. A representation of Róisín Dubh (Dark Rosaleen) in Porracci marble is located below the bust. It is thought that Beatrice Elvery, a student of Sheppard's, was a model for Róisín Dubh. Note the relief on the marble of a woman with a harp representing Irish music and a woman with a child in her arms representing the future of Ireland.

B13 MAGDALENE SEAT, St Stephen's Green *(Adam May, 1995)*

The Magdalene laundries were institutions for 'fallen women' – such as unmarried mothers, 'promiscuous women' and prostitutes – first founded in the eighteenth century. In Ireland they were run by religious orders with the support of the state and mainly used to shelter women who had become pregnant outside marriage. The women remained there for an indefinite period of time, sometimes for the rest of the lives, working without pay in the laundries. Usually their babies were

put up for adoption but sometimes they remained in the laundries to become workers in the institutions as well. There were many of these laundries throughout the state and tens of thousands of girls ended up in unregulated and often cruel conditions over the years. The last laundry closed in 1996 and a subsequent government inquiry produced a report in February 2013

that 'washed the dirty linen in public' so to speak. The living survivors were paid compensation by the government. The 2002 film *The Magdalene Sisters* gives a good account of life in the laundries.

This seat commemorating the Magdalene women was erected by the Office of Public Works in 1995.

B14 BENNETT AND CHENEVIX BENCH, St Stephen's Green
(Francis Barry, 1958)
This bench is named in memory of Louie Bennett (1870–1956) and Helen Chenevix (1890–1963). Bennett was born in Dublin and educated in London. Having travelled extensively she became involved in the women's suffrage movement, which was very active in the early twentieth century. In 1916 she was sub-editor of the *Irish Citizen* and went on to organise the Irish Women Workers' Union with Chenevix. Chenevix was born in Dublin, the daughter of a Church of Ireland bishop. She was educated at Trinity College Dublin and became involved in politics, organising the Irish Women Workers' Union with Bennett. She was a pacifist and became vice-chair of the Irish pacifist movement. Chenevix was a member of the Irish Labour Party and was elected president of the Irish Trades Union Congress. This bench is surrounded by a garden for the blind which has plants with strong fragrances, identified by 26 Braille plaques.

B15 STANDING FIGURE KNIFE EDGE (William Butler Yeats (1865–1939)), St Stephen's Green *(Henry Moore, 1961)*

William Butler Yeats is considered to be one of the greatest poets in the English language of the twentieth century. He was born in Sandymount, Dublin, the son of John Butler Yeats, a barrister and painter, and Susan Pollexfen from Sligo. He was educated at the High School, the Metropolitan School of Art and the Royal Hibernian Academy. During his time as a student he was introduced to the occult, an interest that he pursued for much of his life. He spent much of his childhood in Sligo, where he heard Irish myths and legends that were to influence him towards a career in writing rather than art.

The love of his life was Maude Gonne, whom he met in 1889. He first proposed to her on 1891 – the first of four proposals that were rejected over a space of 25 years. When he was refused the fourth time he proposed to Maude Gonne's daughter, Iseult, an advance that was also rejected.

In 1904, along with Lady Gregory and Edward Martyn, Yeats founded the Abbey Theatre for the performance of plays by Irish writers. He was strongly attached to the movement of cultural nationalism and his nationalist play, *Kathleen Ní Houlihan*, was performed in the Abbey on the opening night. His reputation increased significantly after a tour of the United States; in 1913 he was given a civil list pension of £150 and in 1915 he was offered a knighthood, which he refused.

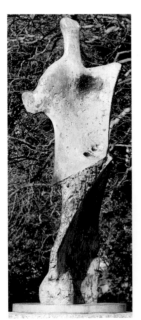

Yeats finally married Georgie Hyde Lees in 1917 and they went on to have two children. He won the Nobel Prize in Literature in 1923, the first Irishman to do so. This was considered a great honour for a country that had achieved independence just two years earlier. In the late 1920s and early 1930s his health started to fail and he spent a lot of time in Italy and France. He died in Menton in south-east France on 28 January 1939 and was buried in Roquebrune-Cap-Martin. In September 1948, his remains were exhumed and re-interred in Drumcliffe, Co. Sligo, as per his wishes.

The list of his works is endless but favourites include 'The Wanderings of Oisin', 'Easter, 1916', 'Winding Stair', 'The Wild Swans at Coole' and the one that most Irish children learn by heart at school, 'Lake Isle of Innisfree'.

This little secluded area of St Stephen's Green allows some peace to reflect on the work of Yeats. This sculpture by Henry Moore, erected as a tribute to Yeats, is known as 'Standing Figure Knife Edge' and was erected here in 1967.

B16 ROBERT EMMET (1778–1803), St Stephen's Green *(Jerome Connor, 1966)*
This statue of Robert Emmet is located opposite his birthplace at 109 St Stephen's Green. He was born the youngest son of a part-time physician in the Viceregal Lodge and a brother of Thomas Addis Emmet, one of the leaders of the United Irishmen who rebelled in 1798. Emmet entered Trinity College Dublin at the age of fifteen and was a brilliant student. He was, however, expelled for his radical political views.

In the early 1800s Emmet tried but failed to get support from the French for a rebellion in Ireland. Despite the rejection, he went ahead with preparations for a rebellion and started to organise the making of folding pikes that could be concealed under garments. He also started to manufacture ladders and explosives which were to be used to attack Dublin Castle, the seat of British power in Ireland. An explosion at one of these factories in Patrick Street killed one man and alerted the authorities to a possible uprising. The explosion forced Emmet to bring forward the date of the rebellion to the evening of Saturday 23 July 1803. It was doomed from the start. Only one of the ladders was completed, the horses that were to bring the rebels secretly in a carriage to Dublin Castle bolted, and many of the rebels had been drinking all day and were in no fit state to rebel. During what turned out to be nothing more than a riot, Lord Kilwarden, the Lord Chief Justice, and his nephew were piked to death.

In all about 50 people were killed during the rebellion but Emmet escaped. He remained elusive for about a month but was captured as he tried to make contact with his sweetheart, Sarah Curran. He was put on trial for high treason and found guilty. Before sentence Emmet gave his famous speech from the dock, which was to inspire many Irish rebels subsequently. The speech ended with the lines, 'When my country takes its place among the nations of the earth, then, and not till then, let my epitaph be written.'

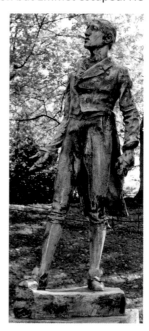

Emmet was hung, drawn and quartered in public outside St Catherine's Church in Thomas Street (**C58**). His body was never claimed after his execution and went missing; to this day its whereabouts has never been confirmed. This statue is a copy of the original, by Connor, which was unveiled in 1919 by Woodrow Wilson in Washington DC. There is another copy in the Golden Gate Park in San Francisco.

B17 ARTHUR EDWARD GUINNESS, St Stephen's Green *(Thomas Farrell, 1891)*
Known as Lord Ardilaun, Arthur Edward Guinness was the great-grandson of Arthur Guinness the brewery founder, and son of Sir Benjamin Lee Guinness (**C49**). He was educated at Eton College and Trinity College Dublin and ultimately became head of the Guinness brewery for nine years. In 1877 he opted out of business and became a philanthropist, spending his money on initiatives that helped the people of Dublin. He completed the restoration of Marsh's Library (started by his father) behind St Patrick's Cathedral and rebuilt the Coombe Women's Hospital. He bought out the key-holders, landscaped and restored St Stephen's Green to the people of Dublin.

Lord Ardilaun owned Ashford Castle on Lough Corrib, Co. Galway, Muckross Estate in Killarney, Co. Kerry and St Anne's Estate in Raheny, Co. Dublin. He lived in Iveagh House (now the Department of Foreign Affairs) on the south side of the Green, which had the Iveagh Gardens (p. 52) as part of its grounds.

This bronze statue was paid for by the poor people of Dublin in recognition of all of the work he did for them. We see Guinness resplendent, reclining in his classic chair.

THE ROYAL COLLEGE OF SURGEONS

The Royal College of Surgeons was founded in 1784 and the initial version of this building was opened in 1810. The college was the first of its kind in the British Isles to admit women to their courses in 1885. During the 1916 Rebellion the building was used as a garrison by the rebels commanded by Michael Mallin and Constance Markievicz. On the building, note the marks of the bullets fired by the British army, who were located in the Shelbourne Hotel north-east of here. Today the college has more than 800 students, many of them from overseas. The pediment of the building has three allegorical statues, which, of course, are all connected with medicine.

B18 ATHENA (left), Royal College of Surgeons, St Stephen's Green West
(John Smyth, 1825)
Athena is the Greek goddess of wisdom and war and patroness of the useful arts. Athena was born fully grown and fully armed from the head of Zeus, the father of the Greek gods. In Greek mythology, Athena and Poseidon did battle over the city that is today called Athens. The contest was one in which the prize was the naming of the city after the victor. The winner would be the one who in

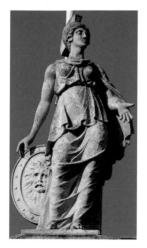

the opinion of the assembled gods offered the most useful gift to the city. Poseidon struck the rock of the Acropolis with his trident and delivered a stream of salty water while Athena stamped her foot and from there the first olive tree grew. The victorious Athena had the city named after her and the olive tree became a sacred tree and the symbol of peace and prosperity.

B19 ASCLEPIUS (centre), Royal College of Surgeons, St Stephen's Green West *(John Smyth, 1825)*

Asclepius is the Greek god of healing. Born of the god Apollo, he was cut from his mother's womb when she died in childbirth. His name means 'to cut open'. He was the father of (amongst others) Hygieia and Panacea. He is said to have shown some kindness to a snake and in return the serpent licked his ears clean and shared the knowledge of healing. He is usually represented holding a rod wreathed with a snake, a symbol still used today to represent healing. He cured many people and is said to have raised people from the dead. He was killed with a thunderbolt by Zeus, who felt that Asclepius was creating an imbalance in the world.

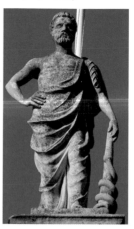

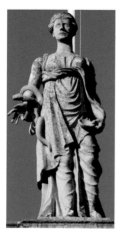

B20 HYGIEIA (right), Royal College of Surgeons, St Stephen's Green West *(John Smyth, 1825)*

Hygieia was the daughter of Asclepius and the goddess of cleanliness and hygiene, which derives from her name. Her cult became popular after the Plague of Athens in the fifth century BC. She was worshipped in order to prevent sickness and to promote continued good health. She is often shown holding and feeding a large snake from a bowl. In this case she is holding the snake in her right hand and the bowl in her left hand. Hygieia's bowl with a snake wrapped around it has been used as a symbol for pharmacists since the early eighteenth century.

THE IVEAGH GARDENS

The Iveagh Gardens are named after Edward Cecil Guinness, the 1st Earl of Iveagh, who once owned the grounds. The gardens were designed by Ninian Niven as a winter garden for the Great Dublin Exhibition of 1865. The exhibition ran for six months from May that year and was attended by 900,000 people. During the exhibition it contained many statues, a boating pond, a rock fountain, an archery ground and two allegorical fountains, some of which still survive today.

Lord Rupert Guinness, the 2nd Earl of Iveagh, presented the gardens, along with Iveagh House on St Stephen's Green, to the state fee gratis in 1939. The gardens can be entered from behind the National Concert Hall on Earlsfort Terrace, from Hatch Street Upper and from Clonmel Street, off Harcourt Street.

B21 REMAINS OF NEPTUNE, Iveagh Gardens
(Unknown, 1863)
The remains of this statue of Neptune were once located in the centre of a boating pond in the garden of Iveagh House, a Guinness residence at the time but today housing the Department of Foreign Affairs.

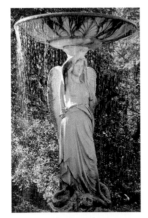

B22 ANGEL FOUNTAINS, Iveagh Gardens
(Unknown, 1865)
The two angel fountains represent Industry and the Arts. They were erected here during the Great Dublin Exhibition of 1865. The restoration of these angel fountains won an award in the European Architectural Heritage Programme in 1993.

B23 LADY STATUES,
Iveagh Gardens *(Unknown, 1865)*
These three damaged statues may be a residue from the Great Dublin Exhibition of 1865.

B24 COUNT JOHN MCCORMACK, Iveagh Gardens
(Elizabeth O'Kane, 2008)
John McCormack was born in Athlone in July 1884, the fourth of eleven children. He attended the Marist School in Athlone and Summerhill College in Sligo. He loved music from an early age and when he came to Dublin to work as a clerk he joined the Palestrina Choir in St Mary's Pro-Cathedral (p. 137) under the

tutorage of Dr Vincent O'Brien. He won the gold medal for singing in the Feis Ceoil (Festival of Music) in 1903, beating James Joyce into second place. He managed to raise funds to go to Milan to train under Vincenzo Sabatini. McCormack already had a wonderful voice, but Sabatini taught him breath control, which allowed him to sing the most difficult operatic arias with apparent ease.

As his stature grew, McCormack began to tour extensively in Europe, Australia, China, Japan and the US. He was particularly popular in the US, where he appeared in many operas and performed in hundreds of concerts. He also performed in many fundraising events for the war effort during the First World War and raised funds for the Red Cross and Roman Catholic charities. He had a very large repertoire of operatic pieces but loved singing the Irish melodies of Thomas Moore (**B47**), for which he is well remembered. Such was his popularity he was made a Freeman of Dublin in 1923 and awarded an honorary Doctorate of Music by University College Dublin in 1927. He was made a Papal Count by Pope Pius XI in 1928 for his charity work for the Church.

With his fame came great wealth and he had luxury homes in various places, including Beverly Hills. He starred in *Song O' My Heart* in 1930, for which he received a fee of $500,000, a huge sum at that time. The performance that he regarded as his favourite was in front of one million people in the Phoenix Park at the 1932 Eucharistic Congress when he sang 'Panis Angelicus'.

McCormack retired from active performance in the late 1930s, but the Second World War prompted him to give some radio performances on the BBC to raise funds for the Red Cross. He tells the story of arriving by train in Bristol during an air raid. The city was in darkness and there were no cabs to bring him to his hotel. There was an army truck parked close by and one of the soldiers recognised him and asked if he was John McCormack. He replied 'Yes God help me, I am.' The soldier, seeing his predicament, loaded his bags up on the truck and brought him to his hotel.

He spent his final years in a house called 'Glena' in Booterstown, Co. Dublin. He contracted emphysema and died on 16 September 1945. He was survived by his wife, Lily, and children, Cyril and Gwen. He is buried in St Patrick's plot in Deansgrange Cemetery, Co. Dublin.

McCormack's great skill was his breath control. The best example of this is his recording of 'Il Mio Tesoro' (My Treasure) from Mozart's opera *Don Giovanni*. In this aria he sings 64 notes without taking a breath. Brilliant! In 2006 the US Library of Congress declared this one of the greatest 100 recordings of the twentieth century and in recognition has added the record to its collection for posterity – a fitting tribute to a great Irish tenor.

His portrait by Sir William Orpen (1923) hangs in the National Gallery, Dublin. This bronze statue sees McCormack in typical concert style in his dress suit, perhaps hitting a high C.

B25 THE KISS, Earlsfort Terrace *(Rowan Gillespie, 1990)*

This statue was commissioned by Burke Kennedy Doyle, Architects. Rowan Gillespie won the competition to design a sculpture and it was inspired by a couple spotted kissing on the site by Gillespie as he was looking for ideas for

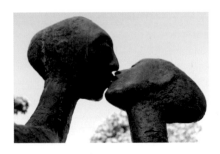

the commission. The statues capture the intimacy of a couple as they share their breaths before their lips connect. Gillespie also took his inspiration from the book *The Prophet* by Khalil Gibran (1883–1931). Gillespie portrays the tenderness of two lovers submitting but leaving a space 'to let the winds of the heavens dance between them as they are about to share the intimacy of a kiss'.

B26 PEACE COMES DROPPING SLOW, Earlsfort Terrace *(Colm Brennan, 1989)*

The title of this sculpture, 'Peace Comes Dropping Slow', comes from the second verse of W.B. Yeats' poem 'Lake Isle of Innisfree'. In the poem the poet longs to be back in Co. Sligo on the Isle of Innisfree. The full line is 'And I shall have some peace there, for peace comes dropping slow, Dropping from the veils of the morning to where the cricket sings'. The artist captures the sound of the water and the wildlife that Yeats yearned for.

B27 THE AWAKENING, Earlsfort Terrace
(Linda Brunker, 1990)

This sculpture, called the Awakening, can be found in the courtyard to the right of the Conrad Hotel. It's a bronze frieze twisting from the earth towards the sky in a celebration of life. The imprint of faces and figures symbolise the awakening of the human spirit that helps us to get through and live our lives to the best of our abilities.

B28 BIO-DYNAMICS, Earlsfort Terrace *(Michael Warren, 1989)*

This bronze sculpture imitating wood was created by Warren when he was in the final year of art college. At the time he was interested in Russian Constructivism, a movement through which many Russian sculptors were trying to symbolise the October Revolution with giant gravity-defying sculptures that matched revolutionary ideals. Warren says that one of his influences for this sculpture came from the Russian constructivist theatre director Vsevolod Meyerhold, who experimented with new staging methods after the Revolution and used the principle of bio-mechanics to express emotions through a number of body poses. Another influence was Umberto Boccioni, an Italian futurist artist from the early twentieth century who tried to represent the deconstruction of solid mass in his sculptures.

B29 THE RIVERS OF TIME, Earlsfort Terrace *(Alexandra Wejchert, 1990)*

Located in the passageway between Earlsfort Terrace and Leeson Street, this ceramic mosaic brings plenty of colour to the blandness of the brick wall behind. The work was commissioned by the Conrad Hotel. Wejchert is perhaps better known for her work 'Freedom', located in front of the AIB Bank Headquarters in Ballsbridge, which is outside the scope of this book.

B30 TRACE, St Stephen's Green East *(Grace Weir, 1988)*
This work in Portland stone, limestone and bronze was the winner of a competition to find a suitable work of art for this location as part of the Dublin Millennium

Sculpture Symposium in 1988. The name, 'Trace', refers to the traces of usage of the streets that can be seen in the sculpture. The artist reflects the shape of the famous Dublin doorways from the many Georgian town houses that were built around St Stephen's Green during the eighteenth century. The markings on the sculpture echo the tram lines, gutters, street markings and street signs of the area. The circular disc in bronze with two stripes represents a manhole cover that has not been replaced properly. At the time of writing this sculpture had been moved due to construction of a new tramline but is due to be reinstated at the south end of Kildare Street.

B31 ARCHBISHOP PLUNKETT, Kildare St *(William H. Thorneycroft, 1901)*
William Plunkett was born in Dublin in 1828, the son of a baron. He was educated in Cheltenham College, where he became head boy, and at Trinity College Dublin. After ordination he spent a number of years ministering in Co. Galway. He married Anne Lee Guinness, daughter of Sir Benjamin Lee Guinness (**C49**), in 1863. They returned to Dublin in 1864 and he was appointed as treasurer of St Patrick's Cathedral. The Guinness connection must have influenced the donation of £160,000 by Sir Benjamin for the restoration of the cathedral in 1866. He was made the 4th Baron Plunkett on the death of his father in 1871. Plunkett went on to become Bishop of Meath in 1876 and Archbishop of Dublin in 1884, a position that he held until his death. He was instrumental in developing the Church of Ireland College of Education in Rathmines and he was closely associated with the reform church in Spain, Portugal and Italy, giving generously to their cause. He died in 1897 and is buried in Mount Jerome Cemetery. This statue to him was unveiled in 1901 by Viceroy Earl Cadogan.

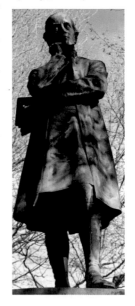

B32 DEPT OF INDUSTRY, Kildare St *(Gabriel Hayes, 1942)*
This art deco building has housed the Department of Industry and Commerce (now known as the Department of Jobs, Enterprise and Innovation) since it was

built in 1942, when Seán Lemass was Minister. Completion of the building was delayed due to a shortage of steel because of the war.

The building has bas-reliefs by Gabriel Hayes, who designed the ½p, 1p and 2p coins for decimalisation in 1972. The relief over the main doorway shows Lugh, the Celtic god of light, launching aeroplanes. The large panels on the minister's balcony show the cement industry and the Shannon Electric Scheme, while the smaller panels show shoemaking, cigarette manufacture, spinning and pottery. The keystone heads above the tall windows on the front and the side of the building represent Éire (Ireland) and St Brendan the Navigator.

B33 UNTITLED, Nassau St *(Gerda Frömel, 1974)*

This somewhat hidden sculpture is located in the plaza of the Setanta Centre beside Kilkenny Design. It is a stainless steel piece with two parts rising from the ground and crossing to form what might be considered a flower. It was sculpted by Gerda Frömel, who was born in Czechoslovakia in 1931 but moved to Ireland in 1956. Tragically, she drowned the year following the erection of this work.

B34 THE TÁIN, Nassau St *(Desmond Kinney, 1974)*

The *Táin*, or *Táin Bó Cúailnge*, is an Irish epic about a cattle raid that is supposed to have taken place about the first century AD. This glass and ceramic mosaic tells the story of the raid in a number of episodes. On the left is Sétanta, a strong young boy, killing the guard dog of Culann. In remorse he takes the place of the dog and becomes known as Cú Chulainn or Cullen's Hound.

The cattle raid arises when Queen Medb and King Ailill of Connaught compare their wealth. Ailill is wealthier because he owns a particularly fertile bull. In her jealousy, Queen Medb decides to restore the balance by stealing a famous bull from the Cooley Peninsula, which was at that time in Ulster. Due to a spell cast upon them, the Ulster army are unable to defend against Queen Medb's army. Cú Chulainn was the only Ulster man who could fight and he asserts the right to single combat at a ford. He sees off all his challengers, including his foster-brother Ferdiad, until he is mortally wounded by a magic spear. He ties himself to a rock so as to face his enemies in death and it is only when a raven lands on his shoulder that his enemies know that he is dead and dare to approach him. Queen Medb brings the captured bull to Connaught where it fights and kills Ailill's bull but it is so wounded that it too eventually dies.

The story reads from left to right, commencing with Sétanta killing the hound and finishing with the bulls fighting. We can also see Queen Medb overseeing the events from her horse.

TRINITY COLLEGE

Trinity College Dublin was founded in 1592 by Queen Elizabeth I. It was founded because up until then some of the Irish aristocracy were going to France and Spain for their education. These were Catholic countries and Elizabeth, a Protestant, was afraid that they would be influenced by 'the evils of Papism'. Catholics were not allowed to attend the college until 1793. Although they were allowed by the college to attend after this date, they were banned by the Catholic bishops from doing so until the 1970s, because of its Protestant ethos. Ladies were not allowed to attend until 1904.

Today the college extends to more than 40 acres and has a student population of 15,000. Within the college grounds there are twelve works to be discovered, some of them by internationally renowned artists.

B35 CACTUS PROVISOIRE, Fellows' Square,
Trinity College *(Alexander Calder, 1967)*

Created by one of the great innovators of twentieth-century sculpture, this bolted steel structure gets a nice airing in Fellows' Square. The title means 'Temporary Cactus'. This is one the artist's 'stabiles', created in his studio in Saché in France. Calder had a retrospective exhibition in New York's Museum of Modern Art in 1943, the youngest artist ever to do so. Much of his revolutionary work was in static mobiles, which initially were powered by motors but subsequently by wind. His later work

reached giant proportions with large public versions of his work found through-out the world in airports, public plazas and corporate head offices. This work was donated by a graduate of Trinity College to mark the opening of the Arts Building.

B36 SFERA CON SFERA, New Square, Trinity College *(Arnaldo Pomodoro, 1983)*
This bronze sphere located on the plaza of the Berkeley Library was donated by the artist with the assistance of Trinity College and Irish–Italian groups. Pomo-doro was awarded an honorary degree in letters by Trinity College in 1992.

The sculptor presents us with a ruptured revolving sphere allowing us to view the inner workings that show the complexity and turmoil within. There are many versions of this sphere to be seen around the world but those in the Vatican Museum in Rome and the United Nations Headquarters in New York are particu-larly noteworthy.

B37 UNTITLED MARBLE SCULPTURE, College Park, Trinity College
(Geoffrey Thornton, unknown)
This contemporary work in marble donated to the college by the artist is located to the east of the Berkeley Library beside the playing fields.

B38 COUNTERMOVEMENT, College Park, Trinity College
(Michael Warren, 1985)
Having a Michael Warren sculpture in Trinity is very appropriate as he studied philosophy, psychology and English at the college during the 1970s, before attending the Accademia di Belle Arti di Brera, Milan. Warren always aims for integration of his work with the landscape and he achieves this with Countermovement, which is skilfully created from Spanish chestnut. Often his work

defies gravity but in this case it is the overhead space that creates a downward pressure on the sculpture. Note that the structure only has three points of contact with the ground.

B39 DOUBLE HELIX, Lincoln Place Entrance, Trinity College *(Brian King, 2003)*
The structure of Deoxyribonucleic Acid (DNA) was discovered in 1953 by James Watson (b.1928) and Francis Crick (1916–2004) using an X-ray diffraction image generated by Rosalind Franklin. The double helix is two spiral chains of atoms joined together by 'base pairing' and this pairing is the basis of information transfer in all living material. This is considered one of the most important scientific

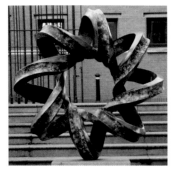

discoveries of the twentieth century and Watson and Crick won the Nobel Prize in Medicine in 1962 for their breakthrough. Today DNA is much used in forensic science for the solving of crime.

The sculpture is two coiled rings, representing the spiral chains of atoms, resting on a granite plinth. Watson's great-grandparents were born in Co. Tipperary and he came to Dublin in 2003 to unveil the sculpture on the 50th anniversary of the discovery.

B40 APPLES AND ATOMS, School of Physics, Trinity College *(Eilís O'Connell, 2013)*
This sculpture, comprising five stainless steel spheres, celebrates Ernest Walton (1903–1995), the one-time student and professor of Trinity College, who with Sir John D. Cockcroft split an atom of lithium in 1932, giving birth to the atomic age. For this work they were awarded the Nobel Prize in Physics in 1951. O'Connell's inspiration for the sculpture came from the spheres that created the spark gaps that were used to split the atom. The apple trees planted on either side represent Walton's other interest, gardening.

B41 RECLINING CONNECTED FORMS, Library Square, Trinity College *(Henry Moore, 1969)*
In creating this piece, Moore said that he used three recurring themes: mother and child; the reclining figure; and large form protecting small form. With this work he seems to have captured all three in one piece, focusing on

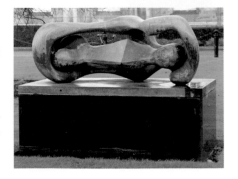

the human instinct of protection. The work was donated by the artist in 1971 with help from Trinity College.

B42 CAMPANILE, Library Square, Trinity College
(Charles Lanyon & Joseph Robinson Kirk, 1852)
The Campanile stands where the medieval Augustinian monastery of All Hallows (suppressed in 1538) once stood. The original spire of the monastery was used as a landmark to help ships navigate their way up the Liffey. The original plan was to replace the buildings demolished in the 1840s with a museum, lecture rooms and campanile. However, Decimus Burton, the English architect who also designed the layout of Phoenix Park,

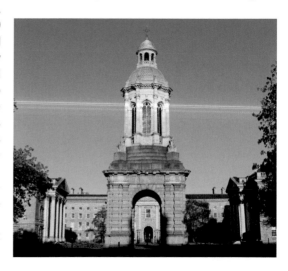

advised the college in 1849 to keep the area open and erect a small but highly architectural object linked by railings or colonnades to the other buildings in the square. With keystone heads of famous ancient Greeks located on the Romanesque arch, it is much larger (30m) than Burton intended. As the name suggests, the Campanile houses the two college bells. The structure was a gift from Lord John Beresford, Archbishop of Armagh and Chancellor of the University.

There are a number of works of interest on the Campanile, all of which were carved by Joseph Robinson Kirk in 1853. The bearded and bald keystone head is **Homer**. He was a Greek epic poet and philosopher who is thought to have lived during the eighth century BC. He is believed to be the author of *The Iliad* and *The Odyssey*, two epics which shaped Greek culture.

The bearded headstone with the fringe is **Socrates**. He was a Greek philosopher who lived in the fifth century BC and is considered to be the founder of Western philosophy. He encouraged change in Greek society and those who opposed it became jealous of him. He was put on trial by his opponents, found guilty and sentenced to death. He volunteered to take poison, which led to his death. Plato was one of his star pupils and it is through his writings that we know Socrates.

The bearded head looking sideways is **Plato**. He was a Greek philosopher and mathematician who lived in the fourth century BC. He came from a wealthy family

and received the best education that money could buy, which included teachers such as Socrates and Pythagoras. He went on to found the earliest-known organised school in Western civilisation, known as The Academy

The blind, bearded keystone head is **Demosthenes**. He was a Greek statesman and orator of considerable talent who lived during the fourth century BC. He had a highly developed skill of rhetoric and oratory which he used to good effect against his guardians, who had squandered most of his inheritance before he came of age. He used his talents to good effect in the Greek court system of the time. Demosthenes encouraged a failed revolt against the King of Macedonia, Alexander the Great, for which he was a marked man. He ended his life by suicide in order to avoid capture by the Macedonians.

The statues carved in Portland stone on the Campanile represent the higher faculties of the college. The seated figure with a book on her lap and holding a cross represents **Divinity**. **Science** is represented by the figure holding the staff. The figure holding the tablet represents **Medicine**. And finally **Law** is represented by the figure holding the fasces, or bundles of rods, which is a symbol of power.

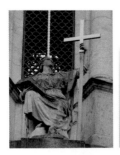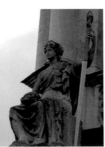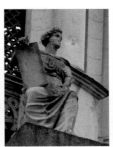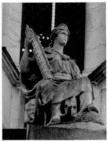

B43 WILLIAM LECKY (1838–1903), Library Square, Trinity College *(William Goscombe John, 1906)*

William Edward Hartpole Lecky was born in Blackrock, Co. Dublin. He studied divinity in Trinity College and graduated in 1859. He achieved his MA in 1863 but on graduating his interest turned to history. He wrote many books, including *A History of European Morals from Augustus to Charlemagne* (1869), *History*

of England in the Eighteenth Century (1878–1890),
History of Ireland in the Eighteenth Century (1892)
and *Democracy and Liberty* (1896). His works were
very influential at the time and in 1913 the Lecky Chair
of History was endowed in his honour. While he was a
unionist, he did have sympathy for the misfortunes of
the Catholic Irish and criticised the methods by which
the 1800 Act of Union had been passed. He is buried
in Mount Jerome Cemetery in Harold's Cross. There is
also a bust of Lecky in St Patrick's Cathedral.

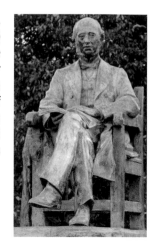

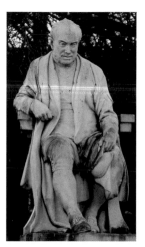

B44 GEORGE SALMON (1819–1904), Library Square, Trinity College
(John Hughes, 1911)

George Salmon was born in Dublin but raised in Cork.
He graduated from Trinity College in 1838 with very
high honours in mathematics and was elected a fellow
in 1841. He wrote the influential geometry textbook
Treatise on Conic Sections in 1848, and it was fre-
quently re-published. He was elected as professor of
divinity in 1866 and from then on concentrated on
theology. He wrote many books on theology, including
The Infallibility of the Church in 1888. He was provost
of Trinity College from 1888 until his death in 1904.
The marble statue shows Salmon sitting in a chair.

B45 EDMUND BURKE (1729–1797), Front Arch, Trinity College *(John Henry Foley, 1864)*

Born at 12 Arran Quay, Dublin, Burke was a great orator, phi-
losopher and statesman. He entered Trinity College at the age
of fourteen. He was born of a Catholic mother and a Prot-
estant father, who was a solicitor. His father hoped that he
would follow in his footsteps and take up law. However, while
studying to become a solicitor in Middle Temple in London
he abandoned his studies to write philosophy, much to his
father's disgust.

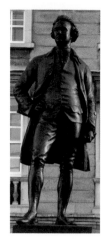

Burke went on to write *A Philosophical Enquiry into the
Origin of Our Ideas of the Sublime and the Beautiful*, which
secured him a well-deserved intellectual reputation. He
was one of the founding members of 'The Club', a group of

philosophers, thinkers and playwrights, which included Oliver Goldsmith (**B46**), James Boswell and Samuel Johnson (who published the celebrated *Dictionary of the English Language* in 1755).

Burke entered Parliament in London in 1765 and used his influence to fight against oppression and injustice. He tirelessly campaigned for improved conditions for Catholics and fair play for the American colonies, and wrote the prophetic *Reflections on the Revolution in France*, forecasting the arrival of Napoleon. Despite being a man of poor means, being mostly in debt due to the misadventures of his brother, he did not use his positions of power to enrich himself. He died on 9 July 1797 and is buried in Beaconsfield Cemetery in Buckinghamshire.

B46 OLIVER GOLDSMITH (1728–1774), Front Arch, Trinity College
(John Henry Foley, 1868)

Goldsmith was born near Ballymahon in Co. Longford to a local clergyman. He attended Trinity College where he did not excel at his studies but managed to obtain a degree. He also studied medicine at Edinburgh University. He was in a constant state of poverty and debt but despite this he headed off on a Grand Tour which took him as far as Italy. On his return to London in 1756 he took work as a schoolmaster, which he hated. He also worked as assistant editor of the *Monthly Review*, a literary magazine. This gave him an interest in literature and he began to write extensively, often plagiarising others' works.

His 'histories' were often inaccurate and unreadable but he also produced works of brilliance that are still read today: *The Traveller* (1764), *The Deserted*

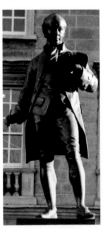

Village (1770) and *She Stoops to Conquer* (1773). His best known work is *The Vicar of Wakefield*, the rights of which he had to sell for £60 to pay his debts. It was published in 1766 and after a slow start became very popular, particularly during the nineteenth century. He was a friend of Dr Samuel Johnson, the English writer, and Edmund Burke, the Irish politician (**B45**) and they were all members of 'The Club', a gathering of notable thinkers of the day. Goldsmith worked hard and played hard and this contributed to his early demise on 4 April 1774. He is buried in Temple Church, London. He left us some good quotes: 'Success consists of getting up one more time than you fall' and 'Life is a journey that must be travelled no matter how bad the roads and accommodations.'

B47 THOMAS MOORE (1779–1852), College Street *(Christopher Moore, 1857)*
Thomas Moore was born in Aungier Street, Dublin, the son of a shopkeeper from
Co. Kerry. He got his love of music from his mother, who came from Co. Wexford.
He is best known for a total of ten volumes of *Moore's Irish Melodies*, which
include such well-known songs as 'The Meeting of the Waters', 'Oft in the Stilly
Night', 'Believe Me, If All Those Endearing Charms', 'The Last Rose of Summer'
and 'The Minstrel Boy'. Many of these songs are still performed throughout the
world today.

Moore was one of the first Roman Catholics to attend Trinity College Dublin
following the partial lifting of the Penal Laws. While in Trinity he became good
friends with Robert Emmet (**B16**) and came to share his revolutionary ideals, until
his mother packed him off to London to study Law. Lord Moira became his ben-
efactor and he began to mix in high circles, which included the Prince of Wales.

In 1806 Moore took extreme exception to a review of his poetry in the
Edinburgh Review and challenged the author, Francis Jeffrey, to a duel. As the
combatants were lining up for their action, the police swooped and arrested both
men. It was rumoured that neither pistol was loaded and Moore was persistently
mocked for this, with Lord Byron commenting on Moore's 'leadless pistol'. Moore
wrote to him asking that he withdraw the comments or he would fight him. By
the time the challenge arrived Byron had departed for Italy. They did meet a few
years later, the disagreement was settled and they became good friends. Byron
gave Moore his papers and agreed that Moore should write his memoirs after
his death. However, Byron's family asked Moore to destroy the papers for fear of
scandal from their contents, a request with which he complied and a decision for
which he was criticised.

Moore was married to actress Elizabeth (Bessy) Dyke
and they had five children, all of whom pre-deceased him.
The death of his last child in 1847 and a stroke damaged
his health severely and he spent the last few years of his
life away from the public gaze being looked after by Bessy.
He is buried in St Nicholas' Church, in Bronham, Wiltshire.

This statue of Moore with quill in hand shares the
traffic island with a public toilet (now closed). Ironically,
one of his compositions was 'The Meeting of the Waters',
as observed by Leopold Bloom in Chapter 8 of James
Joyce's *Ulysses*.

B48 AGRICULTURE, COMMERCE AND TRADE, College St *(Samuel F. Lynn, 1868)*
This work is located on the tympanum of the old Provincial Bank, now part of
the Westin Hotel. The pediment has a sculpture with a huge amount of detail.
The central element is the allegorical figure of Commerce taking account of the

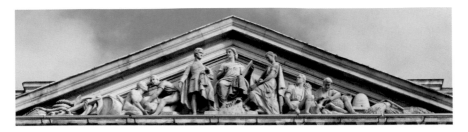

activity taking place on either side. To the right can be seen a figure representing Agriculture and beside this are some scenes of farm activity, such as the saving of corn and the slaughter of a sheep. A beehive can be seen on the extreme right, a symbol of industry. On the left is Trade, symbolised by a merchant with two men lifting sacks of merchandise and on the extreme left an anchor and rope.

B49 STYNE STONE, Pearse St *(Clíodna Cussen, 1986)*
The original Styne Stone was placed in this area by the Vikings in 837 and stood there for nearly 900 years before disappearing in the 1700s. Called after the river that flows in a culvert under the street, the original large stone was used as a marker by the Vikings for navigating their way up the River Liffey. Cussen sculpted this granite stone to represent a smaller version of the missing original.

B50 MR SCREEN, Hawkins St *(Vincent Browne, 1988)*

This piece shows a caricature of a powerful figure in his day – the cinema usher. Browne has sculpted him in all his glory with his braided uniform and, most importantly for showing latecomers to their seats, his torch.

The sculpture is located outside the Screen Cinema, which used to be called the Metropole. Browne jokes that commuters getting off the bus here use his nose as a receptacle for used bus tickets.

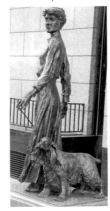

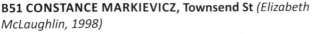

B51 CONSTANCE MARKIEVICZ, Townsend St *(Elizabeth McLaughlin, 1998)*
This playful piece shows famous Irish republican Countess Markievicz walking her dog, Poppet. For more detail on Countess Markievicz, see **B11**.

B52 CONSTABLE SHEAHAN MEMORIAL, Burgh Quay
(W.P. O'Neill, 1906)

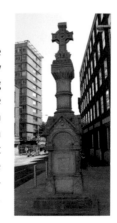

Constable Patrick Sheahan of the Dublin Metropolitan Police gave his life to save others in a sewer gas tragedy on 6 May 1905. He was on duty when a worker called John Fleming was overcome by gas fumes while attempting to investigate a broken pipe in the sewer. Alerted to the problem, Sheahan took off his tunic and descended twice into the sewer in an attempt to rescue Fleming. Sheahan was not to know that Fleming was already dead and he finally succumbed to the fumes himself. This memorial was funded by public subscription. Sheahan is buried in his home town of Glin in Co. Limerick.

B53 THE PEOPLE'S ISLAND,* D'Olier St *(Rachel Joynt, 1988)*

The traffic island between D'Olier Street and Westmoreland Street is a busy pedestrian thoroughfare with thousands of people crossing it every day. But as can be seen from the bronze and aluminium imprints of feet, claws and paws in the concrete, it's not just humans who use the location but animals also. This piece was inserted as part of the Dublin Millennium Sculpture Symposium in 1988.

**Please note that at the time of writing this work is being revised.*

B54 PHIL LYNOTT (1949–1986), Harry St *(Paul Daly, 2005)*

Phil Lynott was born in West Bromwich, England to an Irish mother and a Guyanese father. At the age of four he moved to Ireland to be raised by his grandparents in Crumlin in the southern suburbs of Dublin. He was a member of the rock group Skid Row with Brush Shiels, who taught him to play bass guitar.

When Thin Lizzy was formed in 1969, he became their lead singer and bass guitarist, while also writing many of the group's songs. Their first major hit was 'Whiskey in the Jar', an old Irish ballad jazzed up with an electric guitar. Other hits followed such as 'The Boys Are Back in Town', 'Jailbreak' and 'Sarah', written after the birth of his eldest daughter.

Lynott developed a drug abuse problem and this affected performances, leading him to leave Thin Lizzy for a solo career in 1980. He did have some success with 'Dear Miss Lonely Hearts', 'King's Call'

and 'Old Town', but his drug habit worsened and he collapsed on Christmas Day 1985, dying of septicaemia just over a week later.

The statue shows him with his Afro hairstyle and bass guitar outside the popular music pub Bruxelles, which was much frequented by Thin Lizzy in the 1970s and 80s. You can often see guitar picks between the strings – donations from admiring fans.

B26 Peace Comes Dropping Slow

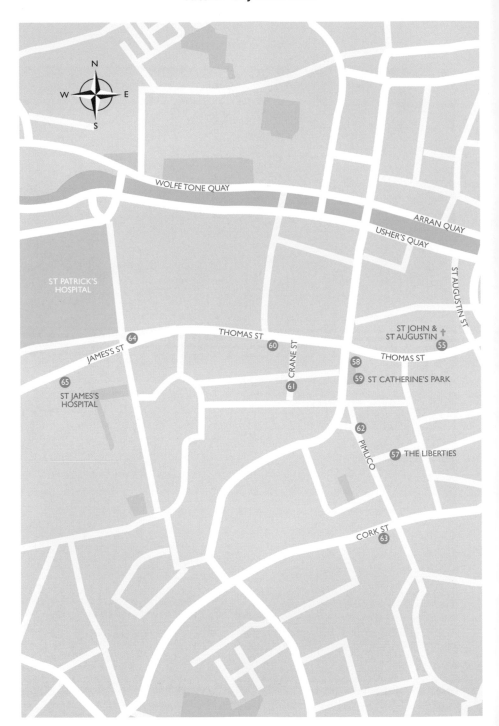

CHURCH ST

MARY'S LANE

CAPEL ST

JERVIS ST

ABBEY ST MDL

ABBEY ST UPR

LIFFEY ST LR

FOUR COURTS

ASTON QUAY

WESTMORELAND ST

14

INNS QUAY

ORMOND QUAY LR

WELLINGTON QUAY

FLEET ST

MERCHANT'S QUAY

WOOD QUAY

ESSEX QUAY

22

Temple Bar

16

CROWN ALLEY

17

ANGLESEA ST

BANK OF IRELAND

10
9
8

30 29

25

24

23

MEETING HOUSE SQ

21

20 19

18

11

5 6 7

3

ESSEX ST W

13

COLLEGE GREEN

4

12

31

DAME ST

WINETAVERN ST

FISHAMBLE ST

1

SUFFOLK ST

ST AUDOEN

52 53 54

26

HIGH ST

32 34 33

41

DUBLIN CASTLE

40

43 42

56

NICHOLAS ST

39

37

35 36 38

FRANCIS ST

LITTLE SHIP ST

GT SHIP ST

BRIDE ST

44

STEPHEN ST LR

2

HARRY ST

GRAFTON ST

GOLDEN LN

45

ST PATRICK'S PARK

46

47

27

28

AUNGIER ST

YORK ST

ROYAL COLLEGE OF SURGEONS

48

49 ST PATRICK'S

ST STEPHEN'S GREEN

KEVIN ST

50

CLANBRASSIL ST

51

3

CITY SOUTH WEST

Dublin owes its name to this part of the city as it includes Viking Dublin. College Green, Dublin Castle and Temple Bar are also included in this section. Here, everything from religious to neo-classical, and from tributary to contemporary sculptures, is waiting to be discovered.

C1 MOLLY MALONE, Suffolk St
(Jeanne Rynhart, 1988)

This is possibly the most photographed statue in Dublin. The statue is based on the song of the same name about a street trader who died of a fever at a young age. Street trading is an old tradition that was handed down from Viking times. Molly Malone sold fish during the day and, according to legend, sold herself during the night. The earliest record of the

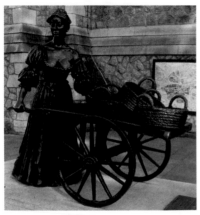

song dates back to Cambridge, Massachusetts, where it was discovered during the 1880s. However, it is thought to have been originally composed by James Yorkston in Edinburgh. Local wags have various names for the statue, including 'The Tart with the Cart', 'The Dish with the Fish' and 'The Trollop with the Scallop'.

The statue was located at the end of Grafton Street but was moved to its current temporary location due to work on the new Luas (tram) line. When completed in 2017 the statue will be relocated

to Grafton Street. Note the detail of the products Molly has for sale in her cart – fish, cockles and mussels.

C2 SCALP, Stephen St Lower
(Frederick Remington, 1900)
This bronze sculpture of an Indian brave on his horse is located in the courtyard of the Grafton Capitol Hotel. The statue is a copy of an original by Remington created by Roman Bronze Works in New York, which was used exclusively by him from 1898. Remington was a journalist during the Indian wars in the US in the 1880s, so he knew his subjects well. He took to painting scenes from the Wild West, which became popular and were published by *Harper's Weekly* at the time.

C3 HENRY GRATTAN (1746–1820), College Green
(John Henry Foley, 1876)
College Green is the perfect place for a statue of the great orator Henry Grattan, facing Trinity College, where he was educated, and to his left the old Irish Parliament building, now home to the Bank of Ireland. For more information on Henry Grattan see **A7**.

C4 THOMAS DAVIS (1814–1845), College Green
(Edward Delaney, 1966)
Thomas Davis was born of an Irish mother and Welsh father in Mallow, Co. Cork. He attended Trinity College, graduated with an Arts degree and was called to the Bar in 1838. He became involved with Charles Gavin Duffy and John Blake Dillon in the founding of *The Nation*, a newspaper that went on to become the most widely read Irish newspaper of its day.

Davis wrote extensively of his vision for an independent Ireland embracing Catholic, Protestant (i.e. Church of Ireland) and Dissenter (i.e. other Protestant denominations, most notably Presbyterianism), with its own language, cities and countryside of which to be proud. Although a Protestant, he always advocated fairness and friendship between all religions. *The Nation* supported Daniel O'Connell (**D23**) in his campaign for the repeal of the Act of Union (passed in 1800, uniting the Irish Parliament with that of the United Kingdom). The paper became the voice of the Young Ireland movement, a group of middle-class Protestants,

including William Smith O'Brien (**D24**), pressurising for an independent Ireland. Davis became the leader of this group. His writings include well-known ballads such as 'The West's Awake' and 'A Nation Once Again'. He died of TB at the age of 30.

This location was originally the site of an equestrian statue of King William III, who defeated King James II at the Battle of the Boyne in 1690; however his head was stolen 1929 and the statue was subsequently replaced with an air-raid shelter during the Second World War. This statue and fountains are of leaden bronze. The group is in the same style as The Famine, another group created by Edward Delaney (**B3**). It features four trumpet-blowing heralds representing the Four Provinces of Ireland. Scenes from the Famine and from the poetry of Davis – 'The Penal Days', 'Tone's Grave', 'The Burial', 'We Must Not Fail', 'The West's Awake' and 'A Nation Once Again' – are shown on the shields. The fountain is overlooked by a representation of Davis himself. Davis is still remembered today with the Thomas Davis Lectures, an annual series of radio lectures by distinguished contributors which was first aired in 1953.

THE BANK OF IRELAND

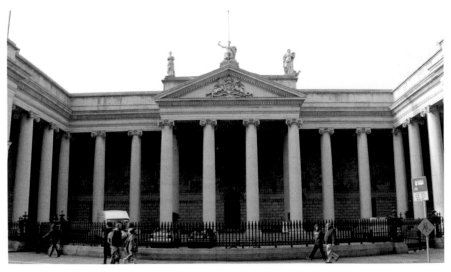

This magnificent building, designed by Sir Edward Lovett Pearse, was originally built for the Irish Parliament in 1728, the first designated parliament building in the world. The east portico was designed by James Gandon in 1785 while the west portico was designed by Robert Parke in 1787. The Irish Parliament remained here until 1800 when the Act of Union was passed, merging it with the British Parliament in Westminster. The building was taken over by the Bank of Ireland under David LaTouche in 1803 and has remained a bank ever since. The three allegorical limestone statues on the south parapet were added by the bank after it took over the building.

C5 FIDELITY (left), Bank of Ireland, College Green
(Edward & John Smyth, 1809)

Note that the statues on the south side are larger than those on the east in order to add gravitas. The statue on the right of the pediment is Fidelity, who is always represented as a woman, often symbolising Penelope, the wife of Odysseus, who remained faithful during his twenty-year odyssey. Sometimes allegorical statues of Fidelity have a dog or a sprig of myrtle symbolising the virtue, but neither are present on this work. However note that there is damage to the right hand of the statue; perhaps the missing fingers once held a sprig of myrtle.

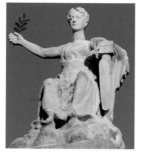

C6 HIBERNIA (centre), Bank of Ireland, College Green *(Edward & John Smyth, 1809)*

Hibernia is the name given to Ireland by the Romans. The word derives perhaps from 'hiberno', the Latin for winter. It seems the Romans were not impressed with the weather here. The allegorical figure of Hibernia is nearly always shown with a harp, one of the national symbols of Ireland, and is usually seated.

C7 COMMERCE (right), Bank of Ireland, College Green
(Edward & John Smyth, 1809)

Clearly the bank wished to project an environment that promoted business and so symbolises this with the allegorical statue of Commerce. A rudder with a relief of a trident and a caduceus can be seen on his left and the bow of a ship can be seen on his right, symbols of overseas trading.

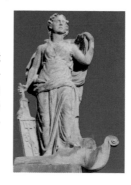

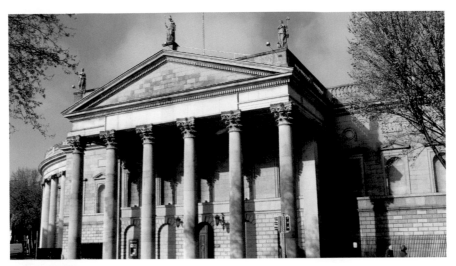

C8 JUSTICE (left), Bank of Ireland, Westmoreland St
(Edward Smyth, 1785)
Justice is seen on the left of the east entrance of the House of Lords. She is carrying two of the symbols of justice – a sword, symbolising the power and rigour of the court, and a scales, signifying the weighing of evidence.

C9 ATHENA (centre), Bank of Ireland, Westmoreland St *(Edward Smyth, 1785)*
The helmeted Athena with her Medusa shield is standing in the centre over the east entrance, protecting justice and liberty. Sitting on her shield are two birds: an owl for wisdom and a dove for truth. Also note that she is holding the serpent Erichthonius in her left hand, a present from the goddess Gaia.

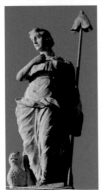

C10 LIBERTY (right), Bank of Ireland, Westmoreland St *(Edward Smyth, 1785)*
Liberty is seen on the right of the pediment holding a staff with a Phrygian or liberty cap resting on top, signifying freedom for the people. The capped staff had revolutionary associations and when the bank took over the building in the early 1800s it was removed, but was replaced during restoration work in

1946. Also note that by Liberty's right foot there is a cat, which is an ancient German symbol of freedom.

C11 TRIUMPHAL ARCH, Foster Place *(Thomas Kirk, 1811)*

This sculpture is located over what was originally the armoury/guard house for the bank but today houses the National Wax Museum Plus. The sculpture is a trophy of arms featuring cannon, cannon balls, ramrods, flags, drums, armour and a helmet, all skilfully carved in Port-

land stone. The building was designed by Francis Johnson, who made many modifications to the building in 1811 after the bank moved in, including blocking the windows overlooking College Green.

C12 ÉIRE GO BRÁGH, College Green *(James Pearse & Edmund Sharp, 1889)*

The former National Bank, founded by Daniel O'Connell, is directly opposite the portico of the unionist Bank of Ireland. The positioning was symbolic as it was the bank for the common, mostly Roman Catholic, people rather than of the richer Protestant people. The Portland stone

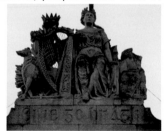

group at the top of the building shows Hibernia with a harp, a wolfhound and symbols of prosperity, which emphasise its Irishness. The shamrock and the slogan 'Éire go Brágh' (Ireland forever) also feature on the sculpture. The sculptors were James Pearse, father of 1916 Rebellion leader Pádraig Pearse, and his foreman Edmund Sharp.

C13 CRANN AN ÓR, Central Bank, Dame Street *(Eamonn O'Doherty, 1991)*

This sculpture was the winner of a competition held in 1991 to celebrate Dublin being European City of Culture. The tree of gilded bronze under the section of a building in Wicklow granite symbolises growth under prudent management. The open style of the granite symbolises that wealth is available to be shared with the people of the country, and not to be locked up in vaults.

TEMPLE BAR

This area of the city is called after Sir William Temple, who owned a house and garden in the locality during the seventeenth century. The 'bar' has nothing to do with a pub, but refers to a sand bar in the River Liffey, which was wider and shallower at the time. When a quay wall was built in the 1760s this enabled the reclamation of land for development of the area. The area went into decline during the 1950s. In the 1980s, CIE, the national transport company, started to buy up land with a view to building a transport hub in the area. The plan ran into difficulties and the company leased out properties at cheap prices, attracting artisans to the area. An opportunity to develop a cultural quarter was spotted and the government passed legislation for the protection of the area and introduced tax incentives to attract businesses. Today Temple Bar is a vibrant and energetic district full of pubs, restaurants and galleries, much loved by visitors to the city. It's maybe not quite as 'cultural' as originally envisaged – but there is some contemporary sculpture to be discovered.

C14 IRISH WRITERS' PLAQUES, Fleet St *(Jarlath Daly, 2011)*

Located on the pavement just outside the Palace Bar are four bronze plaques of famous Irish writers who lived in Dublin, along with a quote of a sample of their work: Patrick Kavanagh, Brendan Behan, Flann O'Brien and Con Houlihan. **Kavanagh (A27)** and **Behan (E1)** are covered elsewhere in this book but the other two were equally colourful characters.

Flann O'Brien (1911–1966), whose real name was Brian O'Nolan, worked in the civil service and was a regular drinker in the Palace Bar. He met the editor of the *Irish Times*, R.M. Smyllie, another regular, who offered him a job writing the satirical column 'Cruiskeen Lawn', which he wrote under the pen name Myles na gCopaleen. The column became very celebrated and O'Nolan went on to write a number of satirical novels under the pen name Flann O'Brien, including *At Swim-Two-Birds* (1939), *The Hard Life* (1962) and *The Third Policeman* (1968).

Con Houlihan (1925–2012) was born in Kerry (aka 'The Kingdom') and was a sports columnist with the *Evening Press* for many years. He was shy man but was well loved and a very astute journalist. His writing, covering everything from

Gaelic football to horse-racing, won him many fans and on his death he was acclaimed a 'giant of journalism and commentary'.

C15 GOGARTY AND JOYCE, Anglesea St *(Hugh Hanratty, unknown)*
This is a sculpture in bronze of two Dublin writers and friends, Oliver St John Gogarty (1878–1957) and **James Joyce** (see **B8** for details of Joyce's life). **Gogarty** was an athlete, rebel, senator, playwright, poet and surgeon. He was born into a wealthy family and attended Clongowes Wood College and Trinity College Dublin. He was a friend of W.B. Yeats (**B15**) and James Joyce. He rented the Martello tower in Sandycove in 1904 in order to provide a place for Joyce to write. However, after only six days in the tower Joyce awoke one night to find Gogarty standing over him with a handgun. He left early the next day and subsequently fictionalised his stay in the tower with Gogarty, in the character of Buck Mulligan, in the opening chapter of *Ulysses*.

Gogarty was a founding member of Sinn Féin and went on to become a senator in the Irish Senate after Ireland won its independence. During this time he was kidnapped by opponents and, with his life under threat, managed to escape by swimming across the Liffey. While visiting the US on a lecture tour in 1939, he was delayed there due to the outbreak of the Second World War and decided to remain and become a US citizen. He suffered a heart attack and died in the New York in 1957 and his body was flown home for burial in Co. Galway.

C16 PALM TREE SEAT AND STOOLS, Temple Bar
(Vincent Browne, 1992)
Perhaps this piece could be called an oasis in the middle of the hustle and bustle of Temple Bar. It provides an opportunity to take a rest and listen to some of the buskers who perform close to this bronze sculpture. It is accompanied by another couple of seats in the form of fruit in the nearby Temple Bar Square.

C17 PAVEMENT ART, Crown Alley *(Rachel Joynt, 1989)*
In the centre of Temple Bar are fifteen pieces of work embedded into the pavement. They include various designs sandblasted into the granite kerbstones on-site by the artist. Each design represents a business which was located nearby at the time; however some of these businesses are no longer here. The work includes a set of hoof prints leading to the Bad Ass Cafe; a fishing

rod outside Rory's Fishing Tackle shop; a foot outside Leo Burdock's, which used to be a shoe shop; a bracelet outside No. 5, which used to be a bead shop; and an elephant outside No. 15, which used to be Rudyard's restaurant.

C18 HISTORIC SEAT, Fownes St *(Betty Newman Maguire, 1992)*
This is a simple bronze seat for the convenience of weary passersby with the bonus of providing a little history of the area. Temple Bar was due to become the central bus depot for the city but the government decided to create a cultural quarter and in 1991 the regeneration of the area began. Today it is a very popular day and night spot for locals, but particularly for tourists who visit the numerous music pubs.

C19 THE GREEN MACHINE, Crow St
(Remco de Fouw, 1994)
One of the doors on the Green Building is an impressive self-watering tree. The tree made from recycled copper pipes and sources its water from a recycled sink. The work is placed on a copper background with machinery icons, creating the sense of a mechanical yet organically operated system.

C20 ABSOLUTE JELLIES MAKE SINGING SOUNDS, Temple Lane
(Maud Cotter, 1994)
This work is located on the Green Building over the door of number 23/24 Temple Lane. Cotter describes this work as 'a vertical wall of beached objects or collectable pieces of scrap layered behind glass, like pickles in a jar. An exercise in

aesthetic recycling, finding a new meaning and use for the discarded, a place for the particular in a wave of change.' Perfect!

C21 UNTITLED, Meeting House Square
(Felim Egan & Killian Schurmann, 1996)
This lead piece with inserted glass and steel is located over the archway on the east side of Meeting House Square. It's an abstract piece that brings our attention upwards to the source of light in the square. Egan lives beside the sea in Sandymount and the wide spaces of the beach at low tide often influence his work. The glass work on the sculpture is by Killian Schurmann.

VIKING DUBLIN

After St Patrick converted the people of Ireland to Christianity in the mid-fifth century many monasteries were founded throughout the country. These monasteries became places of great wealth and learning, but also a target for the Vikings, whose magnificent longships were, in effect, the space shuttles of their day.

The first recorded raid on an Irish monastery was in 795, when the monastery on Lambay Island off the coast of Dublin was attacked. The raiders stole valuables and took the occupants of the monasteries away as slaves or for ransom. The Vikings raided the monasteries for many years before coming to settle in Ireland, founding Dublin in 841, along with Wexford, Waterford, Cork and Limerick. They came to Dublin in 60 longships with up to 3,000 settlers and built a harbour for their boats and a stockade to defend against Irish raiders. They were driven out of Ireland in 902 but returned in 917. They remained strong here until the Battle of Clontarf in 1014 when they were defeated by Brian Boru, the High King of Ireland, resulting in a loss of power for these invaders.

The Viking settlement of Dublin was centred around Wood Quay and during building works in the 1980s the largest Viking archaeological site outside of Scandinavia was discovered and excavated, uncovering thousands of artefacts.

C22 SUNLIGHT CHAMBERS, Essex Quay *(Conrad Dressler, 1901)*
This building was the head office for Lever Brothers, built in 1901 and called Sunlight Chambers after its main brand, Sunlight, a type of laundry soap. The building was restored in 1999.

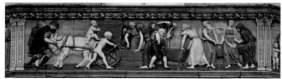

The top band of glazed terracotta tiles between the upper floors of this building tell the story of men working at various chores such as sowing, harvesting, carrying coal, building, ploughing and fishing, and getting their clothes dirty. The bottom band tells the story of women washing, drying and storing the clothes. The work is in the style of the Florentine sculptor Luca della Robbia.

C23 CLOUD STAR BOAT MAP, Essex St West *(Grace Weir, 1996)*

The wall of a building that used to house a Viking interpretative centre until it ran into financial difficulties is the perfect location for this concrete and bronze mural.

As the name suggests, it captures many concepts. It looks like a map or a sea chart and the squares seem like a grid. On closer examination, including the names of stars, galaxies and constellations suggests that it may be a chart of the stars by which the Vikings navigated during their voyages. There are also a number of references to important dates in the Viking history of Dublin, such as 841, the year they arrived to found Dublin, and 988, the year the Irish regained control of Dublin from the Vikings. The work continues around the corner of the building to the right but this area was closed to the public at the time of writing.

C24 VIKING LONGSHIP (BÁITE), Wood Quay *(Betty Newman Maguire, 1988)*

The Vikings perfected the art of shipbuilding and sailing during the seventh and eighth centuries. With shallow clinker-built ships, powered by sails and oars, they could travel the known and unknown world and have access far inland by navigating rivers. These developments allowed them to come to Ireland in 795 and attack many monasteries before finally coming to settle and found the trading town of Dublin in 841. Their longships were the most advanced modes of transport of the day and one is represented

here as a semi-sunken vessel. The title of the sculpture is 'Báite', an Irish word for 'sodden' or 'drowned'.

C25 WOOD QUAY, Wood Quay *(Michael Warren, 1994)*

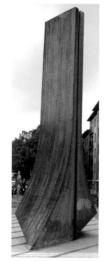

This sculpture, representing the prow of a Viking longship, is located right beside the site of the first Viking settlement in Dublin. The sculpture today heightens the sense of place for this momentous arrival, which occurred in the year 841. Warren works to counter gravity with a grand structure of Portuguese limestone steel and cedar towering into the sky to match the grand facade of the offices of Dublin City Council, who commissioned the work.

C26 WOOD QUAY WALK, Wood Quay *(Rachel Joynt, 1992)*

The site of the first Viking settlement in Dublin is today the location of the Dublin City Council offices. Before the offices were built there was a major archaeological dig on the site and thousands of artefacts were found. Architects were able to discern the outline of 200 Viking houses during the dig. Wood Quay turned out to be the largest Viking archaeological site outside of Scandinavia.

To commemorate this find, Dublin Corporation (as the city council used to be known) commissioned a series of eighteen slabs of black granite, bronze and stainless steel with reliefs of artefacts that were uncovered during the archaeological dig. These can be seen on the streets surrounding the civic offices.

C27 OUR LADY, Whitefriar St Church, Aungier St
(Unknown, 1914)

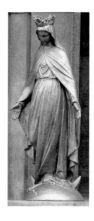

The Carmelite church known as Whitefriar Street Church was built in 1825. It has a statue located on either side of the main entrance – Our Lady on the right and St John on the left. Our Lady is crowned as the Queen of Heaven and she is standing on a snake with an apple in its mouth, indicating that she was born without original sin.

C28 ST JOHN, Whitefriar St Church, Aungier St
(Unknown, 1914)
To the right of the entrance to Whitefriar Street Church is a statue of St John. John was the brother of James and the youngest of the disciples. He was also one of the four evangelists who wrote the gospels of the New Testament. It is thought that John may have written the Book of Revelation.

C29 OUR LADY, Church of the Immaculate Conception, Merchant's Quay *(Gabriel Hayes, 1955)*

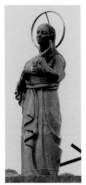

The Franciscans first came to Ireland in 1216 and have had a presence in this area since 1615. The Church of the Immaculate Conception, also known as Adam and Eve's, was build in 1834 and has been modernised and extended numerous times since.

This bronze statue is located at the top of the friary building overlooking the river and city. It was commissioned by CIE Sodality, a prayer group made up of employees of the national transport organisation, which is associated with the friary. Her golden halo is above her head and her left hand is raised in blessing, which is unusual for a statue of Our Lady.

C30 FRANCIS OF ASSISI (1182–1226), Church of the Immaculate Conception, Merchant's Quay *(Seamus Murphy, unknown)*
This statue is located over the entrance to the Franciscan friary containing the Church of the Immaculate Conception. The church is also known as Adam and Eve's due to the fact that before the passing of the Catholic Relief Act granting religious freedom in 1829, Mass was celebrated covertly by the Franciscans in an alehouse called Adam and Eve's.

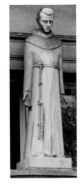

St Francis of Assisi was born into a rich Italian family and lived the high life, even joining the Assisi army and fighting in a war. However, in 1205 he had a vision and changed his ways, committing himself to a life of poverty spent preaching the gospel. Francis was never ordained but his good living attracted followers and he formed the Order of Friars Minor, who became known as the Franciscans, and an order of nuns known as the Poor Clares. He is known for his love of animals and nature, and is said to have had stigmata – the wounds of Christ. The three knots in the cord hanging from his waist signify the vows of poverty, chastity and obedience.

C31 ST ANTHONY OF PADUA, Winetavern St *(Unknown)*
St Anthony was born Fernando Martins de Bulhões in Lisbon, Portugal. He entered the Augustinian order in 1212 but joined the Franciscans shortly afterwards, taking the name Anthony after Anthony the Great of Egypt. He moved to Tuscany where his preaching skills and knowledge of the Bible impressed his superiors. He then moved to Bologna where he met St Francis of Assisi, who was equally impressed. He was appointed as provincial superior of the Franciscan order of Northern Italy and set himself up at Padua. He died in 1231 and was canonised in 1232 due to a number of miraculous events that were associated with him. He is the patron saint of lost items. The national shrine to honour Saint Anthony was built in the church in the Franciscan friary behind this present building in 1912.

DUBLIN CASTLE

Dublin Castle is built close to the pool where the Vikings used to keep their long-ships. This pool had dark water and was known in Irish as 'Dubh Linn' or Black Pool. The Irish name eventually became anglicised to 'Dublin'.

The original castle was built by King John of England in 1204 but little of it remains. Most of the buildings in the castle today were built during the eighteenth and nineteenth centuries. The castle was however the seat and symbol of British power in Ireland until independence was gained in 1921.

Today the buildings house various state offices, the Chester Beatty Library and the State Apartments, which are open to the public. The public space has a number of works which can be viewed during your visit.

C32 INCOMMUNICADO, The Moat, Dublin Castle
(Eileen McDonagh, 1989)
This two-piece black granite structure, polished on three sides, was inspired by a piece of Viking jewellery. It unites the courtyard space with the bridge overhead. The original plan was for the granite to be reflected in the surrounding pond but this changed when the fountains were added. This work can be seen through the Dublin Castle railings on Castle Street.

C33 JUSTICE, Upper Yard, Dublin Castle
(John Van Nost the Younger, 1750)
The statue of Iusticia, the Roman goddess of justice, is located on a broken pediment over the entrance gate from Cork Hill to the castle. She is holding the

symbols of justice – the sword indicating the power of the courts and the scales to weigh up the evidence. She is cast in lead, which is a cheaper material than either bronze or marble but can be painted to look like stone. Indeed, when the statue was restored in 1986 it was discovered that the statue had 30 layers of paint and it split in two when it was being removed.

Note that two holes had to be drilled in the pans of the scales, as due to an arm covering one of the pans, more rain ended up in the other, causing the scales to tip to one side. The statue faces the castle yard rather than the city of Dublin. This provoked the rhyme by one Dublin wag: 'There she sits upon her station, her face to the castle and her arse to the nation.'

C34 FORTITUDE, Upper Yard, Dublin Castle
(John Van Nost the Younger, 1750)
The second and less important gate, from Castle Street, has the statue of Fortitude, the symbol of strength. He is seen here in classical style with his galea (Roman soldier's helmet) sporting a fine set of feathers. He wears a cloak and a suit of Roman armour with fine detail included by the artist. Note that the artist even includes the outline of veins on the arms and legs. His right hand holds a spear, a symbol of power, while the lion, a symbol of courage, stands beside him.

C35 VANE AS A PEACOCK, Chester Beatty Library, Dublin Castle *(Rachel Joynt, 1995)*
At the top of the Coach Tower Building, which today houses the magnificent Chester Beatty collection of Eastern art, is a weather vane in the shape of a peacock. The work in iron, copper and glass reflects the fact that peacocks often feature in Oriental art. The peacock theme is echoed in a water feature located to the right of the entrance in the atrium of the building.

C36 SPECIAL OLYMPICS, Dubh Linn Garden, Dublin Castle *(John Behan, 2003)*
The Special Olympics were held in Dublin on 21–29 June 2003, the first time it was held outside the US. It was a magnificent event with thousands of local people involved as volunteers throughout the country. There were 7,000 competitors who came from 150 countries, accommodated in 177 host towns.

This sculpture captures the stylised figures of the 2003 Special Olympics logo carrying the Olympic flame. The figures and the fountain are surrounded by 137 brass panels displaying the names of the 30,000 participants and volunteers. It's a great tribute to a magnificent event made possible by enthusiastic volunteers.

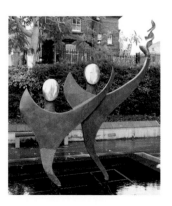

C37 VERONICA GUERIN, Dubh Linn Garden, Dublin Castle *(John Coll, 2001)*

Veronica Guerin was a Dublin-born journalist who cut her teeth at the *Sunday Business Post* and *Sunday Tribune*, investigating corporate fraud and sex scandals in the Catholic Church. In 1994 she joined the *Sunday Independent* as a crime correspondent and began to focus on the drug trade and gangland leaders. She used nicknames for leading criminal figures, such as 'The Penguin', 'The Boxer' and 'The General', in order to avoid libel action. She often door-stepped these men in order to obtain interviews and allowed them to tell their side of the story. However, her articles provoked a strong reaction. She received death threats, shots were fired into her home and she was shot in the thigh. The *Sunday Independent* installed security systems in her home while the Gardaí provided 24-hour protection. However, this hindered her work and she had the protection removed. While interviewing John Gilligan, an ex con, he beat her up and threatened to kill her if he wrote about him. She went on to write an article using real names and faces, exposing these people to the public.

On 26 June 1996, while stopped at traffic lights, she was shot and killed by a pillion passenger on a motorbike. Her funeral was a national event and citizens observed a minute's silence in her memory. Her murder was considered an attack on democracy and it prompted the government to form the Criminal Assets

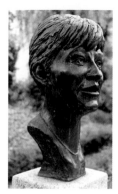

Bureau to confiscate the benefits of crime. Some members of the gang turned State's evidence and ultimately John Gilligan, Patrick Holland and Brian Meehan were tried for the murder. Meehan and Holland were found guilty and sentenced to life in prison. Holland successfully appealed his conviction. Gilligan was not convicted for the murder of Guerin but was subsequently found guilty of importing 20 tons of cannabis and sentenced to 28 years in prison, reduced to 20 years on appeal.

Guerin is remembered as a courageous journalist who used a very risky strategy to get stories. Her courage resulted

in a focus on the issue of gangland crime, and a subsequent Garda clampdown on the activities of the drug barons.

C38 SERPENT WATER FEATURE, Dubh Linn Garden, Dublin Castle
(Killian Shurmann, 1994)

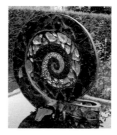

The garden in Dublin Castle was derelict until 1996, when Ireland held the Presidency of the EU. At this time, the Castle was used for many meetings of the heads of state. This formerly empty space was renovated into the garden we see today. Brick paths form interlaced serpents, representing eels from the black pool ('Dubh Linn', from which Dublin derives its name) of the River Poddle, which forms here; these bricks also mark out a helicopter landing zone.

The original pool contained eels, which were caught for food in medieval times and Schurmann represents these eels in his work by fusing molten glass with colour pigments. We can see two eels intertwined over the water, echoing how the area looked in ancient times.

C39 GARDA MEMORIAL GARDEN, Dubh Linn Garden, Dublin Castle
(Jason Ellis & Killian Schurmann, 2010)

The Garda Síochána ('guardians of the peace') is the police force of the Republic of Ireland. Since its formation in 1922, 86 of its members have been killed in the line of duty and they are remembered here. The location is appropriate as there has been a long association between the Gardaí and Dublin Castle. The garden was designed by the Office of Public Works and includes the work of two sculptors.

Killian Schurmann created the glass tree trunk with its rings showing to represent life cut down in its prime. The circular theme of the rings is also reflected in the curved nature of the garden and the ripples on the water in the fountain. He also created the light shard in the granite slab beside the fountain: a glass insert in hard stone to represent the fragility of life.

Jason Ellis created 'Black Pool, White Water', a limestone and marble circle in two halves in the Taoist symbol of yin and yang. Ellis focuses on the families of those killed, with the black limestone representing the grief of the families and the white marble representing hope and the concept of overcoming death. Throughout the garden are displayed limestone panels with the names of those killed.

C40 CHAPEL ROYAL HEADS, Chapel Royal, Dublin Castle
(Edward & John Smyth, 1807)

The Chapel Royal, designed by Francis Johnston, was built in 1807 with a budget of £9,553 but an actual cost of £42,350. It is a beautiful little building, the construction of which created many difficulties, not least of which was the fact that the River Poddle runs underneath it. The carving both inside and outside the building is copious and must have added significantly to the cost.

There are 100 carved heads inside and outside the building. Those outside can be seen on the pinnacles and at the end of the hood moulds over each of the windows. These are thought to be saints and martyrs. There are four that are easily recognisable: On the hood mould of the east door are Brian Boru (left) and St Patrick (right, **D4**), and on the apex of the north door is St Peter (**D2**) holding a key and above him Jonathan Swift (**C44**).

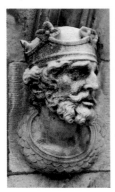 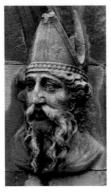 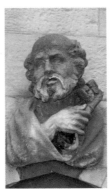 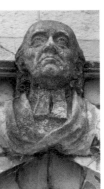

Brian Boru **St Patrick** **St Peter** **Jonathan Swift**

C41 UNBROKEN LINE, Lower Castle Yard, Dublin Castle
(Michael Warren, 2010)

Picasso once said that inspiration exists, but it must find us working. This philoso-

phy was true for Michael Warren when one evening, as he was finishing his work and closing his workshop, a ray of sunlight shone on a number of pieces of off-cut wood on his band saw. 'That's it', he thought, and he picked up the pieces and threw them in the air to see how they would land. He

did this about 200 times until he was happy with the placement of the pieces. That final layout is replicated here to the millimetre in white painted steel. Warren makes the pieces seem light and although large they blend in well with the landscape of the lower castle yard. The title comes from the writings of Konstantin Stanislavsky, the Russian actor and director, who asked his actors to keep in mind the past, present and future of the characters they were playing, to become a continuous being in one unbroken line of consciousness.

C42 THE TREE OF LIFE, Christ Church Place
(Colm Brennan & Leo Higgins, 1988)

The Tree of Life is located in the Peace Park on the corner of Patrick Street and Lord Edward Street. The idea for the park and the sculpture came from biblical quotations and from the works of W.B. Yeats and Patrick Kavanagh, two of Ireland's greatest poets. The quotation on the wall is from Proverbs 3:13, 17–18: 'Happy is the man who finds wisdom ... Her ways are of pleasantness, and all her paths are peace. She is a tree of life to those who lay hold of her.'

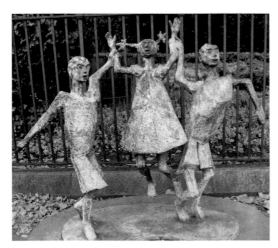

C43 MILLENNIUM CHILD, Christ Church Place
(John Behan, 2000)

This sculpture was commissioned by Barnardos Ireland, a children's charity founded by Dr Thomas Barnardo (1845–1905). He was born in nearby Dame Street and educated at St Patrick's Cathedral School, just around the corner. He studied medicine in London with a view to becoming a medical missionary in China, but abandoned this idea when he saw the conditions in which

homeless children in London were living. He founded Dr Barnardo's Homes in 1870 to look after these children and by the time he died he had established 96 homes, caring for 8,500 children.

Today there are Barnardos organisations in Great Britain, Ireland, Australia and New Zealand helping hundreds of thousands of children. The objective of the organisation here is 'To make Ireland the best place in the world to be a child.'

This sculpture seems to capture the organisation's objective perfectly, showing children playing and having fun at a corner which Thomas Barnardo would have passed hundreds of times on his way to school.

C44 GULLIVER'S TRAVELS, Bride St/Golden Lane
(Michael Charles Keane, 1985)
Jonathan Swift (1667–1745), the man who wrote *Gulliver's Travels*, was born at 7 Hoey's Court, just off Werburgh Street. He was educated at Trinity College Dublin and became dean of St Patrick's Cathedral in 1713. He was a champion of the poor, a critic of the government and one of the foremost prose satirists of the English language. Swift wrote *Gulliver's Travels* in 1726 and the book became an instant success. It is not a children's book, as many think, but a satire against the government of the day.

The scenes on the roundels are influenced by Arthur Rockman's pictures in the 1899 edition of the book. The scenes are produced on terracotta tiles fired at 1160 degrees Fahrenheit and can be seen over the entrances of the red-bricked housing on Bride Street and Golden Lane.

C45 JOHN FIELD (1782–1837), Bride St/Golden Lane
(Colm Brennan & Leo Higgins, 1988)
John Field was born in Dublin and started to learn music from his father at an early age. He made his first public appearance as a pianist at the age of nine. He worked in London as a piano demonstrator and salesman for Muzio Clementi, who subsequently took him on a tour of Europe with visits to Paris, Vienna and St Petersburg.

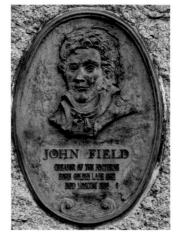

In 1803 he settled in St Petersburg and spent much of his time travelling around Europe giving concerts. He developed the nocturne (a musical composition inspired by, or evocative of, the night), which was ultimately perfected by Chopin in later years. He composed many works, including seven piano concertos and a quintet for piano.

C46 LITERARY PARADE, St Patrick's Park *(Colm Brennan & John Coll, 1988)*
The land where St Patrick's Park stands today was a slum until the new red-bricked Iveagh Buildings to the north of the park were built for the tenants by Lord Iveagh Guinness in the early 1900s – one of many instances of benevolence of the Guinness family.

The literary parade is located at the east end of St Patrick's Park and celebrates the city's literary heritage with portrait plaques of twelve well-known Irish writers, three of whom won the Nobel Prize in Literature: William Butler Yeats (1923), George Bernard Shaw (1925) and Samuel Beckett (1969). The other writers featured are: Austin Clarke, poet; Brendan Behan, author and playwright; James Joyce, author; Seán O'Casey, playwright; John Millington Synge, author and playwright; Oscar Wilde, author and playwright; James Clarence Mangan, poet;

Eilís Dillon, author; and Jonathan Swift, author and satirist. Many of these writers are also represented by statues and sculptures in other parts of the city.

Dublin was declared the fourth UNESCO City of Literature in 2010 and the city continues to live up to this honour with many literary events taking place in the city throughout the year.

C47 LIBERTY BELL, St Patrick's Park *(Vivienne Roche, 1988)*
This steel and bronze sculpture is located in the south-west corner of St Patrick's Park. The bell does not reference any of the bells of the cathedral but is modelled on St Patrick's Bell, which is a relic located in the National Museum, Kildare Street. The bell was thought to have belonged to St Patrick but its eighth- or ninth-century origin makes it too young to be so. The sculpture was commissioned as part of the Dublin Millennium Sculpture Symposium in 1988 to encourage young artists.

C48 SENTINEL, Patrick St *(Vivienne Roche, 1994)*

This sculpture, located just at the main entrance to St Patrick's Park, consists of three elements: two uprights of bronze and a ground element of cast iron. The sculpture took a number of years to complete as the road was being widened and changes in the plans were continuous. The uprights mark the passage towards St Patrick's Park where another sculpture by the same artist, Liberty Bell **(C47)**, is located.

The taller of the uprights represents a Viking needle which was found by archaeologists when the road was being widened. The second upright reflects the shape of the pillars at the entrance to St Patrick's Close, the location of the entrance to St Patrick's Cathedral.

C49 SIR BENJAMIN LEE GUINNESS (1798–1868), St Patrick's Close
(John Henry Foley, 1875)

Sir Benjamin Lee Guinness was born in Dublin, the third son of the second Arthur Guinness and Anne Lee. He was a businessman, politician and philanthropist. He joined the Guinness brewery as an apprentice at the age of 16 and was a partner by the age of 22, but did not take over the brewery until he was 42. During his tenure as head of the brewery he grew the sales five-fold due to the quality of the product, the development of the railways and his utilisation of export markets.

He was elected Lord Mayor of Dublin in 1851 and MP for Dublin in 1865, a position that he held until his death. He was created a baronet in 1867 for his philanthropic works. It was he who adopted the Brian Boru Harp as the Guinness trademark, which is still in use today. During the early 1860s he donated £160,000 for the restoration of St Patrick's Cathedral, and also money for the restoration of Marsh's Library and to the Coombe Hospital.

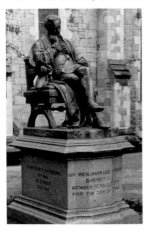

Sir Benjamin married his cousin Elizabeth Guinness and they had four children: Anne, who married Bishop William Plunkett **(B31)**; Arthur, who became Lord Ardilaun **(B17)**; Edward; and Benjamin. He was a shy man for whom religion played a major part in his life and prayers were recited twice daily in his home. He purchased many properties around the city and country, including St Anne's Estate in Clontarf, Iveagh House on St Stephen's Green and Ashford Castle in Co. Mayo.

By the time of his death he was the richest man in Ireland, leaving over £1m in his will. His philanthropy

is recognised in St Patrick's Cathedral with this statue, a boar from the Guinness family crest on many of the floor tiles in the cathedral, and the Guinness harp on the ceiling of the south entrance porch.

C50 MIRROR GRANITE, Kevin St
(Jim Buckley, 1984)

This sculpture in granite can be found on a traffic island on Kevin Street. Lying flat on the grass, its wavy form 'reflects' the distortion that one might sometimes find in a mirror.

C51 CLANBRASSIL STREET STONES, Clanbrassil St *(Eileen McDonagh, 1993)*
McDonagh considers granite to be the noblest and the toughest of stones; she points out that it is the oldest and newest stone, as volcanoes are creating new

granite every day. She likes to keep the integrity of the stone, giving it its own intelligence. This work of standing stones and integrated slabs is located at a bus stop at the north end of Clanbrassil Street. The carvings on the stones echo the Neolithic art found in such locations as Newgrange, Knowth and Dowth in Co. Meath.

ST AUDOEN'S CHURCH

The building of this Roman Catholic church commenced in 1841 and was finished in 1852. It is located on an elevated site which can be best appreciated from behind. The construction used 8,000 tons of calp stone and 48,000 bricks. The granite portico was added between 1898 and 1914. Today this church is home to the Polish chaplaincy in Ireland and it holds Mass in Polish every Sunday.

C52 OUR LADY (left), St Audoen's Church, High St
(Unknown, 1914)

This statue of Our Lady, the mother of Jesus, and a particular object of devotion among Irish Catholics, is located on the left of the pediment.

C53 THE SACRED HEART (centre), St Audoen's Church,
High St *(Unknown, 1914)*

The Sacred Heart depicts Jesus Christ's physical heart as the representation of his divine love for humanity. As in this statue, located in the centre of the pediment, the Sacred Heart is often depicted within Christ's bosom, with him pointing to his heart with his wounded hands.

C54 ST PATRICK (right), St Audoen's Church,
High St *(Unknown, 1914)*

St Patrick is the patron saint of Ireland, generally credited with bringing Christianity to this country in the fifth century. This statue of him is located on the right of the pediment. The story of St Patrick is discussed in more detail in entry **D4**.

C55 FACADE STATUES, Church of St John and St Augustine, Thomas St *(James Pearse & Earley and Powell Church Statues)*

The Church of St John and St Augustine was built on a site where Ailred the Dane founded his hospital for the poor, dedicated to St John the Baptist, in 1180. The Augustinians arrived in the area in 1259 and founded an abbey, which flourished until the Reformation in 1538. They re-established themselves in the nineteenth century and enlisted Edward Pugin to design a church on this site. With a magnificent front elevation of limestone, red sandstone and granite, the building was regarded as 'poetry in stone' when it opened in 1895. The bell tower is the tallest in the city at 200 feet and it contains a myriad of magnificent sculptures in stone. The main items are:

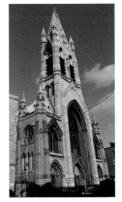

The Sacred Heart in the tympanum by Earley and Powell. This concept of Jesus Christ is thought to originate with St Bernard in the twelfth century, who said that the piercing of Christ's side revealed the goodness and charity of his heart.

Salvator Mundi: This statue depicts Christ holding a cross-bearing orb (*globus cruciger*), a symbol of authority that signifies his domination over the world. On either side of this statue are the signs for Alpha and Omega, the first and last letters of the Greek alphabet, signifying Christ's words 'I am the beginning and the end.'

St Augustine: This is a 10.5-foot statue by Earley and Powell of St Augustine holding a crosier. Augustine was a theologian in Hippo, which is located in present-day Algeria. He converted to Christianity in 387 and went on to write many works of theology. He is regarded as one of the most influential theologians of the early Church and is often called a Church Father. The Augustinians follow the rule of St Augustine.

The Twelve Apostles: Sculpted by James Pearse, father of Pádraig Pearse, the leader of the 1916 Rebellion. These can be seen, with a little difficulty, on the pinnacles of the church.

St Augustine and the Child: This work is located down the laneway to the right of the building. It tells the story of Augustine walking along a beach, lost in thought, trying to decipher the mystery of the Holy Trinity when he comes across a child who is bringing water in a shell from the sea to a hole in the sand. Augustine asks him what he is doing. The child replies that he is emptying the sea into the hole. When Augustine replies that he will never succeed in emptying the sea, the child replies that there is a better chance of him emptying the sea than of Augustine understanding the mystery of the Holy Trinity and he disappears. Augustine realises that the child was Jesus.

St Augustine: Located over the entrance door to the Augustinian residence on the left is St Augustine.

C56 IVEAGH MARKET KEYSTONE HEADS, Francis St *(Unknown, 1906)*
The Iveagh Market was designed by Frederick Hicks and sponsored by the 1st Earl of Iveagh, Lord Edward Guinness. It was built as a wet and dry market for the traders who were dislodged when the area to the north of St Patrick's Cathe-

dral was cleared to create St Patrick's Park. The eight headstones represent Ireland and key trading areas around the world. The market was closed in the 1990s, with plans to renovate as a hotel and shopping centre. These plans were put on hold during the recent economic crisis but were revived in early 2015.

C57 CENTENARY OF CATHOLIC EMANCIPATION,
Gray Street, The Liberties *(Unknown, 1929)*

There was much conflict in Ireland following the Refor-
mation in the sixteenth century and the civil wars in the
seventeenth. In 1690 there was a major battle between
King James II, a Roman Catholic, and King William III,
a Protestant, for the throne of England (and therefore
also Ireland and Scotland). The battle took place across
the River Boyne, near Drogheda, north of Dublin, and
was won by King William. The government went on to
pass what became known as the Penal Laws, which were
designed to suppress the Catholic religion and its adherents in Ireland. Some of
these laws remained in place in one form or another until Daniel O'Connell (**D23**)
challenged them in 1828. His challenge resulted in the passing of the Catholic
Relief Act by Parliament on 13 April 1829. This statue of Our Lady was erected to
celebrate the centenary of this event.

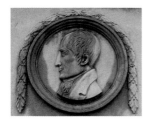

C58 ROBERT EMMET MEMORIAL, St Catherine's
Church, Thomas St *(James McKenna, 1978)*

This is the location of the execution of Robert Emmet,
the leader of the 1803 Rebellion. He was hung, drawn
and quartered outside this church on 20 September
1803. For the story of Emmet see **B16**.

C59 ADULT AND CHILD SEAT, Marrowbone Lane *(Jim Flavin, 1988)*

St Catherine's Park is located at the back of St Catherine's Church in Thomas
Street. It was formerly a cemetery from 1552 but burials ceased in 1894. The
church and graveyard were given to Dublin Corporation in 1969 and the site was
landscaped as a public park in 1985.

This sculpture was created as part of
the Millennium Sculpture Symposium
in 1988, when the artists were asked to
choose from a list of sites for their work.
Flavin requested this one even though it
was not on the list. His soft curved sculp-
ture takes its colour from the headstones
and signifies the continuity of life.

C60 CERES KEYSTONE HEAD, St James's Gate, James's St *(Unknown)*

The Roman goddess of agriculture is represented as a keystone over the main
entrance into the Guinness Brewery, which was founded in 1759 by Arthur

Guinness. The headstone has ears of cereal in her hair, symbolic of one of the main ingredients in Guinness, barley. The other ingredients are hops, water and yeast.

C61 SEÁN'S SPIRAL, Crane St
(Richard Serra, 1984)

A unique creation by the internationally renowned sculptor Richard Serra was inserted on the street for the ROSC Art Exhibition in 1984. The original design was a circle within a circle but Serra discovered that the supplier could not bend the flanged steel into a circle. Unfortunately, the street had already been dug up in

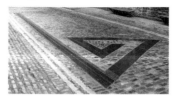

preparation for the work and the design had to be quickly changed to the chevron shape we see today. Despite that change in shape it retained the spiral element of its title and was named after Seán Mulcahy, a structural engineer on the project who became a good friend of Serra's.

C62 PARABLE ISLAND, Marrowbone Lane, Pimlico *(Peter Fink, 1988)*

Cement, steel and ceramic tiles form the outline of an open green space between Marrowbone Lane and Pimlico. Unfortunately, the work had not stood the test of time with many of the tiles being cracked or broken due to vandalism.

C63 WALL DANCE, Cork St *(Felim Egan, 2006)*

The curved lines etched on the external wall of this building determine the cut and the orientation of the 8-mm-thick stainless steel squares. Many of the squares are cut or angled to match the curved lines, giving the impression that they are 'dancing' on the gable of this seven-floor building.

C64 OBELISK FOUNTAIN, James's St
(Francis Sandys, 1790)

This obelisk has a sundial on each side and the fountain would have provided fresh water for the citizens of the area in its day. It was erected by the Duke of Rutland,

Charles Manners, who was the Lord Lieutenant of Ireland at the time. He erected a number of fountains in the city during his time as Lord Lieutenant, including the Rutland Fountain (**A14**).

C65 HYBRID LOVE SEAT, James's St *(Louise Walsh, 2008)*

With the advent of the Luas tram in this area there was a requirement for a 40-metre railing to separate the tram stop from the street and Louise Walsh was selected to help create an appropriate construction. Her idea was to have local involvement, so children from nearby schools were recruited to create the designs for the tops of the railings with support from students of the National College of Art and Design, where Walsh is a lecturer. This was a big commitment from the children as it involved three hours' work per week over thirteen weeks to create the sixteen mini-sculptures we see here.

The structure has utility because as well as being a work of art as it provides seats for both the Luas passengers and the locals who live on the other side of the railing in the form of a traditional 'love seat'.

C34 Fortitude

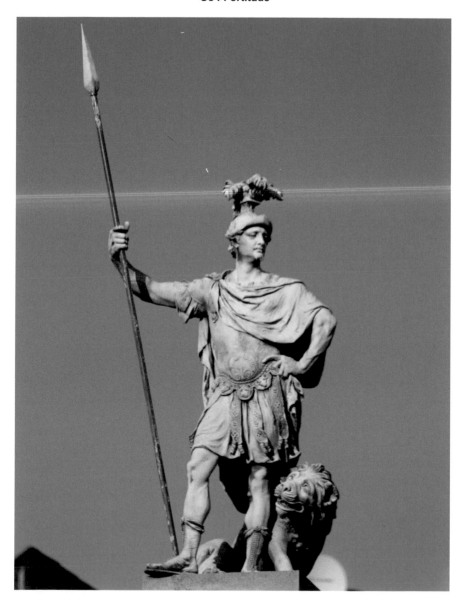

4

CITY NORTH WEST

Included in this section are the Legal Quarter, O'Connell Street and Parnell Square. The works in this part of the city are a little more spread out but nonetheless there are many gems to be discovered. The statuary in King's Inns and on the GPO are impressive while many of our history's heroes can be found in O'Connell Street. Check out the symbolism on the statue of Daniel O'Connell or marvel at the size of the Children of Lir in the Garden of Remembrance.

D1 ANNA LIVIA, Croppies Acre Memorial Park, Wolfe Tone Quay
(Eamonn O'Doherty, 1988)
The Anna Livia sculpture is located in Croppies Acre Memorial Park, named after the executed rebels of the 1798 Rebellion. The sculpture was commissioned by Michael Smurfit, a local businessman, and Dublin Corporation for the city's millennium celebrations in 1988. The original location was the middle of O'Connell Street, where it lay in a granite bath with water washing over it. The wags of Dublin quickly named the sculpture 'the floozie in the Jacuzzi'. It was removed in 2001 as part of renovations to O'Connell Street and was relocated here in 2011, in keeping with the artist's wish that she be located close to the river.

The sculpture represents the River Liffey and was inspired by Anna Livia Plurabelle as portrayed in James Joyce's *Finnegans Wake.* This was his fourth and most difficult book to read; however it makes more sense when you hear Joyce reading the passage aloud, which you can do on YouTube.

ARRAN QUAY CHURCH

This neo-classic church was built between 1837 and 1844. It was one of the first Catholic churches to be built on a main thoroughfare after Catholic Emancipation in 1829. The church closed to the public a number of years ago due to a decline in the number of parishioners. There are three statues to be seen over the pediment in rather poor condition.

D2 ST PETER (left), Arran Quay Church, Arran Quay
(Joseph Robinson Kirk, 1843)

The apostle known as Simon Peter was a brother of the apostle Andrew. The name Peter comes from the Greek 'Petrus', which means rock. According to the gospels, Christ said to him, 'You are Peter and upon this rock I will build my church.' After Jesus was arrested, Peter denied knowing Christ three times, fulfilling Biblical prophecy. However, despite this he went on to become the first pope, and was crucified upside-down in Rome around 64 AD.

This statue is not in very good condition, with its right arm missing. This arm may have held a key, often used to symbolise Peter.

D3 ST PAUL (centre), Arran Quay Church, Arran Quay
(Constantine Panoromo, 1843)

St Paul was born as Saul in Tarsus, in modern-day Turkey. According to the Acts of the Apostles, he was a Roman and a Jew and he spent his early years persecuting the early Christians. One day, when he was on the road to Damascus, he was blinded by a vision of Jesus, who asked, 'Saul, Saul, why do you persecute me?' He asked, 'Who are you?', and Jesus replied, 'I am Jesus, who you persecute.' Saul was brought to Damascus where recovered his sight after three days and converted to Christianity, becoming known as Paul. He subsequently travelled extensively preaching the gospels and writing many epistles, and is regarded as one of the most influential figures in the early Christian Church. It is thought that he died as a martyr in Rome. His statue here is not in good condition with both arms missing.

D4 ST PATRICK (right), Arran Quay Church, Arran Quay
(Joseph Robinson Kirk, 1843)

Patrick was the son of Roman gentry who was captured from his home in Wales by Irish slavers and taken to Ireland in the fifth century. He spent the next six years as a slave minding sheep, perhaps in Co. Antrim. He subsequently managed to escape home, where he became a priest and then a bishop.

In the year 432 he returned to Ireland as a missionary to begin the job of converting the pagan Irish to Christianity. Although he was not the first Christian missionary to come to Ireland, he is recognised as the one who had the most influence and of whom we have the most knowledge, as two pieces of his writings survive. His arrival marks a step-change in Ireland from pre-history to recorded history and begins the transformation of Ireland into the 'Island of Saints and Scholars', with hundreds of monasteries being established throughout the country in the following centuries. The date of his death on 17 March is celebrated as a national holiday in Ireland and throughout the world wherever there are Irish people. The day is often marked by parades, a tradition that originated in the US during the eighteenth century.

D5 THE GREEN LIGHT, Fr Matthew Square, Church Street *(Rachel Joynt, 1990)*

This bronze work, commissioned by Dublin Corporation, was originally located in Moore Street in the centre of Dublin. It was removed to storage in 2005 and remained there for a number of years before being re-erected here in this little park.

Moore Street is the location of a street market and this work includes various representations of vegetables, fish and fruit which are sold in the market. The location here is at a distance from the original market but not too far from the wholesale produce and fish markets in Mary's Lane (p. 111).

KING'S INNS, CONSTITUTION HILL

The Honorable Society of King's Inns was founded in Ireland in 1541, during the reign of King Henry VIII. Its aim was to provide accommodation and education for those who wished to study law. Today the society provides courses for those who

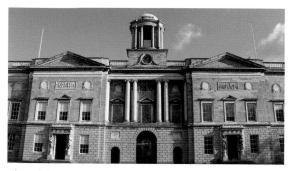

wish to become barristers and practice in the Irish law courts. The building was the last to be designed by James Gandon, who also designed the Custom House (p. 143) and the Four Courts (p. 109). He left the project in 1804 and the building was completed by Francis Johnston, who also designed the General Post Office (p. 118) in O'Connell St and the Chapel Royal (**C40**) in Dublin Castle. While you are here, check out the bench, close to the south-west entrance, that is being consumed by a tree. There is a passageway through the archway that will take you to Henrietta Street for a shortcut to the city. The works to be viewed here consist of caryatids, atlantes and tablets on the main building and three sculptures in the grounds to the west of the building.

D6 COMMERCE, King's Inns, Constitution Hill
(Joseph Robinson Kirk, 1865)
These three limestone sculptures are located in the grounds of King's Inns. Their origin and sculptor are hazy but it is thought that they were originally created for the entrance to the Great Dublin Exhibition, which took place in Earlsfort Terrace in 1865. They were subsequently located on the open plaza

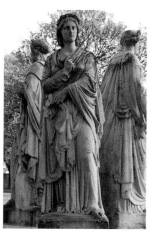

east of City Hall from where they were removed to storage for a number of years before being placed in their present position in 2014. The figure of Commerce is holding a mallet in her right hand and the remains of what perhaps was a stringed musical instrument in her left hand.

D7 HIBERNIA, King's Inns, Constitution Hill
(Joseph Robinson Kirk, 1865)
Hibernia, meaning winter, was the name given to Ireland by the Romans when they occupied Britain between the first and fifth centuries. They never occupied Ireland but the name stuck and became the symbol of Irish independence

from her larger neighbour. The statue of Hibernia is a little taller than the other two statues in the set. She holds the remains of a harp, a popular Irish symbol, in her left hand and perhaps the remains of a wreath, a symbol of victory, in her right hand.

D8 INDUSTRY, King's Inns, Constitution Hill
(Joseph Robinson Kirk, 1865)

Industry has her right hand resting on her hip while her left hand, now missing, held the handle of a sledge hammer, the head of which can be seen on the anvil. There is a large cog at her left foot. This symbolises how Ireland was prospering during the era after the Great Famine with hundreds of miles of railways being laid, enabling the development of industry and commerce throughout the country.

D9 CARYATIDS AND ATLANTES, King's Inns,
Constitution Hill *(Edward & John Smyth, 1817)*

The west facade of King's Inns has an entrance on each pavilion 'guarded' by caryatids (female) and atlantes (male) supporting the pediment. North pavilion: Ceres (L), the Roman goddess of agriculture, with a basket of wheat and a horn of plenty; and Bacchante (R), a follower of Bacchus, the Roman god of wine, with a basket of grapes and a wine goblet. South pavilion: Law (L), holding a book and quill; and Security (R), holding a key and scroll.

D10 TABLETS, King's Inns, Constitution Hill *(Edward & John Smyth, 1817)*

There are three tablets located towards the top of the building: On the left are Bacchus and Ceres, attended by the four seasons. In the centre are lawyers receiving a bible from Queen Elizabeth I. On the right are

Wisdom, Justice and Prudence, attended by numerous figures including Truth, Time, History, Security and Law.

THE FOUR COURTS, INNS QUAY

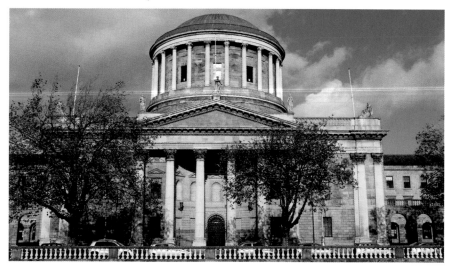

Following on from the success of the Custom House (p. 143), James Gandon took over as architect from Thomas Cooley on the Four Courts, which was commenced in 1785. This is a less ornate building than the Custom House and, despite its comparable size, cost 40 per cent less to build. The building was originally built to house the four courts of Chancery, King's Bench, Exchequer and Common Pleas, all of which have since been abolished. Today the building is used by the highest civil courts in the state. It was very badly damaged during the Civil War in 1922 when forces opposed to the Anglo-Irish Treaty occupied the building. After a long stand-off, Irish Free State troops shelled the building, damaging it badly. One round hit the Public Record Office at the rear of the building, where the insurgents were storing their ammunition. The resulting explosion destroyed almost 1,000 years of records. The statues on the pediment are showing their age and are not in particularly good condition.

D11 AUTHORITY, Four Courts, Inns Quay *(Edward Smyth, 1786)*

The allegorical statue of Authority holding a mace is located above the left parapet of the Four Courts. The mace, originally used as a weapon by royal bodyguards, is today the symbol of authority. This symbolises the power given by the government to the judiciary to legitimately punish convicted criminals for their crimes.

D12 JUSTICE, Four Courts, Inns Quay *(Edward Smyth, 1786)*

Justice is located on the left side of the central pediment. The outline of the pans of the scales can be seen just below her waist. She is missing both of her arms, one of which may have held a sword, the other symbol of justice.

D13 MOSES, Four Courts, Inns Quay
(Edward Smyth, 1786)

Moses is one of the great prophets of Judaism, Christianity and Islam. Born to a Hebrew mother in Egypt, he was raised by the Pharaoh's daughter. Called by God to lead the Hebrew people out of slavery in Egypt, he divided the Red Sea and led his people through the desert to the land of Israel. On Mount Sinai he received from God two stone tablets on which were inscribed the Ten Commandments. We see Moses in the centre of the pediment holding the two tablets representing the laws of God that must be obeyed.

D14 MERCY, Four Courts, Inns Quay *(Edward Smyth, 1786)*

Located on the right parapet is the allegorical statue representing Mercy. She represents benevolence, kindness and forgiveness. Perhaps she serves as a reminder to the judges who supervise the trials here and the fact that mercy benefits the giver and the receiver.

D15 WISDOM, Four Courts, Inns Quay
(Edward Smyth, 1786)

The statue of Wisdom is located to the extreme right of the Four Courts. She is holding a spear in her right hand and a shield and serpent in her left hand, a symbol of knowledge. Known as Sophia in Greek, the word 'philosophy' comes from

philo-sopia, 'love of wisdom'. The statue reminds us of control of emotion, good judgement, application of perception and the application of knowledge.

D16 EMBLEMS OF JUSTICE AND LAW, Four Courts, Inns Quay
(Edward Smyth, 1786)
There are two sculptures over the triumphal arches representing the elements of justice and law. Items included in the works include a key, a scales, a sword, a scroll, a serpent and a fasces (a type of axe with a handle formed from a bundle

of sticks, symbolising magistrates' power). The centre oval has a bas-relief of a harp, one of our national symbols, and a scroll with the words 'Saorstat Éireann', which is Irish for Irish Free State. The oval is sur-mounted by an orb but under British rule it would have been surmounted by a crown. The crown may have been damaged during the shelling of the building by Irish Free State Troops during the Civil War in 1922.

DUBLIN CORPORATION FRUIT MARKET, MARY'S LANE

This premises was built in 1891 to house the wholesale market for fruit, vegeta-bles and flowers. Fresh produce is brought here and sold to shops, restaurants and even the public. Another building was erected for the sale of fish but has since been demolished.

D17 DUBLIN CORPORATION SEAL, Fruit Market, Mary's Lane
(C.W. Harrison, 1892)
The Dublin Fruit and Vegetable Wholesale Market was run by Dublin Corporation. A sculpture of the Corporation seal dating from the seventeenth century can be seen over the north entrance. The central crest has three castles, thought to rep-

resent the medieval entrances to the city, while the flames in the towers represent the spirit of the people of the city. The mace and sword are symbols of author-ity and power. The crest is flanked by two figures, Fair Trade on the left and Justice on the right, although they have lost their symbols. Each holds a palm branch

symbolising peace. At the bottom of the sculpture is the city motto 'Obedientia Civium Urbis Felicitas' (obedient citizens make a happy city).

D18 KEYSTONE HEADS, Fruit Market, Mary's Lane
(C.W. Harrison, 1892)
Note the keystone heads over each of the north and west entrances to the market representing the classification of products that are traded in the market: fish, cereals, vegetables and flowers.

D19 TERRACOTTA LABEL STOPS, Fruit Market, Mary's Lane *(Henry Dennis, 1892)*
Check out the charming terracotta label stops showing some of the products sold here in the markets. There are 31 different varieties of fish, fruit, vegetables and flowers to be discovered.

D20 ÉIRE (1798 MEMORIAL), Little Britain St *(Unknown, 1903)*
This limestone statue of Éire is located in St Michan's Park, which was opened in 1898. The statue is in memory of those who died during and after the 1798 Rebellion against British rule. It was erected in 1903, 100 years after the death of Robert Emmet (**B16**), the leader of the 1803 rebellion. The statue is a representation of Éire, or Ireland, downbeat and dejected. She is holding a wreath in memory of the dead and is attended by an Irish wolfhound. In the background a Celtic high cross can be seen, a symbol of Irish nationalism. The pedestal has reliefs representing the United Irishmen, the society that led the 1798 Rebellion, and the pikes they used as weapons. The inscription in Irish script tells the story of the rebellion. The park is located on the site of the old Newgate Prison, where many of the rebels were kept pending their execution.

D21 AG CRÚ NA GRÉINE, Jervis St
(Jakki McKenna, 2003)
This sculpture is located in what used to be the cemetery for St Mary's Church, where Arthur Guinness got married in 1762. The graveyard was closed in the 1940s and sold to Dublin Corporation in the 1960s

for use as a public park. The sight of cows in the streets of Dublin was common up to the 1960s when they would be brought to the mart near Smithfield and were often marched down the nearby quays to the cattle boats.

The sculpture was created in full public view in Leitrim Sculpture Centre in Manorhamilton, Co. Leitrim so that locals could see the process. Many farmers had the opportunity to give their opinion on what a good cow should look like. The sculpture was commissioned by AXA Insurance, whose offices are to the west of the park.

D22 MEETING PLACE, Liffey St Lower *(Jakki McKenna, 1988)*

This sculpture shows two women in bronze, chatting, with their shopping bags on the ground, seated on a granite bench. The location is between the two main shopping areas of the city, Henry Street on the north and Grafton Street on the south side of the river. The Ha'penny Bridge, built in 1816, provides the link between the two. The Dublin wags call this sculpture 'the hags with the bags'.

O'CONNELL STREET

O'Connell Street is the main thoroughfare of the city, and is always busy as a link between the north and south sides. It is named after Daniel O'Connell, whose statue features at the south of the avenue. He is joined by many other statues and sculptures and an important building as you will discover during your stroll through this part of Dublin.

D23 DANIEL O'CONNELL (1775–1847), O'Connell St *(John Henry Foley, 1866)*

Daniel O'Connell was born in Caherciveen, Co. Kerry into a Roman Catholic family who had lost their lands due to the Penal Laws. He studied in France and was called to the bar in Dublin. He practiced law until 1811, when he became seriously involved in politics, campaigning for Catholic Emancipation.

O'Connell formed the Catholic Association in 1823 with a fee of one penny per month, which raised funds to support MPs who promoted the campaign for Catholic Emancipation. During this period Roman Catholics were not allowed to take a seat in the House of Parliament; however O'Connell discovered that there was no law against a Catholic standing for election. He stood for election in Co. Clare in 1828 and won by a huge majority. This put enormous pressure on the government to pass the Catholic Relief Act, ending the Penal Laws, which was accomplished in 1829. O'Connell fought and won another election and was finally able to take his seat. For this success he became known as 'The Liberator'.

O'Connell's next step was to try to repeal the 1800 Act of Union, which had united the Irish and British Parliaments in Westminster. He held a series of 'monster meetings' throughout the country to put pressure on the British government to allow Home Rule. These meetings were held in historically significant places and attended by many hundreds of thousands of people. O'Connell insisted on no drinking at these meetings and that the gatherings be peaceful. However in 1843 he was forced to cancel a major

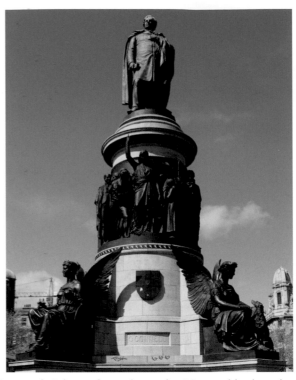

rally in Clontarf due to a threat of violence from the authorities and he lost the power of this mechanic. He was subsequently charged with conspiracy and sentenced to jail for one year. He was freed on appeal after just three months, much to the delight of his supporters. He was still hugely popular but he was getting old and the strain of his campaign was starting to show.

In 1847 he was on a pilgrimage to Rome when he died in Genoa of a sof-

tening of the brain. His final wishes were 'My body to Ireland, my heart to Rome and my soul to heaven.' His heart was taken and buried in an Irish church in Rome and his body was returned to Ireland and was buried in Glasnevin Cemetery on the northside of Dublin. A large round tower was erected over his crypt in his honour.

This statue is brimming with symbolism. O'Connell, a learned man with books by his left leg, is located at the top of the work. Below him is a frieze of the professional and trades people of Ireland being led from slavery by Hibernia, the

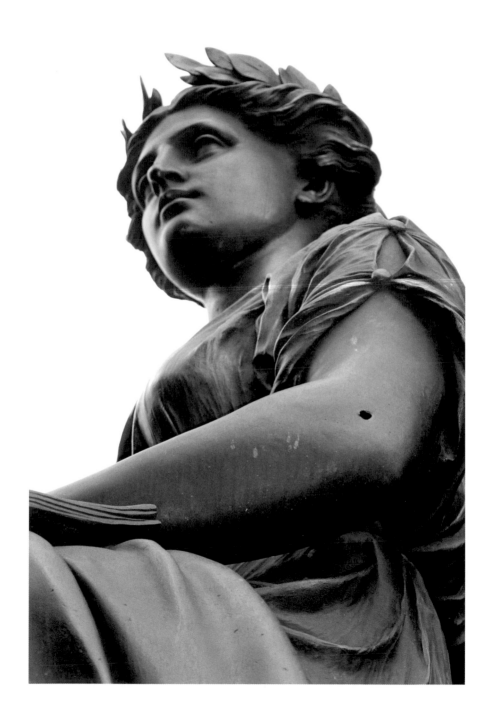

embodiment of Ireland. She is holding a copy of the Catholic Relief Act in her left hand, walking on cast-off chains and pointing to O'Connell as the liberator. Note that a man on the east of the frieze is holding sheet music for the song 'Oh Where's the Slave' by Thomas Moore (**B47**). Below the frieze a pattern of waves indicate that Ireland is separate from Great Britain, a symbol of liberty. The four statues represent Nike, the Greek goddess of victory, in various guises: Patriotism with the sword and shield; Fidelity with the Irish wolfhound; Courage with the snake; and Eloquence with the book. To top it off, the shape of the work when viewed from the top is like a Celtic or ringed cross. Note also the numerous bullet holes in the statute from the 1916 Rebellion.

D24 WILLIAM SMITH O'BRIEN (1803–1864), O'Connell St
(Thomas Farrell, 1870)
William Smith O'Brien was a middle-class Protestant, a nationalist MP and a leading member of the Young Ireland movement. Born in Dromoland Castle, in Co. Clare, he was educated at Harrow and Cambridge University in England. He was elected MP for Clare in 1828 and remained a Member of Parliament until 1848.

Like other middle-class Protestants of his era, such as Thomas Davis (**C4**), Smith O'Brien was a Young Irelander, a member of a nationalist movement whose aim was to restore Home Rule through the use of violence. He supported Catholic Emancipation and joined Daniel O'Connell's Repeal Association in 1843. However, just three years later he withdrew the Young Irelanders from the association over a disagreement on the use of force to achieve its aims.

Smith O'Brien was tried for sedition in 1847 for encouraging rebellion in his speeches, but was not convicted. In 1848 he found himself the leader of a 'rebellion' that became known as the 'Battle of Widow McCormack's Cabbage Patch', which failed miserably. He was subsequently captured, tried and found guilty of high treason. He was sentenced to be hanged, drawn and quartered but after a petition of 70,000 signatories was submitted the sentence was commuted to transportation to a penal colony in Van Diemen's Land (Tasmania). He was released in 1854 on condition that he not return to Ireland but received a full pardon in 1856. He did return to Ireland briefly but did not take active part in politics again. He died in Bangor in Wales on 18 June 1864 and is interred in the family vault in Rathronan, Co. Limerick.

D25 SIR JOHN GRAY (1815–1875), O'Connell St *(Thomas Farrell, 1879)*
Gray was born in Claremorris, Co. Mayo into a Protestant family. He was educated in Trinity College Dublin and Glasgow University, earning a medical qualification.

However, he took an interest in journalism, becoming joint proprietor of the *Freeman's Journal* in 1841 and sole owner in 1850. He made significant improvements to the paper during his tenure, extending its circulation. He also became involved with Daniel O'Connell (**D23**) and his campaign for Home Rule, for which he was jailed for nine months on a false charge of sedition. It was Gray who initiated the campaign and public subscription for the erection of O'Connell's statue after his death. He also supported the Young Ireland movement (for independence) but was against violence.

Gray was elected as MP for Monaghan and as a member of Dublin Corporation in 1852. It was in this role that he initiated the Vartry Scheme to bring clean water from the River Vartry in the Wicklow Mountains to the city of Dublin. The scheme resulted in a reduction in the instance and spread of disease and is still in use today. For this work he was knighted. In 1865 he was elected as MP for Kilkenny and it was during this term that he pushed for the disestablishment of the Anglican Church of Ireland, passed in 1869, and for Land Acts that gave fair rights to tenant farmers. In 1874 he joined the Home Rule Party under Isaac Butt, which was soon to come under the control of Charles Stewart Parnell (**D36**). Gray died on 9 April 1875 in Bath in England but his body was returned to Glasnevin for burial. This statue was funded by public subscription.

D26 JAMES LARKIN (1876–1947), O'Connell St *(Oisín Kelly, 1979)*

Larkin was born into poverty to Irish parents in Liverpool and started work on the Liverpool docks at the age of nine. He rose to the position of foreman but was sacked when he took part in a strike to improve workers' conditions. He became a union organiser with the National Union of Dock Labourers (NUDL) and organised support for striking workers by blackening goods that were being shipped by strike-breaking companies.

His militant methods caused his transfer to Dublin in 1908 and ultimately his suspension from the union. He founded the Irish Trade and General Workers' Union (ITGWU) in 1909 and advocated social and labour reform with proposals such as an eight-hour day, pensions at sixty and the nationalisation of public transport. With James Connolly (**E23**) he founded the Irish Labour Party in 1912. In 1913 Larkin was the chief organiser of strikes that caused the 'lockout' by employers of 100,000 Dublin workers for eight months. The strikes were

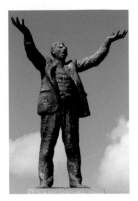

a failure but nevertheless marked a watershed in the Irish labour movement, with Larkin's impassioned rhetoric making a lasting impression. During the Lockout, a workers' protest march was attacked by the police with one protester killed and many injured, leading to the foundation of the Irish Citizen Army, which played a key part in the 1916 Rebellion.

After the Lockout, Larkin went to the United States to raise funds for the union and stayed nine years. During his visit he became involved in organising workers and spent time in prison for criminal anarchy before being pardoned and deported in 1923. Back in Dublin he took up where he left off with the ITGWU but was expelled in 1924 and founded the Workers' Union of Ireland, which was recognised by Communist International.

He went on to be elected to Dublin Corporation and to the Dáil (Irish Parliament). His efforts resulted in better conditions for workers, specifically securing two weeks' holiday for workers after a fourteen-week strike. He died on 30 January 1947 and was buried in Glasnevin Cemetery after a huge funeral.

The statue shows Larkin in typical style as he addresses and motivates a gathering of (probably) protesting or striking workers. The plinth of Wicklow granite has quotations on three sides from Camille Desmoulins (French revolutionary), Patrick Kavanagh (Irish poet, **A27**) and Seán O'Casey (Irish playwright and one-time general secretary of the Citizen Army).

THE GENERAL POST OFFICE (GPO)

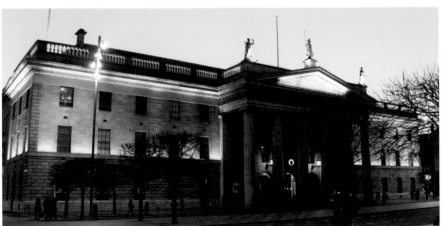

The GPO was designed by Francis Johnston and built in 1814. It is the central headquarters for the Irish postal service. It was the last of the great neo-classic buildings of the Georgian era built in Dublin. It was used by the rebels as their headquarters in the 1916 Rebellion and was badly damaged due to shelling by the British army. It was re-opened in 1929 after many years of restoration. The three statues on the pediment were badly damaged during the rebellion and were ultimately replaced by plaster casts. Note the bullet holes in the pillars, also from the 1916 Rebellion.

D27 MERCURY (left) GPO, O'Connell St
(John Smyth, 1814)

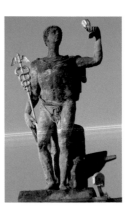

Mercury was one of the most popular Roman gods. He was the patron of finance, commerce, eloquence, communication, travellers, boundaries, luck, trickery and thieves – he was a busy god! He is usually portrayed wearing winged shoes (talaria) or a winged hat (petasos) and often carrying a caduceus (a stick of two intertwined serpents with wings). As the patron of communication it is appropriate that he is located above the General Post Office.

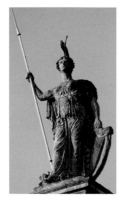

D28 HIBERNIA (centre), GPO, O'Connell St
(John Smyth, 1814)

Hibernia is the name given to Ireland by the Romans. The word derives perhaps from 'hiberno', the Latin for winter. It seems the Romans were not impressed with the weather here. The allegorical figure of Hibernia is always shown with a harp, one of the national symbols, and is usually seated. Here however she is shown in a defiant stance and ready for action wearing her helmet and with her spear in her right hand.

D29 FIDELITY (right), GPO, O'Connell St
(John Smyth, 1814)

The allegorical statue of Fidelity on the right is seen here holding a golden key, signifying the faithfulness of the postal service. The other symbol of fidelity shown is the dog sitting by her left leg.

D30 DEATH OF CÚ CHULAINN, GPO, O'Connell St *(Oliver Sheppard, 1935)*

Cú Chulainn is a hero of the ancient Irish epic *Táin Bó Cúailnge* (the Cattle Raid of Cooley) **(B34)**, which tells the story of Queen Medb of Connaught and her attempt to steal a prize bull from the King of Ulster. Cú Chulainn was a powerful warrior, the champion of the Ulster army. The statue represents his death after defeating many champions from Queen Medb's army in single combat. However, he was hit by a magical spear which mortally wounded him. Realising that he was dying, he tied himself to an upright stone so that he could die on his feet, facing his enemies. They were afraid to approach until a raven landed on his shoulder, indicating that he was dead.

This sculpture is a memorial to those who died in the Easter Rebellion of 1916 and is located in the window of the GPO, which was the rebel headquarters. The

character of Cú Chulainn was much referred to in the revival of cultural nationalism in the early twentieth century. Pádraig Pearse, leader of the rebellion, believed in blood sacrifice for Irish freedom. He founded his boys' school in Rathfarnham to recreate the knightly tradition of Cú Chulainn.

Sheppard's masterpiece is a heroic nude male drawn from mythology and influenced by Michelangelo's *Pietà* and Rodin's *Call to Arms*. It was first exhibited in 1914 but not finally executed until it was selected by Éamon de Valera, then Taoiseach, in 1934 as a memorial to the men of 1916. It was erected in 1935 on a base of Connemara marble with an excerpt from the Proclamation of Independence signed by the seven leaders of the Rebellion engraved on a plaque fixed to the base. The statue has been used by nationalists and unionists alike as a symbol of their struggle for their demands.

D31 AN TÚR SOLAIS (THE SPIRE), O'Connell St *(Ian Richie, 2003)*

An Túr Solais means the Monument of Light. In the late 1990s Dublin City Council launched plans to regenerate O'Connell Street and create a grand boulevard that would be a focus of attention for the city. The council held a competition for the creation of a centrepiece that was to be an iconic monument that would be instantly recognised as a symbol of Dublin. The competition was won by Ian Richie, who proposed this stainless steel cone marking the city centre. It is located on the site of Nelson's Pillar, erected in 1808 and blown up by the Irish Republican Army (IRA) in 1966.

The structure is 121.2 metres (398 ft) in height. The top twelve metres are illuminated and can be seen from several miles away. The sway of the spire is controlled by a tuned mass damper which counteracts the effect of any high winds. It is the tallest free-standing sculpture in the world and is the only monument on O'Connell Street not associated with Irish politics, history or ideology.

D32 JAMES JOYCE (1882–1941), North Earl St
(Marjorie Fitzgibbon, 1990)
The pedestrianisation of certain city centre streets commenced in the 1980s and North Earl Street was included in the second phase of this initiative. To mark the event, local businesses, along with the Dublin City Centre Business Association, commissioned this statue of James Joyce. They considered Joyce to be 'one of their own' as he was manager of the Volta Cinema in nearby Mary Street for a few months in 1909–1910. The sculptor, Marjorie Fitzgibbon, was requested to

submit a maquette for consideration and this was accepted as the model for the work. She portrays Joyce with a confident demeanour, well dressed and perhaps at the height of his fame following the success of his masterpiece, *Ulysses*. It was decided to erect the statue on a low plinth to keep it level with pedestrians and allow them access to it. You can read more about Joyce in entry **B8**.

D33 THE TEN VIRGINS, O'Connell St *(Sir John Steell, 1863)*

Number 65–66 O'Connell Street is a neo-classical building in golden sandstone designed by David Bryce. On the pediment at the top of the building is a sculpture of the Ten Virgins by Sir John Steell. This refers to the parable told by Jesus in St Matthew's Gospel of the wise and foolish virgins who were invited to a wedding. They were asked to bring lamps to provide light for the ceremony; however while the five wise virgins ensured their lamps were full of oil, the five foolish virgins did not have oil in their lamps and had to go and get some. While they were away, the bridegroom arrived and the ceremony took place without them.

The wise virgins are in the centre of the group with their full lamps while the foolish virgins are located to the right and left looking dejected. The parable refers to the necessity to always be prepared for Judgement Day, but this building was built for the Standard Life Assurance Company and the message was clear – to be covered by insurance for any eventuality.

D34 FR THEOBALD MATHEW (1790–1856), O'Connell St
(Mary Redmond, 1892)

Theobold Mathew was born near Golden in Co. Tipperary into a comfortable family. He studied in Kilkenny and Maynooth College, and was ordained a priest in the Capuchin order in 1814. He spent many years in Cork working with the poor and saw the impact that alcohol was having on families. He founded the Cork Total Abstinence Society in 1838 in an effort to encourage people to take a pledge that they would totally abstain from drink for life.

The movement quickly gathered momentum and Fr Mathew travelled throughout the country enlisting people to the commitment. He also preached against violence, crime and secret societies. By the early 1840s it is estimated that nearly 3,000,000 people had taken the pledge (more than half the adult population of Ireland), resulting in a significant reduction in the level of all types of

crime throughout the country. His non-religious, non-political campaign led to the consumption of alcohol being halved for a period, although distillery and brewery owners may not have loved him as many of them closed due to his campaign.

Fr Mathew was also known to be a kind and generous man and during the hardship of the Famine (1845–1849) he gave much help to starving families. He travelled to the UK and US where he had significant success in getting people to take the pledge. While in the US his health deteriorated significantly and when he returned to Ireland in 1851 he was quite sick. Despite his illness he continued to work to negate the impact of alcohol on the population. He died in Cobh on 8 December 1856 and is buried in St Joseph's Cemetery, Cork. He is remembered in Dublin with this marble statue. The bridge

over the River Liffey linking Bridge Street and Church Street is also named after him.

D35 THE THREE GRACES, Cathal Brugha St *(Gabriel Hayes, 1941)*

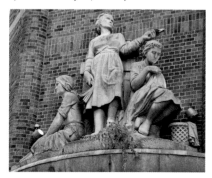

This sculpture is located on the north-west corner of the Dublin Institute of Technology College of Catering building on Cathal Brugha Street. This building housed a school of domestic science in its time. The sculpture shows three 'graces' involved in various chores: clean-ing, sewing and reading. The sculptor also designed the panel on the Department of Industry and Commerce (**B32**) and the Irish decimal ½p, 1p and 2p coins, which are now defunct.

D36 CHARLES STEWART PARNELL (1846–1891), O'Connell St
(Augustus Saint-Gaudens, 1911)

Known as the 'Uncrowned King of Ireland', Charles Stewart Parnell was a Protes-tant from the landed gentry born in the estate house of Avondale in Co. Wicklow. He was elected a Home Rule League Member of Parliament for Meath in 1875 and began a great career as a formidable politician. He used the tactic of obstruction-ism (using technical procedures to obstruct the work of the House of Commons) to highlight the needs of Irish tenant farmers. In 1877 he formed an alliance with the Fenians and in 1880 was elected chairman of the Home Rule League. He was involved in the Land War of the 1870s, agitating for greater rights for Irish tenant farmers, and became President of the Land League in 1879. Parnell advocated a tactic of boycotting people and businesses opposed to the tenants and withhold-ing rent in order to further the demands of the tenant farmers. They were looking for the 'Three Fs': fair rent, fixity of tenure and free sale.

Parnell was arrested and imprisoned without trial in Kilmainham Gaol for his opposition to the Land Act of 1881. After seven relatively easy months in prison he agreed the Kilmainham Treaty with Prime Minister William Gladstone, in which it was agreed that future Land Acts would move towards the demands of the tenant farmers in return for a scaling back of the agrarian unrest.

In 1882, he moulded the renamed Irish Parliamentary Party into a force to be reckoned with in Westminster by the introduction of the party pledge or 'whip', by which all members of the party agreed to vote en bloc on all issues, and would be expelled for voting the wrong way. This was ground-breaking as until then members of political parties would vote as they liked rather than as a party. The

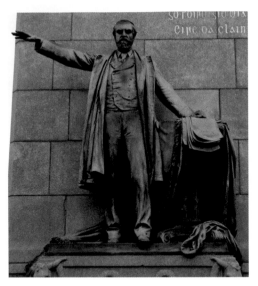

party won 85 seats in the 1886 election and held the balance of power, enabling them to force the introduction of the first Irish Home Rule Bill, which was ultimately defeated.

From 1880 Parnell was involved in an affair with a married woman named Katherine O'Shea, wife of MP Captain William O'Shea. In 1889 William sued for divorce, naming Parnell as the third party. By this time Katherine had three children by Parnell. Parnell did not contest the divorce, which was finally granted in 1890. This led to major conflict with Gladstone threatening to end support for the Home Rule campaign if he did not stop seeing her. Parnell refused and it led to a bitter split in the Irish Parliamentary Party.

Parnell married Katherine in 1891 and the Catholic hierarchy and his party turned against him. James Joyce says of this: 'They did not throw him to the English wolves; they tore him to pieces themselves.' Parnell's health deteriorated and he gave his last address in Creggs in Co. Galway in pouring rain. He returned to Katherine in Brighton where he died of a heart attack on 6 October 1891. His body was returned for burial in Glasnevin Cemetery with an estimated attendance of 200,000 people.

This monument was organised by John Redmond, his successor in the Irish Parliamentary Party, and was funded by public subscription. The 37ft triangular column of Galway granite shows Parnell on the plinth making a speech to Parliament. The inscription above his head – 'No man has the right to fix the boundary to the march of a nation ...' – is from a speech he made in Cork in January 1885. The harp is a symbol of Ireland. The four ancient provinces of Ulster, Connaught, Leinster and Munster are named on the front while the 32 counties of Ireland are represented in bronze around the base. It is interesting to note that two counties are named King's County and Queen's County; these were renamed Offaly and Laois after independence in 1922.

D37 SUZANNE WALKING IN LEATHER SKIRT,
Parnell Sq North *(Julian Opie, 2006)*

This two-sided animated LED display can be seen to the left of the entrance to the Dublin City Gallery (the Hugh Lane Gallery). The display was once a part of a five-panel exhibition installed on O'Connell Street and Parnell Street in 2008 featuring similar electronic displays. The exhibition brought art to the public and made it available in an outdoor setting, breaking the normal barriers of galleries. Opie has done much of this type of work with display panels showing moving versions of couples, crowds, fish, boats and horses. He created the LED display for the set for U2's Vertigo tour in 2005.

D38 LET'S DANCE, Parnell Sq North *(Redmond Herrity, 2007)*

In its day, Parnell Square was a popular place for young people as it boasted many dance halls during the showband era of the 1960s and 1970s. One of the best-known showbands was the Miami Showband, formed in 1962. They toured extensively in Ireland, Britain and the United States. While the line-up changed over many years, the band remained popular into the 1970s.

On 31 July 1975 the band was returning from a dance in Banbridge in Northern Ireland when their minibus was stopped by a group of Ulster Volunteer Force (UVF) gunmen in British army uniform. A bomb intended for the bus exploded prematurely and two of the UVF gunmen were killed. The other gunmen opened fire on the band, killing three of the group and critically injuring another, while a fifth managed to flee. A sixth member had a lucky escape as he had not travelled with the group that night.

The event was one of many that shocked the country and made Northern Ireland a no-go area for bands coming from the Republic of Ireland. Since the Good Friday Peace Accord in 1998, there is calm in Northern Ireland and relationships between nationalists and unionists continue to improve to this day.

This sculpture erected in the band's memory is located outside what used to be the National Ballroom, a venue where the band would have performed many

times. The work consists of three elements: dance steps on the ground in bronze; a trio of curved structures representing the three members of the band who lost their lives with the number of dots on the structures representing their ages; and a plaque with the names and ages of those killed.

D39 GARDEN OF REMEMBRANCE, Parnell Sq East *(Dáithí Hanly, 1966)*

This garden was opened on the 50th anniversary of the Easter Rising to commemorate all those who gave their life for Irish freedom. The mosaic patterns in the crucifix-shaped pool represent a broken spear and other weapons thrown

into the water as an offering to the gods at the end of hostilities. This is where Queen Elizabeth II made her first stop during her historic visit to Ireland in May 2011. She laid a wreath and bowed her head in homage to those who fought against her ancestors, thus winning the hearts of the people of Ireland.

D40 CHILDREN OF LIR, Garden of Remembrance, Parnell Sq East
(Oisín Kelly, 1966)

This sculpture represents the Children of Lir, one of the three sorrowful legends

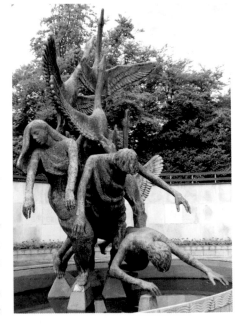

of Ireland. The legend tells of King Lir, who married Aoibh, the daughter of the King of Connacht. She bore him four children: Fionnuala, Aodh, Fiachra and Conn. Aoibh died and Lir married her sister Aoife, who was jealous of Lir's love for his children. She took them, along with a knight, to Lough Derravarragh, Co. Westmeath, and requested he kill them. When he refused she struck them with a druidical wand and turned them into four beautiful white swans and cursed them to live for 300 years on the lake, followed by 300 years on the Sea of Moyle (off the Co. Antrim coast) and finally 300 years on Inisglora off the coast of Co. Mayo.

When Lir heard of the events he turned Aoife into a grey vulture. He

spent the rest of his life visiting the swans but the curse could not be removed until they heard the sound of a Christian church bell. When they finally heard a bell ringing on Inisglora, after 900 years, they were returned to human form but due to old age died immediately and were raised to heaven. In some versions of the legend they were baptised into the Catholic faith before they died. The legend was immortalised in song by Thomas Moore (**B47**), who wrote 'Song of Fionnuala' (sometimes called 'Silent O Moyle') in the early 1800s.

The sculpture symbolises revolution and how people can be changed utterly by significant events, such as those of the 1916 Rebellion and the subsequent Irish War of Independence. The poem 'We Saw a Vision' on the back wall is by Liam Mac Uistín, who won a competition to pen an appropriate piece in 1976.

D41 THE IRISH VOLUNTEERS, Parnell Sq East
(Werner Schurmann, 1960)

The Irish Volunteers were founded in 1913 in the gardens of the Rotunda Hospital in response to the establishment of the Ulster Volunteers. The Irish Volunteers were in favour of an independent Irish Republic while the Ulster Volunteers wanted Ireland to remain part of the United Kingdom. The message in Irish tells us that the garden beside the Rotunda was the location of the founding of the Irish Volunteers on 25 November 1913. The broken chain clearly indicates the volunteers' objectives – freedom and independence for Ireland.

D42 NATURAL HISTORIES, Blessington St *(Austin McQuinn, 1992)*

Blessington Street Basin was originally constructed in 1803 to provide clean water for the city. It maintained this function until the Vartry Reservoir was built in the 1860s by Sir John Gray (**D25**). The basin continued to provide water for two distilleries in the area until the 1970s. It was subsequently renovated as an amenity for the area.

Austin McQuinn proposed to utilise the north wall of the enclosure for an art project. He engaged the children of fifth class in St Mary's Boys' School, Dorset

Street to create fishlike organisms, using a variety of methods such as painting and clay modelling. He then took the seventeen most interesting and created bronze sculptures for insertion into the wall. This symbolises the wall opening up to reveal hidden organisms, a metaphor for the renovation of the basin itself.

D43 THE SOLDIER, North Circular Rd *(Leo Broe, 1939)*
This limestone sculpture is located at the North Circular Road end of Blessington Street Park. It is a monument to the men of 'C' Company, 1st Battalion, Dublin Brigade, Irish Volunteers who fought and died during the Easter Rising in 1916 and in the Irish War of Independence between 1918 and 1921.

The sculpture is a statue of a man in Volunteer uniform in the kneeling position with his rifle. The pediment has three reliefs showing scenes from Irish history and mythology: the arrival of the first inhabitants of Ireland, the Milesians; Cú Chulainn fighting at the ford; and the death of Brian Boru after the Battle of Clontarf in 1014. The pediment also has a bronze inscription in Irish (conveniently translated), Celtic designs and a non-functioning fountain.

D44 THE FOUR MASTERS, Berkley Rd *(James Cahill, 1876)*
Inscribed in Irish, English and Latin, this Celtic cross is a monument to the Franciscan friars from Donegal known as the Four Masters who wrote the *Annals of the Four Masters*, a history of Ireland up to 1616. This was an important document written in Irish which summarised texts available at the time. It commented on the defeat and flight of the Earls of Ulster in 1607, a key event in Irish history.

The sculpture is a high or ringed cross, similar to those often found in the monasteries of Ireland from the ninth century. These crosses sometimes featured reliefs of scenes from the Bible and may have been used as a teaching aid for the illiterate people of the time. There are exceptionally good examples of these crosses to be found at Monasterboice, Co. Louth and Clonmacnoise, Co. Offaly. This sculpture was proposed by Sir William Wilde, an antiquarian and father of Oscar (**A1**), in 1871 but he died before it was erected.

D45 HEALING HANDS, Berkley Rd *(Tony O'Malley, 2000)*
This sculpture is located in the park opposite the old entrance
to the Mater Hospital. It consists of a bronze tree-trunk-style
pedestal holding a bronze sphere with handprint cutouts con-
taining an eternal flame. It was commissioned by the hospital
and erected in 2000 to celebrate the arrival of the third mil-
lennium of the birth of Christ.

It symbolises the healing ministry of Christ which is con-
tinued today in the nearby hospital, founded by the Sisters
of Mercy in 1861. The flame represents the everlasting love
of God for his people. Handprints were gathered by the artist
from the staff and patients of the hospital and used to shape
the cutouts on the sphere.

D23 Daniel O'Connell (detail)

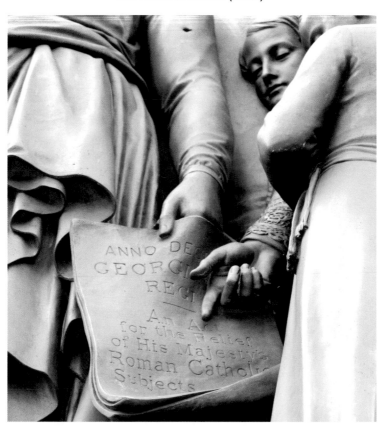

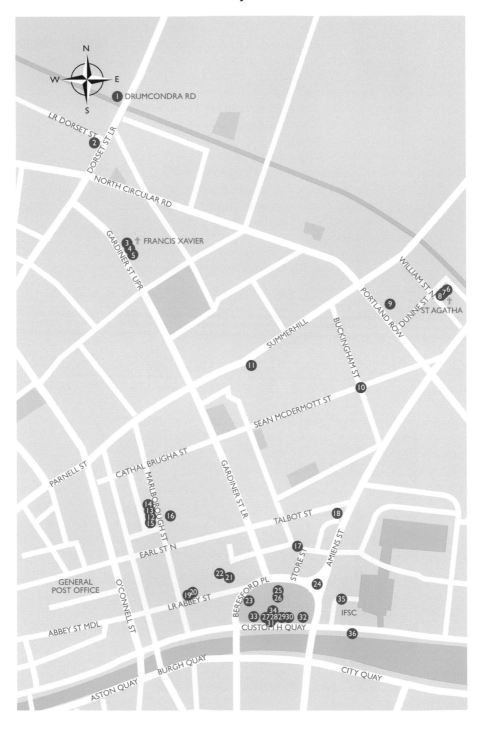

EAST WALL RD

37
MAYOR SQ

40
EAST WALL RD

38 NORTH WALL QUAY

39

5

CITY NORTH EAST

This part of the city covers the area east of O'Connell Street. In this section the statues are spread out but they are worth finding, particularly Brendan Behan's statue on the Royal Canal and the magnificent sculptures and keystone heads on the Custom House.

E1 BRENDAN BEHAN (1923–1964), Drumcondra Rd *(John Coll, 2003)*

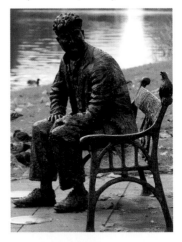

Brendan Behan, the celebrated Irish playwright, poet and rebel, was born in Dublin to a father who was interested in literature and a mother who was interested in politics. He left school at the age of thirteen and started work with his father as a house painter. He joined Fianna Éireann (the junior branch of the IRA) at four-teen and the IRA at sixteen. Without clearance from the IRA he set out to bomb Liverpool Docks in 1939, but was caught in possession of the explosives, tried and sent to a borstal (a prison for young offenders) for three years. He was subsequently deported to Ireland.

In 1942 he was sent to Mountjoy Prison, located on the other side of the canal, for attempted murder of two detectives. While in prison he studied Irish and became fluent in the language before being released in 1946 as part of a general amnesty. He moved to Paris in the early 1950s and worked as a house painter. His break-through as a writer came in 1954 with the production of *The Quare Fellow*, a play about a man who is about to be hanged in prison. The well-known Dublin song 'The Auld Triangle' comes from this play. This success was followed with another

play, *An Giall* (*The Hostage*), which was first produced in 1958. This was also the year that he published *Borstal Boy*, his best-selling autobiographical novel.

With all of his success, Behan was becoming more and more dependent on alcohol and indeed was diagnosed with diabetes as a result. Alcohol became part of his profile and he often quipped about it, for example, 'I only drink on two occasions, when I am thirsty and when I am not', or upon arriving in Canada, 'I saw a beer mat with the slogan "Drink Canada Dry" [a brand of mixer], so I'm here to give it a try.' His drinking led to the darker side of Behan coming to the fore, such as violence and unfaithfulness (with both sexes) to his wife, Beatrice, and public appearances in a very drunken state. He died at the age of 41 and was buried in Glasnevin with a huge attendance at his funeral, including a significant display from the IRA. He once said that there was 'no bad publicity, only your obituary'. Indeed!

This sculpture of Behan on the bench is within sight of Mountjoy Prison, where he spent some time. He is looking at a blackbird, a symbol of his fine tenor singing voice. If you look closely at the blackbird, among its feathers you will see music notes from 'The Coolin' (An Chúil Fhionn), a song often sung by Behan and popular with his parents. The words of some of his songs and poems are embossed on the sculpture while his most famous song, 'The Auld Triangle', is represented by a couple of triangles resting on the bench. Finally, note the shape of the arms of the bench is the same as the barred cell windows of Mountjoy Prison.

E2 PEADAR KEARNEY (1883–1942), Dorset St Lower *(Linda Brunker, 2002)*

Peadar Kearney was born in number 68 Lower Dorset Street. He wrote the lyrics for 'Amhrán na bhFiann' (The Soldiers' Song) in 1907 while Patrick Heeney

wrote the music. Kearney was very much involved in the Irish independence movement in the early 1900s and he was one of the founder members of the Irish Volunteers in 1913. After Irish independence in 1921 there was initially no official national anthem and in some cases 'God Save the King' was sung. This issue was addressed by the Dáil (Parliament) in 1926 when 'Amhrán na bhFiann' was adopted as the Irish national anthem. The state bought out the copyright to the song in 1933 for £980.

The sculpture here shows the national flag in bronze while the music for the anthem is on the granite base.

St Francis Xavier Church, Gardiner Street Upper

This Jesuit church was built between 1829 and 1832, one of the earliest churches to be built on a main thoroughfare after Catholic Emancipation. James Joyce lived locally for a time and was educated by the Jesuits. He mentions the church in Part 2 of *Ulysses* as the Reverend John Conmee SJ from the church makes his way to the north of the city. It also gets a mention in 'Grace', a short story from *Dubliners*, when some of the characters in the story attend a retreat in the church. There are three Portland stone statues in poor condition located over the pediment of the church.

E3 ST IGNATIUS OF LOYOLA (1491–1556) (left), St Francis Xavier Church,
Gardiner St *(Terence Farrell, 1877)*

St Ignatius was born in the castle of Loyola in the Basque country. He joined the army at seventeen, fought against the Moors and was seriously wounded at Pamplona. While recovering from his wounds he read extensively, particularly religious books, which greatly influenced him. He saw a vision of Our Lady with the baby Jesus at Monserrat and spent several months as a hermit at prayer in a cave where he formulated his Spiritual Exercises. These are a set of meditations, prayers and exercises designed to be carried out over the period of a month. He went on to study in Paris where he met Francis Xavier and together they formed the Society of Jesus (the Jesuits). Ignatius was the first Superior General of the Jesuits. He died of malaria in Rome and was canonised by Pope Gregory XV in 1622. St Ignatius is the statue on the left holding the book of Spiritual Exercises.

E4 SACRED HEART (centre), St Francis Xavier Church, Gardiner St
(Terence Farrell, 1877)

This concept of Jesus Christ is thought to originate with St Bernard in the twelfth century, who said that the piercing of Christ's side revealed the goodness and the charity of his heart. The Sacred Heart had so much devotion in Ireland over many hundreds of years that when electricity was provided to many country homes in the 1940s and 1950s the first light installed was that below the picture of the Sacred Heart.

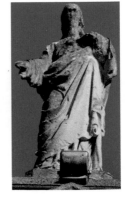

E5 ST FRANCIS XAVIER (1506–1552) (right), St Francis Xavier Church, Gardiner St *(Terence Farrell, 1877)*

Francis Xavier was born in the Navarre region of Spain to a wealthy family. He studied in Paris where he met Ignatius of Loyola and they both went on to found the Society of Jesus, known as the Jesuits, in 1534. He was ordained a priest in 1537 and spent the rest of his life as a missionary in India, China and Japan. He died of a fever in Shangchuan off the coast of China. His body was brought to India and today it rests in the Basilica of Bom Jesus in Goa. His right arm was taken in a reliquary and rests in the Jesuit Il Gesú Church in Rome. He was canonised by Pope Gregory XV along with St Ignatius Loyola in 1622. The statue of St Francis is located on the right of the pediment.

ST AGATHA'S CHURCH, WILLIAM STREET NORTH

This church was built between 1878 and 1908. After it was started money ran out and construction stopped. Around 1893, a sum of £8,000 was left by a Miss Walsh in her will towards the building fund. This was a considerable sum at the time. Fr John O'Malley, the then parish priest, wanted to change the location of the building to a higher profile street but the local bishop would not agree. O'Malley took the bishop to court but lost the case, at a cost of £2,000 to the building fund. Fr Nicholas Dudley was appointed as senior curate and administrator to the parish and O'Malley died in 1904. The church was finally completed in 1908. The court case was high profile at the time and James Joyce mentions Fr Nicholas Dudley CC in Part 2 of *Ulysses* as he descends from an inbound tram. There are three statues located on the parapet of the church.

E6 ST PATRICK, St Agatha's Church, William St North
(Unknown, 1908)
The patron saint of Ireland, St Patrick is located on the left of the pediment. For more detail on St Patrick, see entry **D4**.

E7 SACRED HEART, St Agatha's Church, William St North *(Unknown, 1908)*
The Sacred Heart is located in the centre of the pediment. For more detail on the concept of the Sacred Heart, see entry **E4**.

E8 ST AGATHA (231–251), St Agatha's Church, William St North
(Unknown, 1908)

St Agatha of Sicily is located on the right of the parapet. She was one of the early Christian virgin martyrs. Born into a noble family, she dedicated her virginity to God at the age of fifteen. However, a Roman official made amorous advances to her which she rejected. He had her sent to a brothel but she refused to cooperate and was sent to prison where her breasts were cut off. She died in prison at the age of twenty.

<p style="text-align:center">***</p>

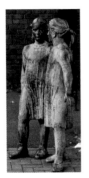

E9 BEDS, Portland Row *(Fred Conlon, 1993)*
This piece represents two children waiting their turn in a game of hopscotch or 'beds', a popular Dublin children's game. The object is for the player to kick a polish tin filled with clay along each square on the bed, which is represented by the numbered squares on the pavement. The sculptor chose this location as he spent time in digs in Seville Place not far from here when he was a student at the National College of Art and Design. After the installation was completed he returned to find, to his delight, some children actually playing beds on the numbered squares of the piece.

E10 HOME, Buckingham St *(Leo Higgins, 2000)*
Drug abuse is a major problem in modern-day Dublin and this area has suffered its fair share of sadness due to numerous deaths as a direct or indirect consequence of heroin. Since 1996 a Christmas tree is erected here each year with a star in memory of each person from the area who has died from drug abuse. By 2000 there were 124 stars on the tree. Relatives said that they felt a sense of loss when the tree came down each January so a more permanent reminder was required. It also was intended to send a signal to the drug pushers, that the local people had had enough. With the cooperation and support of Dublin Corporation, well-known artists and local groups created this limestone doorway with a gilded bronze flame, which was erected in 2000.

E11 SUMMERHILL GROUP, Summerhill *(Cathy Carman, 1992)*

Before the city became so busy with traffic and before the dual carriageway was built, this was quieter street and children used to play on this road. This is clearly

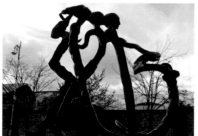

not possible today.

Carman reminds us of children playing in the area with this bronze group of five children 'miraged' together on Kilkenny limestone. The wavelike pattern suggests movement of the limbs attached to the sometimes alien-looking faces. This group was commissioned by Dublin Corporation as part of the Per Cent for Art scheme.

St Mary's Pro-Cathedral, Marlborough Street

St Mary's Pro-Cathedral was opened in 1825 with Daniel O'Connell (**D23**) in attendance. It was built on a back street as some of the Penal Laws suppressing the Roman Catholic religion were still in force at that time. While Dublin has two Anglican cathedrals (St Patrick's and Christ Church), it does not have a full Catholic cathedral. A pro-cathedral is an acting cathedral and there was a plan to build a 'full' cathedral in Merrion Square on the south side of the city. However plans for this have been shelved and the square has been opened as a public park. The facade of the Pro-Cathedral is modelled on the Temple of Theseus in Athens. John Count McCormack (**B24**) started his singing career here with the Palestrina Choir in 1903. There are three statues located on the pediment.

E12 ST LAURENCE O'TOOLE (1128–1180) (left), Pro-Cathedral,
Marlborough St *(Thomas Kirk, 1845)*

Laurence O'Toole was born to a wealthy family in Castledermot, Co. Kildare.

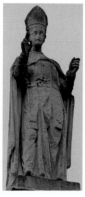

At a young age he joined the monastery in Glendalough, Co. Wicklow. He quickly established himself there and became abbot in 1154 at the age of 26. He was known as a reformer and worked at bringing the Irish Church into line with Rome by establishing links with European religious orders, particularly the Augustinians. He became the first Irish-born archbishop of Dublin at the age of 32 and mediated between the Irish and the Anglo-Normans when the latter arrived in Dublin in 1170. He died in the Abbey of St Victor in Eu, northern France. His heart was brought back to Dublin and was kept in Christ Church Cathedral until it was stolen on 3 March 2012. Following a

significant number of miracles, Laurence O'Toole was canonised 45 years after his death by Pope Honorius III.

E13 OUR LADY (centre), Pro-Cathedral, Marlborough St
(Thomas Kirk, 1845)

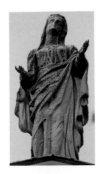

The statue in the centre of the pediment is Our Lady, the mother of Jesus. According to Christian teaching she was born without original sin, conceived Jesus by divine intervention (the Incarnation), was the mother of God and ascended straight into heaven without dying. She has the highest level of veneration of all the saints and is particularly venerated by Irish Catholics.

E14 ST KEVIN (right), Pro-Cathedral, Marlborough St *(Thomas Kirk, 1845)*

St Kevin was a sixth-century saint who was born to a wealthy family in Co.

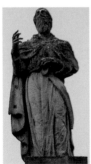

Wicklow. His life is not well documented and most of what was written is dated hundreds of years after his death. He studied for the priesthood and became a hermit, living in a cave in Glendalough overlooking the upper lake. He became known as a wise man and a good teacher and a number of disciples came to follow him. Many people came to Glendalough to get his help and ask for his advice. The monastery that he founded in Glendalough became a major place of pilgrimage for hundreds of years. The ruins of some of the Middle-Age stone buildings survive today and are a popular tourist destination. Kevin is one of the patron saints of the diocese of Dublin.

E15 THE DUBLIN MARTYRS, Marlborough St *(Conall McCabe, 2001)*

The Dublin Martyrs are two of seventeen Irish martyrs selected as representatives of Irish martyrs who died for their faith, and were beatified by Pope John Paul II in 1992.

Margaret Ball (1515–1584) was born in Co. Meath. She married Alderman Bartholomew Ball, whose family operated the bridge over the River Dodder and who later became Lord Mayor of Dublin. She was a devout Catholic and after the Reformation she refused to take the oath of allegiance. Her house was often used as a safe house for Catholic priests and bishops who were

on the run from the authorities. Her eldest son, William, converted to the Anglican faith and became Commissioner for Ecclesiastical Causes in 1577. He arrived at his mother's house one day and discovering a member of the Catholic clergy there, arrested him. Margaret was subsequently committed to the dungeon of Dublin Castle where she died in 1584. She was declared blessed in 1992 for her martyrdom.

Francis Taylor (1551–1621) was born in Swords, Co. Dublin. He was a merchant and an alderman of Dublin, becoming Lord Mayor in 1595. He was a devout Catholic and refused to convert to the Anglican religion. Despite his position he was put in prison without trial and remained there until his death seven years later. He was declared blessed in 1992.

E16 WISHING HAND, Department of Education, Marlborough St
(Linda Brunker, 2001)
The buildings of the Department of Education frame this sculpture perfectly while the open space provides the border – a perfect picture. The large bronze hand was inspired by one of Brendan Kennelly's poems, 'A Man Who Speaks to Flowers'. Brunker singles out three lines of the poem, 'Grow for me, You know

you can grow, Into your own beauty', as particular inspiration. She felt that this is especially appropriate for the educators who 'plant the seed of learning and nurture a desire for knowledge'. She says that the sculpture is only complete when a child is sitting in it, although we never stop learning, so maybe an adult will do too.

E17 SCÁTHÁN, Store St *(Robert McColgan, 2007)*
The Irish title of this piece means mirror in English. It's a 9-metre-

high bullet-like structure of mirrored stainless steel. Located in a busy plaza close to a transport hub, the work also includes seats to encourage people to stop and rest a while.

E18 DUBLIN AND MONAGHAN BOMBINGS MEMORIAL, Talbot St *(Unknown)*
On 17 May 1974 a number of car bombs exploded without warning in Dublin and Monaghan during the busy rush hour. A total of 33 innocent men, women and children were killed and nearly 300 were injured as a result of the explosions. All of the cars had Northern Irish registrations and had been stolen in Belfast earlier that day.

The Ulster Volunteer Force (UVF) initially denied responsibility for the bombings but finally admitted culpability in 1993. This was one of the largest losses of life in a single day due to the so-called 'Troubles' in Northern Ireland and it brought the horror of everyday life at the time in Northern Ireland to the Republic of Ireland. This memorial, located at the site of the second bomb, lists the names of all those killed on that day.

E19 TRICOLOUR PLAQUE, Abbey St Lower *(Linda Brunker, 1998)*

The traditional flag of Ireland was a green flag with a yellow harp, in use since the seventeenth century. The idea for the Irish tricolour originated with Thomas Francis Meagher, a rebel leader from Waterford, who first spotted the impact of the French tricolour when he was at an event in France in 1848. He was presented with a silk tricolour of green, white and orange by French women who were sympathetic to the Irish cause and he produced it at a meeting in Waterford in March 1848. It was flown over the GPO during the 1916 Rebellion and used as the national flag by the Irish Free State after independence in 1921. It was officially adopted as the national flag in article 7 of the 1937 Constitution. The green signifies the nationalists while the orange signifies the unionists (supporters of King William III of Orange) and the white signifies peace between the two communities.

E20 TALKING HEADS, Abbey St Lower *(Carolyn Mulholland, 1990)*

This set of three heads is located on a plaza on Lower Abbey Street. It was commissioned by Irish Life Assurance Company who own the nearby buildings and who

requested a suitable sculpture for this small plaza. The heads represent some of those waiting at the local bus stop. The sculptor describes them as 'a dreamer, a worker and a girl'. The piece is titled 'Talking Heads' despite the fact that they appear to be silent.

E21 THE CHARIOT OF LIFE, Abbey St Lower
(Oisín Kelly, 1982)

The Chariot of Life is located in the plaza of the Irish Life Centre on Abbey Street. Commissioned by Michael Lucy, who developed the centre, the bronze sculpture represents the attempt of reason to control the emotions. Kelly captures the noise of this conflict with the water continuously

gushing from the fountains as the driver tries to control the galloping horses. The sculptor suffered a heart attack during the preparation of the plaster model for this sculpture and died the year before the work was unveiled here.

E22 THE HARPY, Abbey St Lower *(Desmond Kinney, 1982)*

This ceramic work is located on a wall at the back of the Irish Life Plaza to the left. It represents a harpy, a creature in Greek and Roman mythology. It was said to be a birdlike monster in female form with a human face. It was reputed to steal food from its victims and to carry away evil people to their judgement and retribution.

Sudden mysterious disappearances were often attributed to harpies. The origin of the concept is thought to have come from sudden gusts of wind. The passageway here is a draughty one and is often subject to gusts of wind, perhaps caused by a local harpy.

E23 JAMES CONNOLLY (1868–1916), Beresford Place
(Eamonn O'Doherty, 1996)

James Connolly was born into extreme poverty in Scotland to Irish emigrant parents in 1868. He left school at a young age and served in the British army, but developed a hatred for imperialism. He became involved in the socialist movement and in 1896 moved to Dublin with his wife and young family to take up a position with the Dublin Socialist Club, which under his leadership became the Irish Socialist Republican Party. He published the *Workers' Republic*, a paper that gained him an international reputation, and he spent some time in the US. In 1910 he returned to organise the Ulster branch of the Irish Trade and General Workers' Union (ITGWU) and took over leadership of the ITGWU during the 1913 Lockout. He went on to form the Irish Citizen Army (ICA) to defend the workers

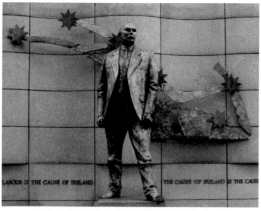

against attacks from the Royal Irish Constabulary (RIC). He planned the 1916 Rebellion with leaders of the Irish Volunteers and the Irish Republican Brotherhood and was the Commander of the Dublin Brigade with its headquarters in the General Post Office (GPO).

On the morning of the Rebellion he marched with his troops from Liberty Hall, the office of his newspaper, to the

GPO. He was wounded during the fighting and when the rebels surrendered he was taken to hospital in Dublin Castle. As leader and signatory of the Proclamation of Independence he was tried by court martial, found guilty and sentenced to be shot. Despite his wounds he was taken from his hospital bed, brought to Kilmainham Gaol in an ambulance and shot sitting in a chair. His body was buried, with the other executed leaders, in quicklime in Arbour Hill. Connolly's execution shocked the world and further executions were prohibited by Prime Minister Asquith.

This statue, commissioned by the Services, Industrial, Professional and Technical Union (SIPTU), situated in front of Liberty Hall (now the headquarters of SIPTU), shows Connolly standing proudly in front of the plough and the stars, which featured on the flag of the ICA. Connolly is also remembered with a statue in New York. Connolly Station and Connolly Hospital Blanchardstown are named after him.

E24 UNIVERSAL LINKS ON HUMAN RIGHTS, Beresford Place
(Tony O'Malley, 1995)

This sculpture of interlinked chains and bars was the winner of an art competition for an appropriate structure for this site. Commissioned by Amnesty International, this sculpture represents prisoners of conscience around the world. The quotation on the base reads: 'The candle burns not for us but for all those whom we failed to rescue from prison. Who were tortured, who were kidnapped, who disappeared. That is what the candle is for.' This is a quote from Peter Benson, founder of Amnesty International.

THE CUSTOM HOUSE, CUSTOM HOUSE QUAY

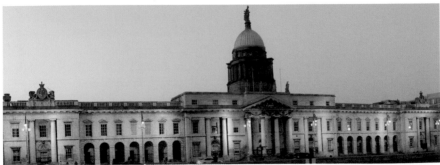

The Custom House is Dublin's most spectacular public building, built to be seen from all sides. It was built by the Rt Hon. John Beresford to process the paperwork for imports and exports when he was appointed Chief Commissioner of the Revenue in 1780. Beresford was a brother-in-law of Luke Gardiner, who was developing property in the north and north-east of the city. The original custom house was on Wellington Quay just below the final bridge at that time, Essex (now Grattan) Bridge on the Liffey. A bridge further down river would benefit Gardiner's north city developments but would block ships' access to the old custom house. Beresford had the old building declared unsafe and commenced work on a new one at the current position, enabling new bridges to be built.

The Custom House was the first major commission for the noted architect James Gandon, who used the best craftsmen he could find. As we can see, the result is a very fine tribute to him and his craftsmen. The building uses Portland stone, from Dorset, and Irish granite. Not everybody liked the building, with Henry Grattan (**A7**) commenting that the building was 'sixth rate in architecture and first rate in extravagance'. 'Luckily' there was money left at the end of the project to allow Gandon to design a house for Beresford at Abbeville in Kinsealy, which was to become the home of Charles Haughey, our Taoiseach (Prime Minister) in the 1980s.

You may notice that the dome is clad in a different colour stone to the rest of the south facade. This is because the building was attacked and set on fire by the IRA in 1921 in an attempt to disrupt British rule in Ireland. When the building was being rebuilt Ireland was engaged in an economic war with Great Britain so a local Ardbraccan stone was used instead of the original Portland stone. The building is currently occupied by the Department of the Environment, Community and Local Government.

E25 CUSTOM HOUSE MEMORIAL, Custom House, Beresford Place
(Yann Renard Goulet, 1956)

Located to the north of the building is a memorial to the men killed in the Battle of the Custom House. On 11 July 1921, during the Irish War of Independence, 100 IRA volunteers, armed with hand guns and a small amount of ammunition, entered the Custom House and set it alight. They were quickly surrounded and as they tried to make their escape five of them were killed and a further eighty were captured. The building burned for five days, the dome collapsed and many historical records were destroyed.

This sculpture was the winning entry in an international competition to find a suitable memorial. It shows the proud

and defiant figure of Mother Éire (Ireland), armed with her sword, protecting a wounded soldier.

E26 THE FOUR CONTINENTS, Custom House, Beresford Place
(Thomas Banks, 1791)

On the pediment on the north side of the Custom House there are four statues representing four of the continents of the world. From left to right: Europe with a sword and helmet at her feet, a horn of plenty on her right and holding a bunch of grapes in her left hand; Asia with the veil and a missing hand; Africa, a proud tall woman with a headdress; and America symbolised as a Native American woman. Note that there is no statue for Australia as it had only been discovered by Thomas Cooke in 1770 and had no trading relationship with Ireland when the Custom House was built.

E27 MERCURY, Custom House, Custom House Quay *(Agostini Carlini, 1791)*

The statue of Mercury is located on the left of the pediment facing the River Liffey. Note his winged petasos or helmet. Mercury was the god of commerce and travellers and so is a particularly appropriate figure to place above the Custom House. If you look carefully you might notice that the legs from the foot to the knee are out of proportion, which was necessary to make the statues seem in proportion at such a great height.

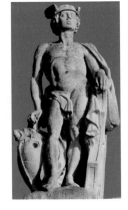

E28 PLENTY, Custom House, Custom House Quay
(Edward Smyth, 1791)
To the right of Mercury is the statue of Plenty with her horn of plenty or cornucopia on her right-hand side, clearly signifying the bounty that will come from trading with other countries.

E29 INDUSTRY, Custom House, Custom House Quay *(Edward Smyth, 1791)*
To the right of Plenty is Industry. The beehive at her right foot is significant as bees are the most industrious of creatures, constantly working for the good of the hive – a hint to the people of Dublin.

E30 NEPTUNE/POSEIDON, Custom House, Custom House Quay *(Agostini Carlini, 1791)*
On the right-hand side of the pediment is Neptune (Roman) or Poseidon (Greek), the god of the sea. He is holding a trident, which is common to both gods, but there is a horse head at his right foot, which is usually associated with Poseidon.

E31 PEDIMENT SCULPTURE, Custom House, Custom House Quay *(Agostini Carlini & Edward Smyth, 1791)*
In the tympanum above the pediment is a sculpture brimming with significance. In the **centre** are two figures: Britannia on the left with her shield, holding an olive branch, signifying peace, and a spear with a Phrygian cap, signifying liberty; and Hibernia on the right holding a harp, the symbol of Ireland. Note that they have their arms around each others' shoulders, signifying the friendship between the two countries. On the **left** is Poseidon with his trident driving away famine and despair, and his son Aeolus, the god of wind, blowing to

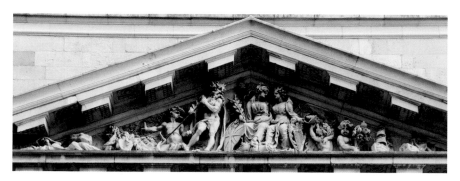

bring the boats to their destination. On the **right** is Triton, another son of Poseidon, blowing his conch shell to calm the seas over which he has power. A figure holding a horn of plenty can also be seen along with two ships sailing in opposite directions, symbolising imports and exports. The sculpture was designed by Carlini and carved by Smyth.

E32 COAT OF ARMS, Custom House, Custom House Quay *(Edward Smyth, 1791)*

The royal coat of arms for Ireland is located over the pavilions at the four corners of the building. On the left is the symbol of England – a lion indicating bravery, strength and royalty. On the right is a unicorn – the symbol for Scotland. Note that the unicorn is chained as there is a danger it might escape. In the centre is the harp, a symbol of Ireland, dominated by a crown, indicating that Ireland was under British rule at the time the Custom House was built.

E33 RIVERINE KEY STONES, Custom House, Custom House Quay *(Edward Smyth, 1791)*

Liffey	**Foyle**	**Barrow**

Over many of the doors and windows of the Custom House are keystones in the shape of symbolic heads representing thirteen of the major rivers of Ireland and the Atlantic Ocean. Starting from the main entrance and working clockwise around the building they are: Liffey, Erne, Foyle, Slaney, Barrow, Suir, Lagan, Lee, Shannon, Bann, Atlantic (Ocean), Blackwater, Nore and Boyne. This is not an original idea as there are similar heads on Somerset House (also designed by Gandon), but the work here is considered superior.

E34 COMMERCE, Custom House, Custom House Quay
(Thomas Banks, 1791)

At the very top of the building is a dome with a copper roof. At the top of the dome stands Commerce, the symbol for trade, resting on the stock of an anchor, the bottom of which can be seen in green oxidised copper.

DOCKLANDS AND FINANCIAL QUARTER

As the ships got larger with containerisation and needed deeper water, the port of Dublin moved east, leaving the old docklands area available for development. The Finance Bill 1987 designated this area as exempt from normal tax laws and created the Irish Financial Services Centre. The initiative attracted many banks and financial institutions and today there are as many as 30,000 people employed in the area. The tax laws also attracted developers who built hotels, apartments and shopping centres, along with the National College of Ireland, which was established in the area.

E35 BEAR AND BULL, IFSC House *(Don Cronin, 1999)*
Outside IFSC House is a bronze statue of a bear, one of a pair of statues commissioned by Dermot Desmond, one of the main developers of the Irish Financial

Services Centre. The other is a bull, which can be seen in the foyer on the other side of the building. Both are symbols used in the *Táin*, an Irish epic story dating from the first century (**B34**). Both also represent the mood of the stock market, the bear for a negative trend in the market and the bull for a positive trend, which is appropriate for the area.

E36 FAMINE MEMORIAL, Custom House Quay *(Rowan Gillespie, 1997)*
This group represents the hardship and pain of the people impacted by the failure of the potato crop during the 1840s. In 1845 there were about eight million people living in Ireland. About three million of these were tenant farmer families who were dependent on the potato for food and to raise money to pay their rent. The potato was a highly efficient crop and could feed a large population on relatively little land.

Blight arrived from Eastern Europe in 1845 and began to destroy the crop. Over the next five years at least one million people died of starvation and disease and more than one million emigrated to the United Kingdom, the United States and Canada. To make matters worse, when the crop failed these families had no money to pay their rent and up to 500,000 people were evicted from their homes.

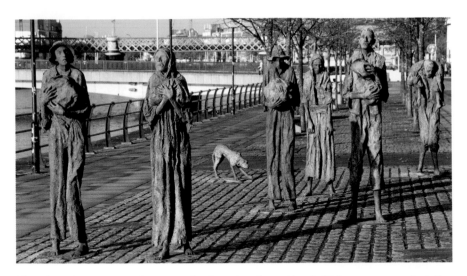

The situation was made worse by inaction from the British government at the time as it had a laissez-faire policy and some members of the government even believed that the famine was sent by God to force the Irish into self-sufficiency.

Gillespie uses his skill and knowledge to show us what starving people might have looked like. The people are barefoot, ragged and gaunt, with their bones showing through skin. He knew how to portray the scene as he had seen his sister die of anorexia. The man carrying the child is based on the story of a man who walked 10 miles carrying his child from his home to a soup kitchen run by the Quakers in Clifden. On the first two days the soup had run out by the time he arrived. On the third day he was in time for the soup but the child had died. The group also includes a dog, which may have been the best nourished at the time as they fed on the corpses of the dead. There is a similar sculpture group, again by Gillespie, standing in Toronto, representing the arrival of the emigrants in the New World, which was presented to the people of Canada in 2007 by then President Mary McAleese.

E37 NC IRIS, Mayor Square *(Vivienne Roche, 2006)*

Located in Mayor Square, this sculpture was inspired by two flowers, the iris and the lily, signifying growth and optimism. It is 14.2m (47ft) in height and weighs 6.6 tons. It is made from stainless steel tubing, similar to that used for pipelines in the North Sea, and 22,500 stainless steel rings welded to form chainmail. It is lit by coloured lamps recessed in the ground that change colour each month. The full range of colours can be seen each

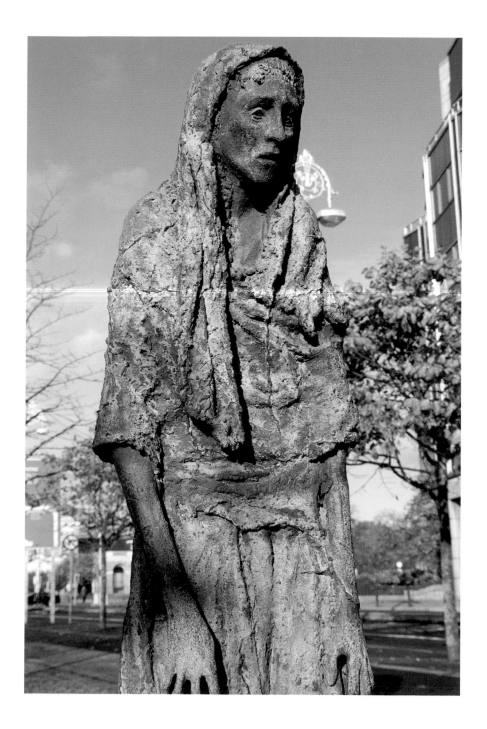

evening at 10 p.m. when there is a light show. The sculpture was commissioned by the nearby National College of Ireland.

E38 FREE FLOW, North Wall Quay
(Rachel Joynt, 2006)
A total of 900 internally lit glass cobbles were commissioned by the Dublin Docklands Development Authority for insertion along 1 km of walkway along the north bank quays of the River Liffey. The cobbles are made from cast glass containing copper and steel fish lit from below by LEDs and enclosed in stainless steel.

E39 THREE BEARS, North Wall Quay *(Patrick O'Reilly, 2005)*
This sculpture of three bears in bronze was created during a time

of strong growth in the Irish economy but due to the arrival of the economic crisis in 2008 there were not sufficient funds to complete the granite plinths on which they should stand. The result is that the bears are on temporary concrete bases, to be hopefully replaced once our economy improves.

E40 BOUNDARY KINGS, North Wall Quay *(Patrick O'Reilly, 1999)*
These coloured fibreglass heads were originally located in Thomas Street outside the Vicar Street venue but due to planning issues they have been moved here to North Wall Quay. The concept created by O'Reilly was that they were to mark the old boundary of the Liberties during the Middle Ages.

E1 Brendan Behan

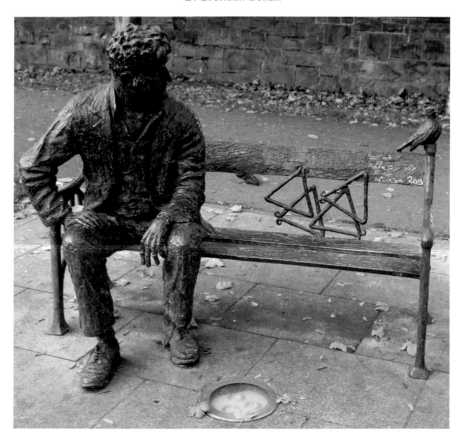

THE JOYCE TRAIL

E41 THE JOYCE TRAIL, Dublin City Centre *(Robin Buick, 1988)*

Ulysses by James Joyce tells the story of Leopold Bloom as he makes his way through the streets of Dublin on 16 June 1904. In Chapter 8, 'Lestrygonians', he makes his way from Middle Abbey Street on the north side of the city to Kildare Street on the south side. This journey is marked by fourteen bronze plaques inlaid on the pavement at the various stops that Bloom made in Chapter 8. Each plaque has a quote from the book relevant to the stop where the plaque is located.

The plaques are located at: the north side of Middle Abbey Street, the west side of Lower O'Connell Street, the north-west side of O'Connell Bridge, the south side of Aston Quay, the east side of Westmoreland Street (2), the east side of Grafton Street (3), the south side of Duke Street (2), the west side of Dawson Street, the north side of Molesworth Street and the east side of Kildare Street.

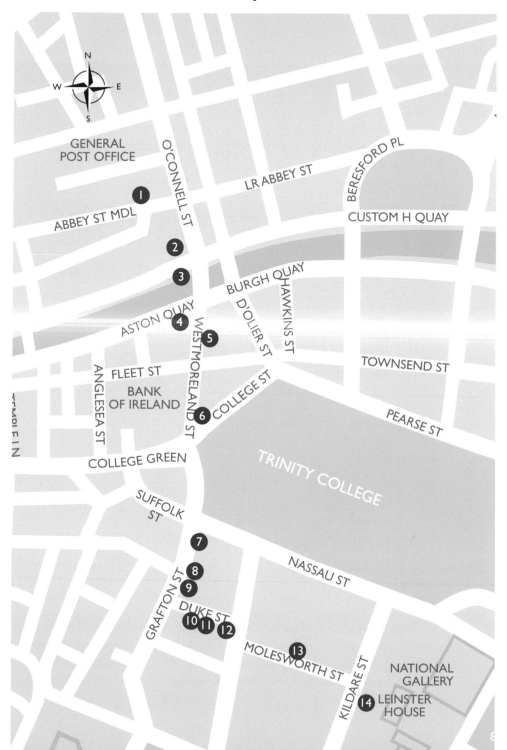

INDEX OF SCULPTORS

Artist	Work	Ref. No.	Location	North	West
Delaney, Edward	**Famine Commemoration**	B3	St Stephen's Green	53.338379	-6.256288
Delaney, Edward	**Wolfe Tone**	B4	St Stephen's Green	53.338393	-6.256176
Delaney, Edward	**Thomas Davis**	C4	College Green	53.344359	-6.260646
Denis, Henry	**Terracotta Label Stops**	D19	Mary's Lane	53.348108	-6.271534
Dressler, Conrad	**Sunlight Chambers**	C22	Essex Quay	53.345312	-6.267752
Egan, Felim	**Wall Dance**	C63	Cork Street	53.338359	-6.279939
Egan, Felim & Schurmann, Killian	**Untitled**	C21	Meeting House Square	53.344893	-6.265064
Ellis, Jason & Schurmann, Killian	**Garda Memorial**	C39	Dublin Castle	53.342762	-6.266572
Farrell, Terence	**St Ignatius of Loyola**	E3	Gardiner Street Upper	53.357913	-6.260015
Farrell, Terence	**Sacred Heart**	E4	Gardiner Street Upper	53.357865	-6.259978
Farrell, Terence	**St Francis Xavier**	E5	Gardiner Street Upper	53.357817	-6.259933
Farrell, Thomas	**William Dargan**	A15	Merrion Square	53.340533	-6.251686
Farrell, Thomas	**Arthur Edward Guinness**	B17	St Stephen's Green	53.338622	-6.261396
Farrell, Thomas	**William Smith O'Brien**	D24	O'Connell Street	53.348247	-6.259581
Farrell, Thomas	**Sir John Gray**	D25	O'Connell Street	53.348530	-6.259697
Fink, Peter	**Parable Island**	C62	Marrowbone Lane, Pimlico	53.341091	-6.281339
Fitzgibbon, Majorie	**James Joyce**	B8	St Stephen's Green	53.337291	-6.260044
Fitzgibbon, Marjorie	**James Joyce**	D32	North Earl Street	53.349913	-6.259780
Fitzsimons, Derek A.	**Memories of Mount Street**	A31	Mount Street Upper	53.336492	-6.243245
Flavin, Jim	**Adult and Child Seat**	C59	St Catherine's Park	53.342306	-6.281162
Foley, John Henry	**Prince Albert Memorial**	A17	Merrion Square West	53.339889	-6.252887
Foley, John Henry	**Edmund Burke**	B45	Trinity College	53.344570	-6.259187

Artist	Work	Ref. No.	Location	North	West
Foley, John Henry	Oliver Goldsmith	B46	Trinity College	53.344371	-6.259206
Foley, John Henry	Henry Grattan	C3	College Green	53.344450	-6.259772
Foley, John Henry	Sir Benjamin Lee Guinness	C49	St Patrick's Close	53.339364	-6.271789
Foley, John Henry	Daniel O'Connell	D23	O'Connell Street	53.347729	-6.259344
Frink, Dame Elisabeth	A Tribute Head	A5	Merrion Square	53.339841	-6.248375
Frömel, Gerda	Untitled	B33	Nassau Street	53.341935	-6.256015
Fundicion de Bronce Artistica SRL	Admiral Brown	A40	Sir John Rogerson's Quay	53.346166	-6.239307
Gillespie, Rowan	Birdy	A32	Mount Street Upper	53.336553	-6.243808
Gillespie, Rowan	Aspiration	A37	Grand Canal Street	53.339326	-6.240068
Gillespie, Rowan	The Kiss	B25	Earlsfort Terrace	53.333998	-6.258245
Gillespie, Rowan	Famine Memorial	E36	Custom House Quay	53.348034	-6.250035
Goulet, Yann Renard	Custom House Memorial	E25	Beresford Place	53.349174	-6.253162
Grant, Peter	Henry Grattan	A7	Merrion Square	53.339588	-6.249903
Greene, Catherine	Throne	A12	Merrion Square	53.339931	-6.249029
Hanly, Dáithí	Garden of Remembrance	D39	Parnell Square	53.353980	-6.263677
Hanratty, Hugh	Gogarty and Joyce	C15	Anglesea Street	53.345436	-6.261783
Harrison, C.W.	Dublin Corporation Seal	D17	Mary's Lane	53.348125	-6.271284
Harrison, C.W.	Keystone Heads Fruit Market	D18	Mary's Lane	53.348153	-6.270857
Harrison, C.W. & Power, Albert	Urns and Four Figure Groups	A22	Merrion St Upper	53.338894	-6.253095
Harron, Maurice	The Barge Horse	A30	Percy Place	53.335530	-6.243245
Hayes, Gabriel	Bas-Reliefs on Dept of Industry and Commerce	B32	Kildare Street	53.340080	-6.255858
Hayes, Gabriel	Our Lady	C29	Merchant's Quay	53.344918	-6.272260

Artist	Work	Ref. No.	Location	North	West
Hayes, Gabriel	The Three Graces	D35	Cathal Brugha Street	53.352115	-6.259965
Herrity, Redmond	Let's Dance	D38	Parnell Square	53.354193	-6.264298
Higgins, Leo	Home	E10	Buckingham Street	53.354323	-6.249764
Hughes, John	George Salmon	B44	Trinity College	53.344560	-6.257337
John, William Goscombe	William Lecky	B43	Trinity College	53.344232	-6.257368
Joynt, Dick	Michael Collins	A10	Merrion Square	53.339512	-6.250349
Joynt, Rachel	The People's Island	B53	D'Olier Street	53.346867	-6.258927
Joynt, Rachel	Pavement Art	C17	Crown Alley	53.345282	-6.262835
Joynt, Rachel	Wood Quay Walk	C26	Wood Quay	53.343676	-6.270303
Joynt, Rachel	Vane as a Peacock	C35	Dublin Castle	53.342416	-6.267555
Joynt, Rachel	The Green Light	D5	Church Street	53.348708	-6.274515
Joynt, Rachel	Free Flow	E38	North Wall Quay	53.347416	-6.240279
Keane, Michael Charles	Gulliver's Travels	C44	Bride Street, Golden Lane	53.341114	-6.269888
Kelly, Oisín	James Larkin	D26	O'Connell Street	53.349086	-6.259933
Kelly, Oisín	Children of Lir	D40	Parnell Square	53.353617	-6.264542
Kelly, Oisín	The Chariot of Life	E21	Lower Abbey Street	53.349482	-6.255237
King, Brian	An Dún Cuimhnaecháin – Monument to the Defence Forces	A13	Merrion Square	53.340040	-6.251298
King, Brian	Double Helix	B39	Trinity College	53.342279	-6.251427
Kinney, Desmond	The Táin	B34	Nassau Street	53.342144	-6.256032
Kinney, Desmond	The Harpy	E22	Lower Abbey Street	53.349560	-6.255653
Kirk, Joseph Robinson	Homer, Socrates, Plato & Demosthenes	B42	Trinity College	53.344396	-6.257292
Kirk, Joseph Robinson	Divinity, Science, Medicine & Law	B42	Trinity College	53.344396	-6.257292

Artist	Work	Ref. No.	Location	North	West
Kirk, Joseph Robinson	**St Peter**	D2	Arran Quay	53.346184	-6.277624
Kirk, Joseph Robinson	**St Patrick**	D4	Arran Quay	53.346152	-6.277470
Kirk, Joseph Robinson	**Commerce**	D6	Constitution Hill	53.353243	-6.272603
Kirk, Joseph Robinson	**Hibernia**	D7	Constitution Hill	53.353257	-6.272551
Kirk, Joseph Robinson	**Industry**	D8	Constitution Hill	53.353297	-6.272601
Kirk, Thomas	**Triumphal Arch**	C11	Foster Place	53.345092	-6.261194
Kirk, Thomas	**St Laurence O'Toole**	E12	Marlborough Street	53.350814	-6.258591
Kirk, Thomas	**Our Lady**	E13	Marlborough Street	53.350922	-6.258638
Kirk, Thomas	**St Kevin**	E14	Marlborough Street	53.351026	-6.258680
Lanyon, Charles	**Campanile**	B42	Trinity College	53.344396	-6.257292
Lynn, Samuel F.	**Agriculture, Commerce and Labour**	B48	College Street	53.345502	-6.258243
MacManus, Dony	**The Linesman**	A42	City Quay	53.347104	-6.249314
May, Adam	**Magdalene Seat**	B13	St Stephen's Green	53.338179	-6.259962
McCabe, Conall	**The Dublin Martyrs**	E15	Marlborough Street	53.350755	-6.258639
McColgan, Robert	**Scáthán**	E17	Store Street	53.350295	-6.252524
McDonagh, Eileen	**Incommunicado**	C32	Dublin Castle	53.343400	-6.268210
McDonagh, Eileen	**Clanbrassil Stones**	C51	Clanbrassil Street	53.336634	-6.273190
McGrath, Raymond	**Obelisk**	A16	Merrion Square West	53.340342	-6.253002
McKenna, Jakki	**Ag Crú na Gréine**	D21	Jervis Street	53.348195	-6.266988
McKenna, Jakki	**Meeting Place**	D22	Lower Liffey Street	53.346648	-6.263327
McKenna, James	**Robert Emmet Memorial**	C58	Thomas Street	53.343033	-6.281393
McLaughlin, Elizabeth	**Countess Constance Markievicz**	B51	Townsend Street	53.345987	-6.254381